FANTASY GENESIS
CHARACTERS

A CREATIVITY GAME FOR DRAWING ORIGINAL PEOPLE AND CREATURES

CHUCK LUKACS

IMPACT
CINCINNATI, OHIO
IMPACTUniverse.com

CONTENTS

1 GETTING STARTED ...4

Begin exploring the vast world of character design.

2 EMOTIONS: OUR INNER THEATER ...16

Learn the building blocks of what makes our characters show exactly what you want them to feel.

3 BEHAVIOR & ARCHETYPE ...46

Find out how to make your characters virtuous, villainous, old or young, cute-ish or brutish.

4 COSTUME & CULTURE ...78

Take on challenges to create unique costumes from once upon a time, to all over the world.

5 CREATURES AMONG US ...102

Tune your wig bubbler to new techniques for designing creatures in ways yet unimagined!

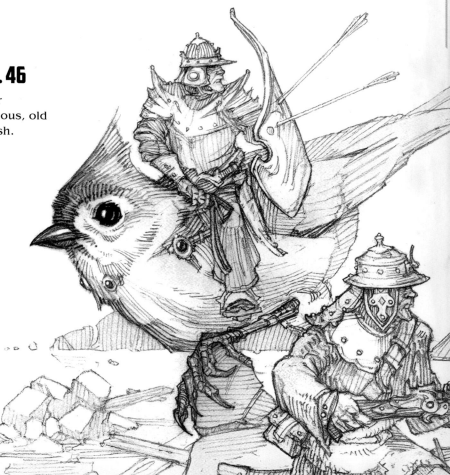

WHERE WE LEFT OFF

It's been seven years since the release of my first tutorial creativity game. In that time, *Fantasy Genesis* has been used by countless artists and craftsfolk, illustrators both digital and traditional, professional conceptual designers, and teachers and students in high schools and colleges from across the sphere. It has even been used by psychologists as a mind-expanding, world-building exercise for their patients. My simple brain game has evolved in ways I'd never expected, and I can't thank all its fans and supporters enough!

Almost immediately after its release, I also started teaching with *Fantasy Genesis*, using my games as a group of sketch challenges in my character design class. After consistent student success, I realized that my game was a powerful tool in the creation of imaginative characters, and that it might be time for another tutorial book.

In *Fantasy Genesis Characters* we will further explore our inner theater by expanding on emotional states and anatomical studies. We will journey into character archetype, behavior and age, conceptualizing cultural costumes for classy crowds, and creating crazy-cool critters and carefully confident creatures. I'll try not to practice my alliteration too much, but we'll be covering that as well. So, brush the dust off that stack of papers, sharpen your graphite six shooters, and set your wig bubblers to eleven because *Fantasy Genesis Characters* is about to begin!

WHAT YOU NEED

Surfaces
- sketchbook
- copier paper, 8½" × 11" (22cm × 28cm) (optional)
- semitransparent paper, 14" × 17" (36cm × 43cm) (optional)

Pencils and Erasers
- several sharpened graphite pencils
- erasers and retractable rubber erasers
- mechanical pencil (optional)

Inks
- markers
- dual brush pens (optional)

Other Supplies
- gaming dice: 2 six-sided dice, 2 four-sided dice, 1 eight-sided die, 1 twenty-sided die
- compass and ellipse template (optional)
- computer + Photoshop (optional)
- maquettes (optional)

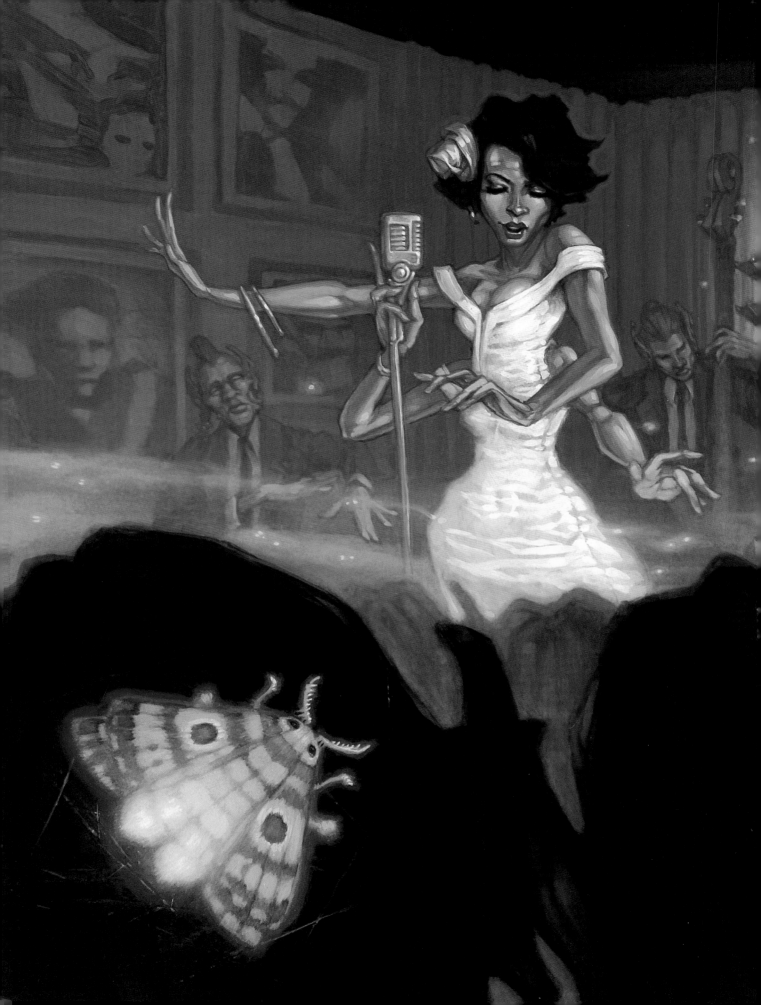

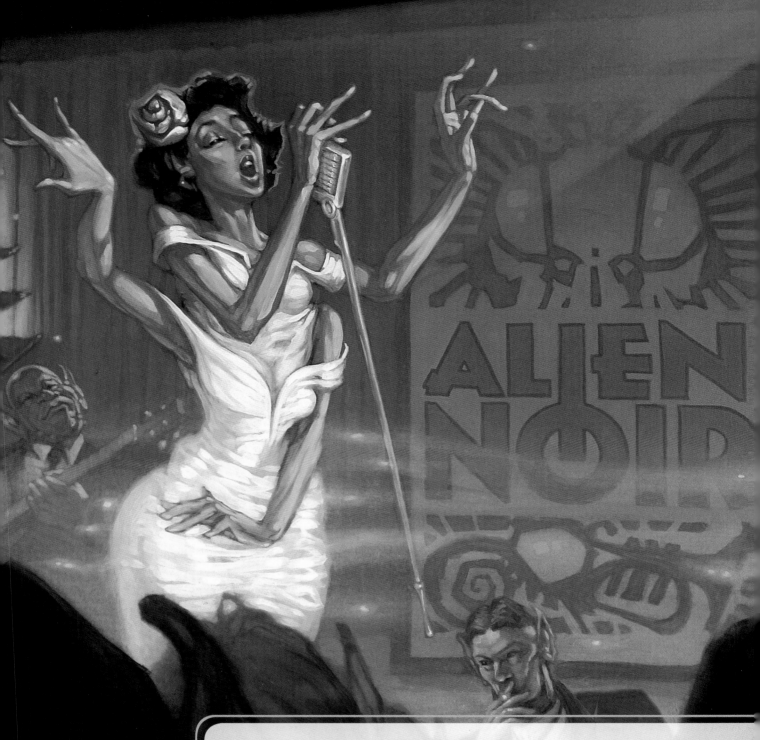

CHAPTER 1
GETTING STARTED

Explore this swinging scene of elves, alien moths and jazz-singing, multicultural multipeds, but not for too long. The vast world of character design awaits you inside!

SUPPLIES FOR OUR JOURNEY

Every artist has their favorite tools: a host of markers, pens and pencils of different makes, a set of watercolors, or perhaps a graphics tablet. We all grow into exactly what works most consistently for us over the years, and there are bound to be differences in what we all create with. I've found it's worth trying high-quality materials first and then looking into less expensive substitutes.

Never be afraid to craft your own tools to fit your specific needs perfectly: gloves or rubber bands for a better grip, brass tubing for chalk holders, or a pencil holder refitted with tiny retractable erasers. Make tools that work for you, but remember that there's nothing in this book you can't do with just a set of dice, paper, pencil and your imagination!

Sketchbook and paper: Your sketchbook is your most immediate and reliable surface for creating your characters. So, whether small or large, smooth or toothy, whether you buy it or bind it up yourself, keep one or two around at all times. Along with my traveling sketchbook, I keep a pad of 14" × 17" (36cm × 43cm) Bienfang Graphics 360 semitransparent paper, along with loose 8½" × 11" (22cm × 28cm) sheets of copier paper on hand.

Pencils: Keep a number of sharpened graphite pencils around so you can grab one when the ideas come to you. Once one goes dull, switch to a sharp one or a mechanical pencil, keeping the dull one for thick outlines or wide hatching. I mainly use General's Kimberly HB–3B pencils, but their no. 531–4B sketching pencils and no. 555 layout pencil can be used for a variety of inventive marks. I also use Tombow MONO 2B-3B pencils.

DICE
You'll need six gaming dice to roll most of these challenges (two six-sided dice, two four-sided dice, one eight-sided die, one twenty-sided die). Alternatively, simply pointing at the words randomly can be fun.

ERASERS, BRUSH & INK
I've used Sanford Union erasers for as long as I can remember making mistakes, but now I use them along with a thinner retractable rubber eraser on my Shorty's pencil holders for deductive marks from smudged-in tone. I also use a 2-inch (51mm) brush to wipe rubber shavings cleanly away without extra smudging.

Markers are effective for quickly concepting characters, using silhouetting techniques (see chapter 4). Tombow dual brush pens (nos. 879, 977, 912, 850 and 020) are excellent for making thick and thin marks like a brush. Digital inking and sketching can be the quickest inking technique, but drawing with vintage metal dip nibs, ballpoints, brushes and hand-crafted crow quills can give you rougher, more serendipitous effects that newer materials can't achieve.

MAQUETTES & TABLEAUX

There is no real substitute for life drawing or drawing straight from nature, but I'll sometimes enlist the use of maquette models and toys to help. I've constructed paper buildings and walkways, glued animal toys to pieces of Plexiglas, and made tiny capes and doll clothes to get the exact right light and forms for certain characters. Then I'll shoot photos of my maquettes and tableau scenes. It might seem complex, but it actually saves time.

MAQUETTES
The anatomy tutorials (see chapter 5) are up in my studio all the time, but I also use a set of anatomical models (*écorché*) to gain more realism and to help with theatrical light when my memory or photo reference is lacking. At most art supply stores you'll find Art S. Buck articulated mannequins, which can be very useful for their heads and hands alone. Truetype figures are also articulated and will offer more detail in their faces and skin textures.

3-D DIGITAL MODELS
Using 3-D digital models can be a great way to conceptualize a character's pose and expression as well as the setting and environment. I'll sometimes use 3-D Warehouse's library of 3-D Sketch Up models, life scans from Anatomy 360 (anatomy360.info), Handy phone app for hand poses, the many MARA3D anatomy *écorché*, and facial expression apps for your phone. If you're interested in sculpting digitally, Sculptris, the modeling engine that drives Pixologic's ZBrush is both easy to use and free!

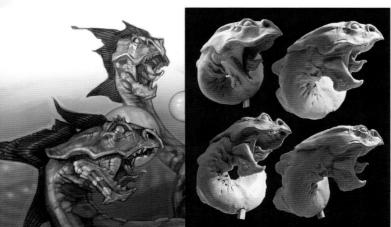

CLAY SCULPTURES
When I'm not having any luck with photo reference, models 2-D or 3-D, I'll sometimes bring out the gray Roma Plastilina no. 1 clay from Sculpture House and just start sculpting what I need out of clay.

GAME PLAY BASICS

Fantasy Genesis Characters is a series of game challenges to jump-start your brain into creating new ideas, new combinations and new visual solutions. They're not really rules; think of them as modes of thinking to help create better, more memorable characters. Some of these challenges will contain two or more lists that will supply the building blocks of the character you'll go on to develop and bring to life. Roll the dice to get a number of words, then choose which words you think would become a fun character. It's that simple! You could even pick these exact same words, and come up with wonderfully different combinations of characters. And therein lies the magic of each challenge: your imagination!

HOW TO PLAY

1. Roll six emotion words and six action words. This should give you a really good range of emotional states and actions to choose from.

2. Pick out pairs of words from each list. For example, At Attention + Deadpan or Paranoid, Shifty + Absorb, Eat.

3. Search the words for photo reference. This isn't necessary for everyone, but I find it helpful for the serendipitous changes, which visual associations are bound to bring to my character.

4. Then create a character sketch by free associating with a combination of words from both lists.

DICE SHORTHAND

The first number plus the letter d tells you how many dice to use for that roll. The second number refers to how many sides the die should have. So, 2d6 means two six-sided dice. 1d20 + 1d4 means one twenty-sided die and one four-sided die.

EMOTION LIST
1d20 + 1d4

2. Embarrassed
3. Anger
4. Timid, Bashful, Coy
5. **Giggling**
6. Derision, Bored
7. Smiling - Smirk
8. Stressed, Disgust
9. Fear
10. Thoughtful, Contemplative
11. **Deadpan**
12. **Berserk**
13. Smiling - Insane
14. Pining, Forlorn
15. LOL
16. Shock, Surprise
17. Gape, Gawk
18. Relief, Ease of Mind
19. Sneering
20. **Paranoid, Shifty**
21. Bliss, Joy
22. Confusion
23. Sad, Crying
24. Stern, Pouting

ACTION LIST
1d20 + 1d8

2. Smash
3. Drenched by Water
4. Blown by Wind
5. **Shove, Drag**
6. Sneezing
7. Crouched for Attack
8. **Hang, Climb, Plummet**
9. Proclaim, Explain
10. Disco Dance
11. **At Attention, Slouch**
12. Grabbing, Pushing
13. Kicking, Punching
14. Jump, Jive, Wail
15. **Absorb, Eat**
16. Meander, Shuffle
17. Spin, Whirl
18. Jump, Dart, Dash
19. Melted, Glowing, On Fire
20. **Squished in Crowd**
21. Heave, Lift
22. Thrash Metal Dance
23. Snooping, Listening
24. **Chop, Dig**
25. Balance It on Head
26. Flick at, Pick at
27. Creep, Tip-Toe
28. Shoot, Slash

11 DEADPAN + 11 AT ATTENTION

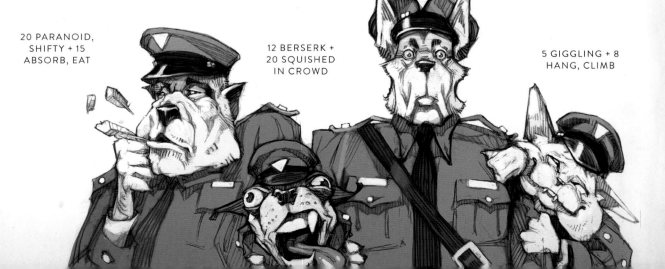

20 PARANOID, SHIFTY + 15 ABSORB, EAT

12 BERSERK + 20 SQUISHED IN CROWD

5 GIGGLING + 8 HANG, CLIMB

THERE'S NO EQUATION FOR CREATIVITY

TIPS ON FREEFORM CHARACTER IDEATION

The challenges you'll find here won't teach you to draw by themselves, but they will expand your skills through new possibilities and unexpected combinations. Some of the free associations and interpretations will seem completely mad until you form them into an idea. Read through these tips, never stop perfecting your sketching techniques, and these game challenges will help you explore new modes of thinking to imagine characters that no one has seen before!

MASH-UPS

Morph, mix and mash up the meanings of the words along with their forms, parts, behaviors, time periods, even symbolic meanings. Becoming skilled in mash-ups along with visualizing and rendering the transitions between the parts you're mashing up are valuable skills.

JUXTAPOSITION

A penguin tanning on a tropical beach. A vegetarian lion. Take an accepted generalization, and think about the opposite of that standard or norm. The purpose of a number of challenges is to play with juxtaposing what the audience sees as normal. Like a shadow archetype: bad guy turns out good. Or concentrate on size and scale, like an enormous baby. Think the opposite of whatever your character is known for and integrate that contradiction.

GROWTH AND DECAY

Think about the age of your character as well as their body shapes and forms. Should they be fresh from the egg or hunched and wrinkly? Will the construction and condition of their costuming be shiny and new, or falling apart with rust and holes? Perhaps the change of the seasons says something about their behavior, how they interact, how they appear.

HABITAT AND DIET

Think about your character's habitat and their costume. How will they have evolved in those temperatures, and what kind of craft or occupations may spring out of a specific habitat? Are they an herbivore, carnivore or omnivore? Will they hunt for energy, and how will they prepare and eat it?

ASK QUESTIONS

What, where, when, how and why can speak volumes about who. Don't be afraid of getting specific with your questions, and answer them all in detail. What is their taste in fashion? Music? Are they selfish? Team player? Apprehensive? Your sketches may never reveal these details, but asking questions about their tastes and ideologies will surely make them better characters.

WRITE IT DOWN QUICKLY

Ideas come and go quickly. Try sketching a thumbnail of what comes into your mind right when you make the connection of how the character or creature might look. Don't wait to flesh out the full gesture or look up photo reference.

RULES TO BE BROKEN

When you open your mind to impossibilities, ideas flow easily. Make your brain believe that anything is possible, and it will be far easier to make your character a memorable one. Try subtracting or adding a list of words, rolling over and over again, until your eyes open wide with an idea that you just can't pass up. Make up your own games, more specific to the cast of characters in your story, but make sure you search those infinitely impossible places to make things possible!

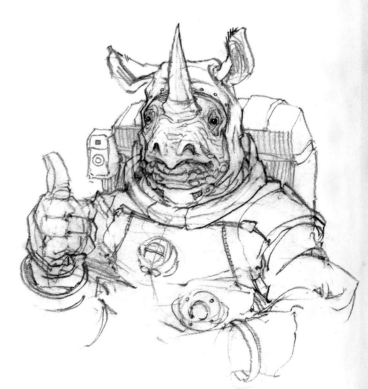

ASTRONOCEROS MASH-UP
The head of a rhino on a human body makes for a fun mash-up. Now add an astronaut occupation and presto! Meet your first astronoceros!

ON PHOTO REFERENCE

Since the dawn of optics, artists have used photographic reference to bring more realism to their work. Some Golden Age illustrators were able to hire photographers that would follow them through the countryside, snapping pictures of people, animals and landscapes that the illustrators would use to make stunning and believable paintings. It's no different when preparing for the challenges and games in this book. Every time you roll a word, look up a couple pictures for that roll to help you sketch and bring more realism to your work.

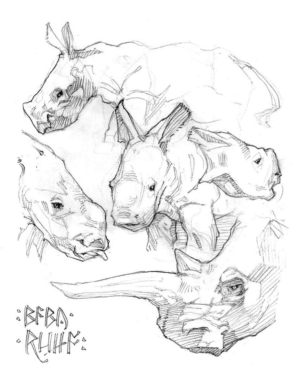

ACTION SKETCHING

If a character from a movie, television show or theatrical production keeps popping up in your search, look up that specific show and their role to see if you can screen-capture live footage. Sketching from live footage is the next best thing to sketching from life, as it contains movements, gestures and behavior. I paused a low-res video of a baby rhinoceros being born to create this sketch.

HUNTING FOR PHOTO REFERENCE

The Internet offers us the luxury of 2-D photo reference libraries as well as search engines dedicated to hunting down and cataloging any subject and 3-D 360-degree views of the most remote and beautiful places imaginable! Here are a few tips for a quicker and more effective hunt:

Be specific. If you're looking up kicking/punching, first search *kicking* and *punching*, then try *boxing* or *karate*. Similarly, if looking up *dancer*, try looking up *ballet dancer in Peter Pan* or *dancing the twist*.

Look at societies or college departments who archive your particular subject, competitions and festivals, specific groups, or photo journalists who specialize in your particular subject. Look at the bibliography at the end of this book for books and websites that catalog some of the most interesting people on the planet. They're just waiting to be sketched as your new cast of characters.

SHOOTING PHOTO REFERENCE

I use a few cameras to shoot my own reference on different occasions: a larger Canon digital camera, my phone camera, and sometimes I'll even use silly phone apps and computer filters to distort faces and expressions.

Pay attention to dramatic and high-contrast lighting. Having your subject or model face the light isn't always the most theatrical. Try to stage your scene with underlighting, side lighting or even backlighting. I use bright tungsten bulbs for neutral color, fluorescent bulbs for a cooler hue, and incandescent to go a bit warmer. Bike lights with color film or paper can also be really simple and effective.

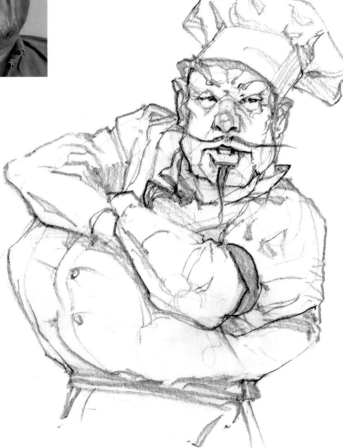

USING PHOTO REFERENCE

Look at the photo, then hide it. Don't let a photo get in the way of the character that's bubbling to the surface. Bend and twist the shapes in the photo to suit your needs, and draw from memory what you think the character will look like. When I was sketching this chef, I was looking at an illustration painted by J.C. Leyendecker for the period costuming and facial hair, but sketched as many of the natural shirt wrinkles in the photo as I could to keep the pose intact and believable.

 CANDID CROWD SHOTS

Some of the most expressive poses and emotions can be caught when folks aren't reacting self-consciously. Capturing crowd shots can often reveal a genuine nature, impossible with a staged shot. Characters are everywhere if we look for them.

CHARACTERS, CHARACTERS EVERYWHERE!

These two warm-up exercise challenges really help me limber up those sketch muscles and get my wig bubbler firing on all cylinders. They work purely through visual associations and how your wonderful brain imagines the funky world around you. The human brain is hardwired to react in specific ways to visual stimuli.

APOPHENIA AND PAREIDOLIA

Apophenia and pareidolia are psychological phenomena or experiences involving vague or sometimes random bits of meaningless visual data being perceived as something more significant or meaningful. Seeing animals in the clouds, or the man on the moon, even seeing dancing Ganesha in your slice of burnt toast is a form of apophenia and pareidolia. This exercise can produce some wonderfully unique characters because it's based on random shapes and your special ability to fill in the gaps. Create what's not there. Most of the time you don't even have to find these faces and figures, as they simply won't go away!

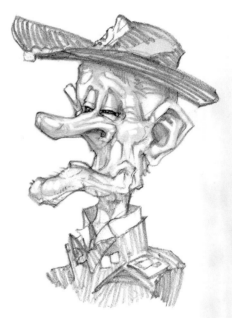

APOPHENIA & PAREIDOLIA CHALLENGE

Try your hand at sketching a couple characters from this leering technoid. Will yours have lasers shooting from their eyes or jet engines for flying? The knobs, spigot and drain on any sink can turn into eyes, nose and mouth.

Now find your own hidden characters—they're all around you! Look at sections of random pattern and a character might crawl out of the woodwork. Once you find them, sketch them quickly or take a picture. They can disappear as easily as they appear to you.

WALL PLASTER INFANTRYMAN

After rotating and looking at this wall plaster texture for a minute or two, I found this old gentleman with a long nose and sunken jaws, standing at attention. The hat shape could have given a number of different associations, but I looked up Civil War-era costuming, and this infantryman character emerged completely at random from all the shapes given to me.

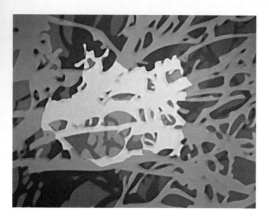

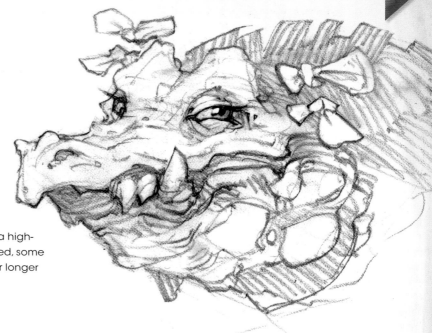

TREE BRANCH CROCODILE

I saw a dragon or crocodile snout with eyes in the area high-lighted in these tree branch patterns. Then, as I sketched, some of the shapes looked like bows, so I gave my character longer eyelashes and made her a creepy crocodile.

PENCIL TECHNIQUE

I use this sketching technique throughout this book:

1. Start with light, expressive use of the side of the pencil.

2. Then, build detail with darker, finer marks with the tip of the pencil.

3. Smudge in tone with the flat of your palm or side of your finger.

4. And finally, erase through the tone with different-sized erasers.

 You may want to stop short of steps 3 and 4 if you get something you're happy with and don't want to overwork your sketch. Try gripping the pencil in different ways, and remember which series of marks were successful for you.

 RANDOM PATTERN & TEXTURE SOURCES

Search for random patterns and textures in: wood grain, plaster walls, shower curtains, bark and branches, veins of leaves, clouds, frosty windows, polished gemstones and crystals, crumpled paper, foamy waves, blades of grass, fabric and embroi-dery, ink blooms, stains and rust, cracks in cement.

PLANT A DOUBLING TREE

Sketching a doubling tree is one of my favorite exercises to kick-start my hands into making and my brain into thinking in new directions. The basis is an exponentially growing series of numbers. No matter what you make, sketching a doubling tree develops many different drawing skills at once. It shows the way life forms grow and develop into believable patterns, and it develops technique as you sketch your content large and then incrementally smaller and smaller.

1, 2, 4, 8, 16, 32 and so on . . .

BASIC DOUBLING TREE CHALLENGE

Start with one simple shape. Then place two slightly smaller but similar shapes growing from one end. Two more similar shapes then divide and grow from every one shape exponentially. Outline the shapes to define forms, and watch for all the negative and positive spaces that spring from the expanding mass.

Make your shape thin at the bottom to allow for as many divisions as possible. Also allow some of the branches to overlap as they get smaller and smaller to form unexpected and random patterns. This exercise can be used to make any number of naturally occurring patterns: plant forms reaching for the sunlight, cloud formations, insect wings, fins, antlers, hairstyles and body shapes.

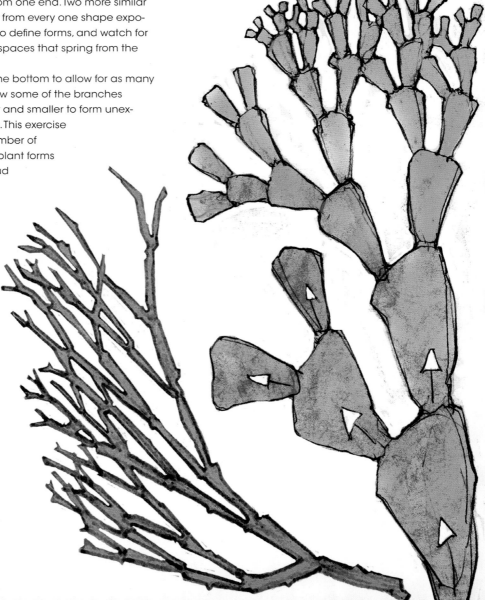

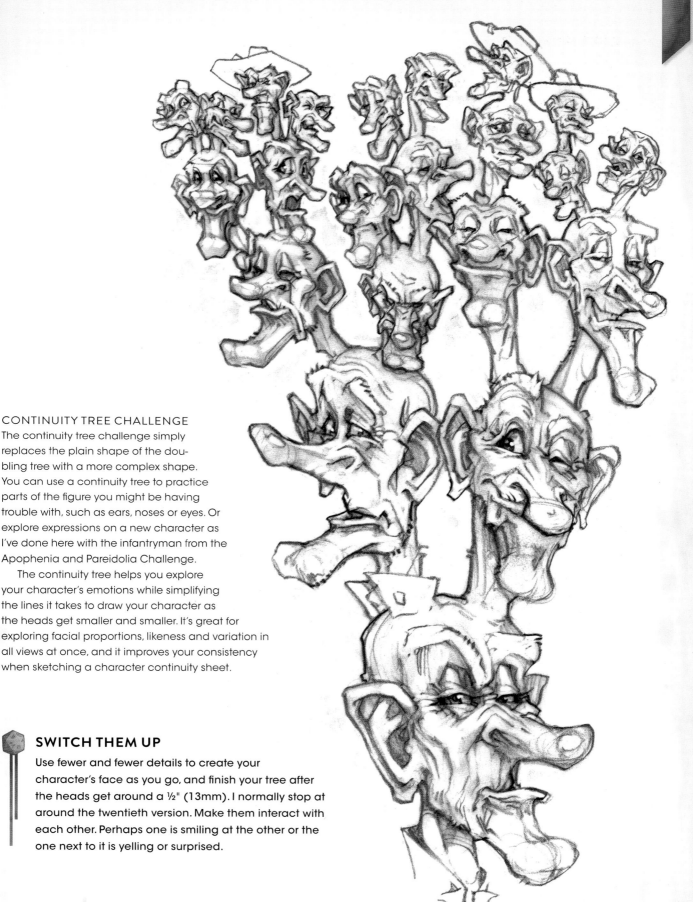

CONTINUITY TREE CHALLENGE

The continuity tree challenge simply replaces the plain shape of the doubling tree with a more complex shape. You can use a continuity tree to practice parts of the figure you might be having trouble with, such as ears, noses or eyes. Or explore expressions on a new character as I've done here with the infantryman from the Apophenia and Pareidolia Challenge.

The continuity tree helps you explore your character's emotions while simplifying the lines it takes to draw your character as the heads get smaller and smaller. It's great for exploring facial proportions, likeness and variation in all views at once, and it improves your consistency when sketching a character continuity sheet.

SWITCH THEM UP

Use fewer and fewer details to create your character's face as you go, and finish your tree after the heads get around a ½" (13mm). I normally stop at around the twentieth version. Make them interact with each other. Perhaps one is smiling at the other or the one next to it is yelling or surprised.

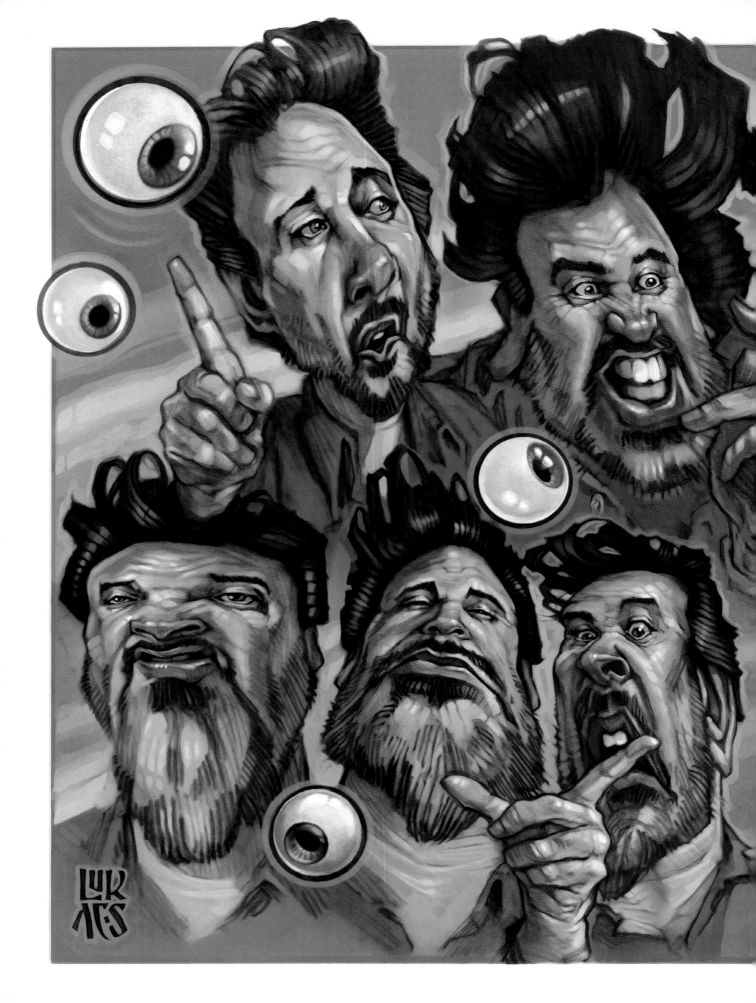

CHAPTER 2
EMOTIONS: OUR INNER THEATER

Emotions. Actors and comedians study them, philosophers debate them, and artists learn to sketch them. This chapter is filled with the building blocks of what makes our characters show exactly what you want them to feel!

DETECTING EMOTIONS

The more we learn to observe human behavior, the more we can add to the emotional depth of our characters. Our perception of subtle peculiarities, individual "tells" and quirks will have direct impact on who our characters become and how memorable they will be for our audience. This chapter is all about our inner theater, being able to detect emotion on any face and then sketching those emotions into our characters. We won't cover the intricacies of every human emotion, but consider chapter 2 the building blocks to a great many of them, which will help in telling our audience just how our characters are feeling.

All of these demos include the specific words that they illustrate on the emotion list. The first set of demos concentrates on the upper half of the face, and the second set covers the lower half.

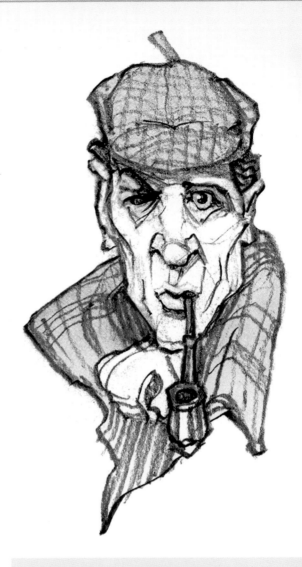

- Passive Brow
- Inverted Brow
- Aggressive Brow
- Staggered Brow
- Wide Eyed

- Smiles
- Frowns
- Lip Pursing
- Duck Face
- Teeth Baring

EMOTION GAME
Check out all the demos in chapter 2, and then play around with the things you've learned!
- Roll two emotional states from the list.
- Create a character with one of those emotions.

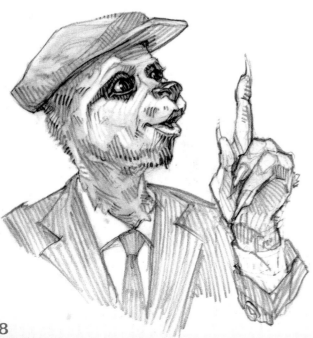

EMOTION LIST
1d20 + 1d4

2.	Embarrassed	14.	Pining, Forlorn
3.	Anger	15.	LOL
4.	Timid, Bashful, Coy	16.	Shock, Surprise
5.	Giggling	17.	Gape, Gawk
6.	Derision, Bored	18.	Relief, Ease of Mind
7.	Smiling - Smirk	19.	Sneering
8.	Stressed, Disgust	20.	Paranoid, Shifty
9.	Fear	21.	Bliss, Joy
10.	Thoughtful, Contemplative	22.	Confusion
11.	Deadpan	23.	Sad, Crying
12.	Berserk	24.	Stern, Pouting
13.	Smiling - Insane		

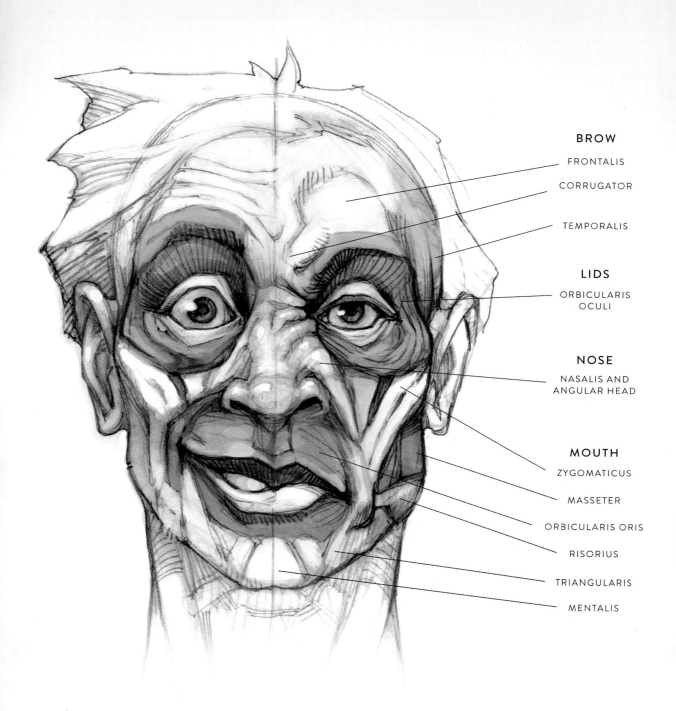

BROW

FRONTALIS

CORRUGATOR

TEMPORALIS

LIDS

ORBICULARIS
OCULI

NOSE

NASALIS AND
ANGULAR HEAD

MOUTH

ZYGOMATICUS

MASSETER

ORBICULARIS ORIS

RISORIUS

TRIANGULARIS

MENTALIS

MAKING SENSE OF MUSCLES

There are forty-two muscles in the face that create the infinite variety and subtlety of emotions our faces are capable of. I've condensed those muscles into the ones most important to artists, and those closest to the surface of the face. Use this page as a reference guide as you work through the demos in this chapter.

Studying surface anatomy isn't essential in making a memorable character, but the more you learn, the more believable your character will become. At times, I like the anatomical mistakes I sketch. They may appear more dynamic than pure realism. So, although there are more anatomy charts at the end of the book, never let them inhibit your imagination!

PASSIVE BROW

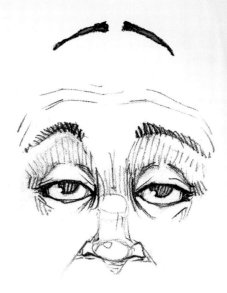

A passive or raised brow can be seen on any character archetype, in just about any situation. It is the foundation for a wide range of emotional states including enlightenment as seen throughout Asian art history, from shock and surprise to an air of humble relaxation, dumbfounded indifference or smiling bliss. It's a great expression for the calm, meditative strength behind your virtuous, wise old guide, the wide-eyed enthusiasm for your sidekick archetype or your villain's derisive retort.

ARCHED MUSCLES

The passive brow line is created mainly by an arching and lifting of both corrugator muscles and the forehead's frontalis muscle, and can often create horizontal wrinkles along the forehead because of that upward lifting.

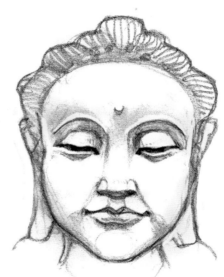

BROWS & EMOTIONAL INTENSITY

You can change the intensity of a character's emotion (just like turning up the volume on music) with two variables: how high the brow line is raised and how far the eyes are opened. Tired, heavy eyelids or lowered, meditative lids might be 1–2 on the dial, while wide eyes rank in at 11!

EMOTION LIST
1d20 + 1d4

2. **Embarrassed**
3. Anger
4. **Timid, Bashful, Coy**
5. **Giggling**
6. **Derision, Bored**
7. **Smiling - Smirk**
8. **Stressed, Disgust**
9. Fear
10. **Thoughtful, Contemplative**
11. **Deadpan**
12. Berserk
13. **Smiling - Insane**
14. **Pining, Forlorn**
15. **LOL**
16. **Shock, Surprise**
17. **Gape, Gawk**
18. **Relief, Ease of Mind**
19. **Sneering**
20. **Paranoid, Shifty**
21. **Bliss, Joy**
22. **Confusion**
23. Sad, Crying
24. Stern, Pouting

 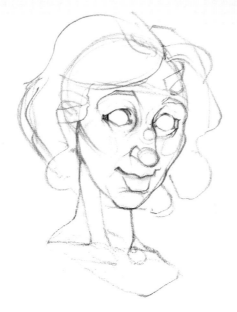 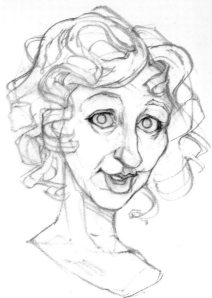

1 Measure the Proportions

Begin by measuring the proportions of the face: circles for the cranium, eyes and tip of the nose. Draw in the line of the passive brow, paying attention to the way both eyelids and eyebrows form an arch, and the line between the lips forming a small smile.

2 Sketch the Features

Sketch more details, forming the specific shapes of the eyes, brow, nose, lips and hair. Notice some of the neck muscles developing, the bridge of the nose and curve of the lips.

3 Develop the Features

Erase the proportion guidelines and circles to smooth out the skin texture. Avoid darkening the texture of female characters' skin too much. Similarly, younger characters shouldn't have deep-seated wrinkles under the eyes, nose and mouth. However, notice that darker eyelashes on the outside corners of the eyes create more contrast and depth in the face.

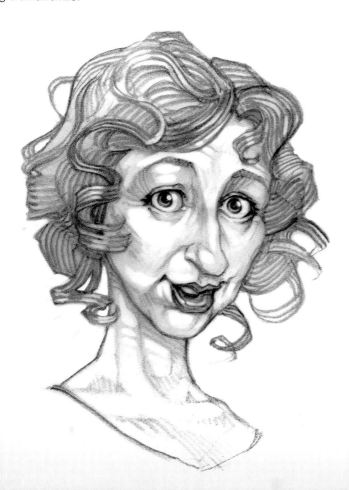

4 Add Final Details

Darken the points of highest contrast to lock in the facial expression at the darks of the mouth and lips, irises and pupils. Then erase the bright highlights. Smudge in areas of shadow on the smooth face and looping hair shapes, filling them with tone and directional line hatching. Then, again, erase the highlights inside that tone.

INVERTED BROW LINE

An inverted brow with calm and passive lids and a smile can make your character appear timid and bashful, while both inverted brow and lids will send clear messages of worry, regret or fear. Whether your character's inverted brow is there because of expectantly positive or negative emotions, it is a clear sign of unrest and being unsure.

HIGH & TIGHT

The expression is made when the frontalis and temporalis muscles of the forehead lift up, while the obicularis oculi and corrugator muscles invert upward and toward the center of the face.

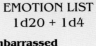

EMOTION LIST
1d20 + 1d4

2. **Embarrassed**
3. Anger
4. **Timid, Bashful, Coy**
5. **Giggling**
6. **Derision, Bored**
7. **Smiling - Smirk**
8. **Stressed, Disgust**
9. **Fear**
10. Thoughtful, Contemplative
11. Deadpan
12. **Berserk**
13. **Smiling - Insane**
14. **Pining, Forlorn**
15. LOL
16. Shock, Surprise
17. **Gape, Gawk**
18. Relief, Ease of Mind
19. Sneering
20. Paranoid, Shifty
21. Bliss, Joy
22. Confusion
23. **Sad, Crying**
24. Stern, Pouting

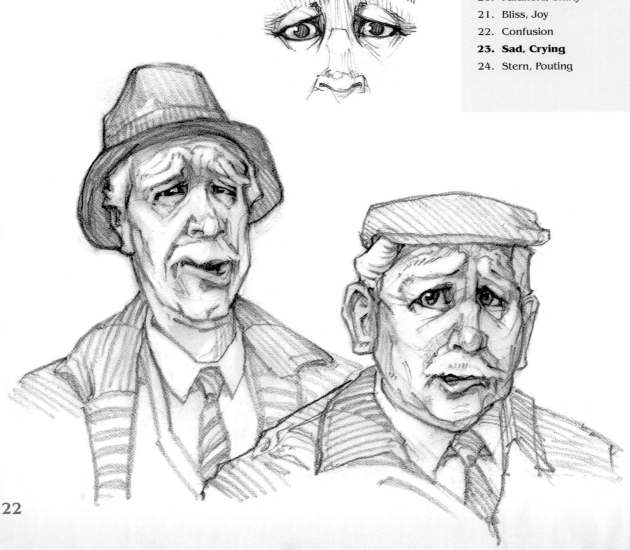

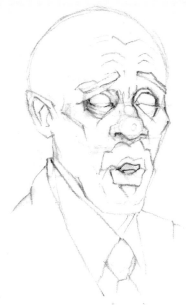
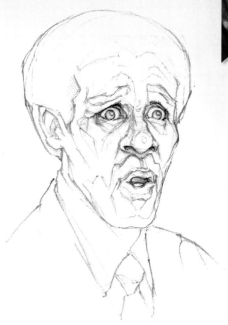

1 Measure the Proportions

Begin by measuring the proportions of the face: cranium, jawline, ear, eyes, lips and tip of the nose. Carefully sketch in the inverted eyebrows that will become the base of this comically fearful expression.

2 Sketch the Features

Sketch more details into the shoulder line and costume. Then concentrate on the angular details of the face, mapping out the dark inverted eyebrows, mustache and facial hair, slightly raised nostrils, upper and lower eyelids, and wrinkles of the forehead. Notice how they form an M pattern because of the frontalis muscle rising.

3 Develop the Features

Place the irises inside the eyes and darken the details of his inverted expression: both eyelids, lashes and lips. Notice the shape for lower teeth peeking out and show a slight extension of the jaw.

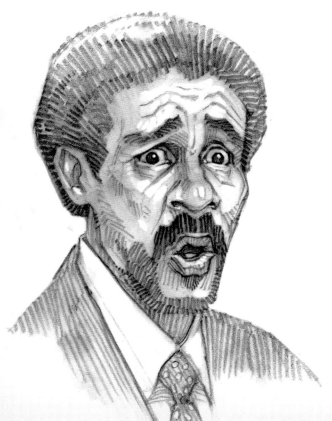

4 Add Final Details

Darken the irises, pupils and lashes, then erase the bright highlights. Mark out areas of shadow, filling them in with smudged-in tone, then erase marks into that tone to form the brightest highlights. When sketching short hair or a shaved scalp, I like to make marks that radiate out from the tip of the nose since there aren't many curves or curls in the hair to play with.

AGGRESSIVE BROW

Common in villain archetypes and characters with serious roles to play, the aggressive or knitted brow is an expression of contemplation, discomfort, anger and rage. Perhaps your character is a no-nonsense warrior, brooding inventor or sarcastic phone operator.

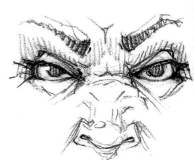

MUSCLE & WRINKLE LINES

In its extreme, the muscles along the nose are also drawn up, causing horizontal and vertical lines that develop between the corrugator muscles and the bridge of the nose. There are also wrinkle lines that can form an M shape between the bridge of the nose and the raised muscles of the nasalis and angular head. These wrinkle lines may not appear on every aggressive brow, but they can be added to indicate anger when the brow line is completely obscured by bangs, a hat or glasses.

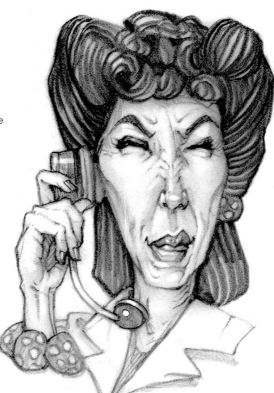

EMOTION LIST
1d20 + 1d4

2. Embarrassed
3. **Anger**
4. Timid, Bashful, Coy
5. Giggling
6. **Derision, Bored**
7. **Smiling - Smirk**
8. **Stressed, Disgust**
9. Fear
10. **Thoughtful, Contemplative**
11. Deadpan
12. **Berserk**
13. **Smiling - Insane**
14. Pining, Forlorn
15. LOL
16. Shock, Surprise
17. Gape, Gawk
18. Relief, Ease of Mind
19. **Sneering**
20. Paranoid, Shifty
21. Bliss, Joy
22. Confusion
23. Sad, Crying
24. **Stern, Pouting**

LOW & TIGHT

Whether your character's aggressive brow is temporary or permanent, it is generally formed as a result of the brow's corrugator muscles being drawn down. Wrinkles will move from the forehead and radiate out from the inner corners of the eyes.

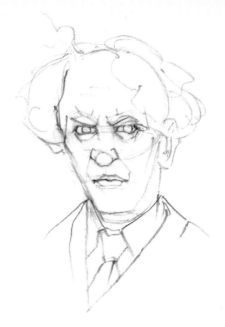
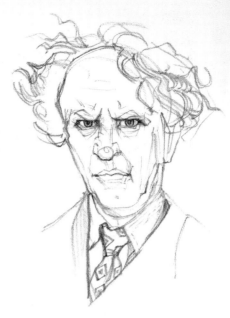

1 Measure the Proportions

Begin by measuring the proportions of the face: cranium, jaw, ear, corners of the mouth and the tip of the nose. Lightly sketch the downward lines of both upper eyelids and eyebrows and the shapes of the eyes that will become the focus of this expression.

2 Sketch the Features

Lightly sketch out the shapes for the hair, shoulder line and costume, and place the line between the lips and their corners. Then place the irises inside the eyes, and notice how the aggressive tilt of the lids and brow instantly affects the disgruntled and bent expression.

3 Develop the Features

Start adding more details to the costume and expression, darkening the irises, pupils, eyelids and lashes. Notice the flat, stern, angular shapes of the eyes and nose, and how they contradict the disheveled forms developing in the hair.

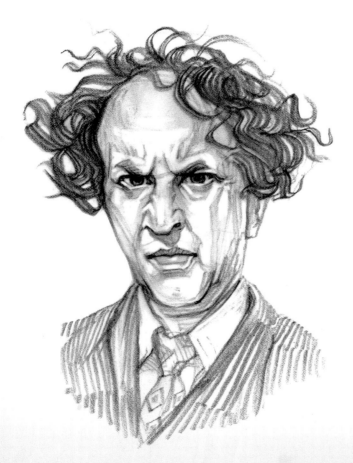

4 Add Final Details

Finish with playful marks to darken the hair, eyes and lashes, and keep the M shape in mind when defining the shadows underneath the stern, aggressive brow. Mark out areas of shadow, filling them in with smudged-in tone, then erase marks in the toned areas to form the brightest highlights.

EMOTIONS
STAGGERED BROW

Common in sneering shadow archetypes and playfully suave characters, the staggered brow is inherently deceptive. When used with a smile, it can indicate a charming confidence, but it can also be used to show an animal-like doubt or confusion when reinforced with a slight tilt of the head.

CONTRADICTORY EMOTIONS

The staggered brow is a contradictory expression: One half of the face is saying the opposite of the other half. Take your hand and cover up the left eye and brow on any of these faces, then cover up the right. Notice the difference in emotions? Try making the expression in the mirror—not everyone can do it!

UP & DOWN
The expression is made mainly with the frontalis and corrugator muscles. Half the frontalis and corrugator lift one brow upward, while the other corrugator pushes the opposite brow down into a more aggressive position.

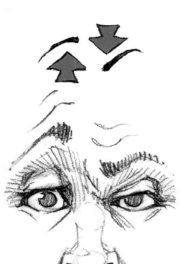

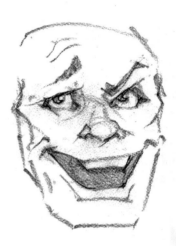

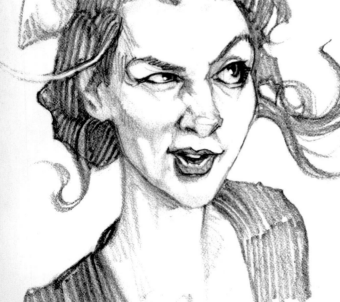

EMOTION LIST
1d20 + 1d4

2. Embarrassed	14. Pining, Forlorn
3. Anger	15. LOL
4. Timid, Bashful, Coy	16. Shock, Surprise
5. Giggling	**17. Gape, Gawk**
6. Derision, Bored	18. Relief, Ease of Mind
7. Smiling - Smirk	**19. Sneering**
8. Stressed, Disgust	**20. Paranoid, Shifty**
9. Fear	21. Bliss, Joy
10. Thoughtful, Contemplative	**22. Confusion**
11. Deadpan	23. Sad, Crying
12. Berserk	24. Stern, Pouting
13. Smiling - Insane	

1 Measure the Proportions

Begin by measuring in the proportions of the face and the distance between the eyes, ears, tip of the nose, mouth and jawline. Sketch the eyelashes and brow line to create the staggered brow with the left brow turning downward and right brow tilting upward, opening the eye wide.

2 Sketch the Features

Sketch in more details, forming the shapes of the eyes, brows, nose, line between the lips, and the shapes of costuming and hair. Notice the wrinkles forming on the forehead because of the lifting of the corrugator and frontalis muscles.

3 Develop the Features

Sketch in the rest of his costume and direct the flow of his parted hair. Place the irises inside the eyes, and darken in the details of his staggered expression, including eyelashes, eyebrows and lips.

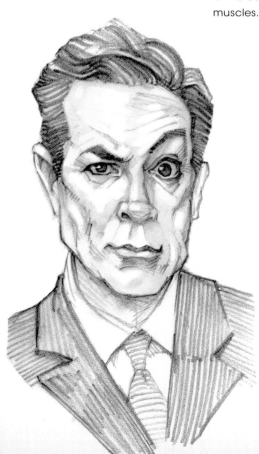

4 Add Final Details

Darken the final details of the face. Notice how both the eyebrows fade from dark to lighter, as do sections of the folds in the hair. Mark out areas of shadow, filling them in with smudged-in tone, then erase marks into the toned areas to form the brightest highlights.

WIDE EYES

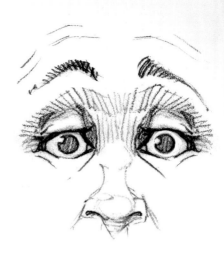

Wide eyes will wildly intensify whatever expression your character is experiencing. Wide eyes add more contrast to the face, the whites of the orbit surround the dark of the irises, and thus the eyes are one of the first things our brain is drawn to. Wide eyes were used in 1930s–1940s animation and comics to show a constant enthusiasm in every character, and they're effective in portraying the bold and piercing eyes of a hero, villain and shadow archetype, or the vacant deadpan stare of a childlike adult. If your character has wide eyes, the audience is going to want to know why.

EYE HIGHLIGHTS

The highlights cast on the rim of the bottom eyelid can be used to fine-tune the eyes. They can change the direction of the eyes and can also accentuate your character's wide eyes, surrounding the dark circle of iris with light.

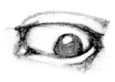
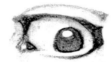

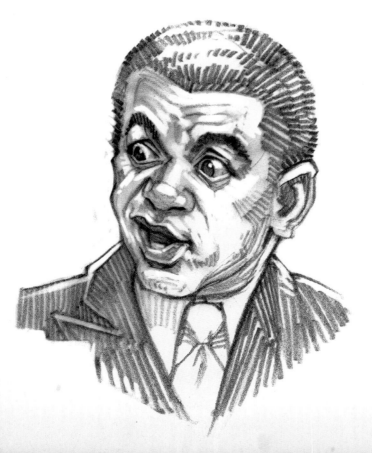

EMOTION LIST
1d20 + 1d4

2. **Embarrassed**
3. **Anger**
4. Timid, Bashful, Coy
5. **Giggling**
6. Derision, Bored
7. **Smiling - Smirk**
8. **Stressed, Disgust**
9. **Fear**
10. Thoughtful, Contemplative
11. **Deadpan**
12. **Berserk**
13. **Smiling - Insane**
14. **Pining, Forlorn**
15. **LOL**
16. **Shock, Surprise**
17. **Gape, Gawk**
18. Relief, Ease of Mind
19. **Sneering**
20. **Paranoid, Shifty**
21. Bliss, Joy
22. **Confusion**
23. **Sad, Crying**
24. **Stern, Pouting**

1 Measure the Proportions

Begin by measuring the proportions of the slightly down-turned face: cranium, lips, tip of the nose, and jawline. Carefully sketch the large white shape of the eyes, which will become the focus of this expression.

2 Sketch the Features

Lightly sketch out the shapes for the hat, hair, shoulder line and costume. Then place the irises inside the eyes, and notice how the inverted line of the lids turn upward, while the slightly aggressive line of the brows turn downward at the same time. Watch for this subtle juxtaposition, and add it to your shadow archetype characters—one moment passive and the next very wide-eyed and intense!

3 Develop the Features

Sketch in the rest of the costuming elements, and start adding the details of expression. Notice the elegant curve of the upper lip's Cupid's bow, the angular features of the jawline and the spiraling forms developing in the hair.

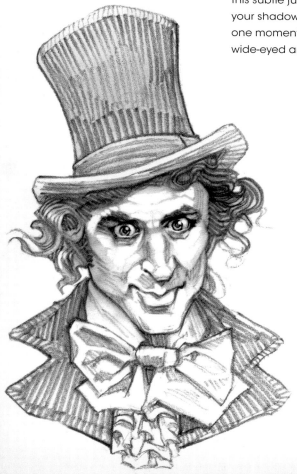

4 Add Final Details

Darken the irises, pupils and lashes, then erase the bright highlights, defining that intense gaze. Mark out areas of shadow, filling them with smudged-in tone, then erase marks into the toned areas to form the brightest highlights.

LIPS & JAWLINE

The lower half of the face is equally expressive in portraying your character's personality traits and intricacies. Visualizing and sketching the quirks of the lips, jaws and speech patterns can give you loads of useful visual information to create very memorable characters. Practice sketching yourself in the mirror or freeze-framing video to see how the muscles of the mouth form certain emotions.

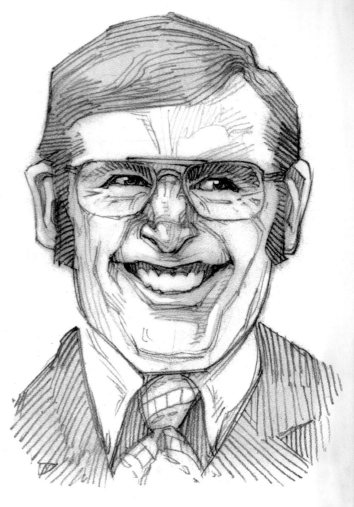

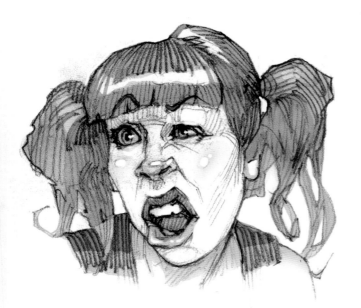

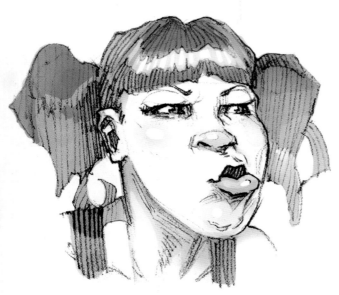

JAW POSITION
Pay attention to:
- The resting position, angles and size of your character's jawline and teeth.
- The distance you place between the nose and each lip is a good indication of relative jaw position.
- Overbite and underbite. Both can sometimes make a character's face go a bit slack-jawed or buck-toothed. Great for comic relief, but may not fit a serious character, who typically has a symmetrically centered jaw.
- How both upper and lower teeth appear against the dark of the mouth. This contrast can immediately tell the viewer how far your character's jaw is extended or retracted, but is also one of the first things we notice about any character when the mouth is open.

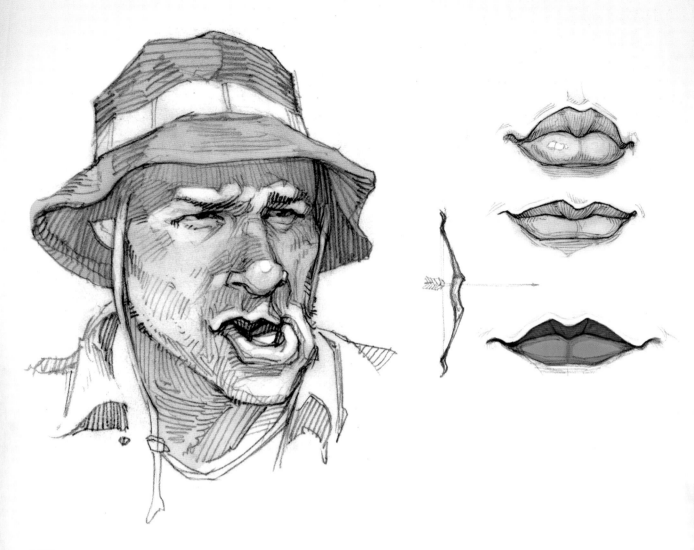

LIPS

Keep a couple things in mind while sketching:

- Your audience will normally look to the position of the corners of the mouth and to the line between the lips to tell them what emotion your character is feeling. Changing a character's emotion can be as easy as changing the direction of that line between the lips or raising or lowering either corner of the mouth.
- The top lip is almost always in shadow and darker, the bottom lip catching more light.
- Most lips are comprised of three forms on top and two forms on bottom. Visualize them as one central V- or heart-shaped divot that parts the four forms to each side of the top and bottom lips.

- Consider the gender of your character and look up specific photo reference to illustrate the gender you choose. Gender can play a role in the forms and size of the lips as can the ethnicity you choose for your character. I find it fun to play around with gender reversal sometimes, like with Chuck Jones's Bugs Bunny character. To feminize lips, treat the five forms a bit more like fuller, inflated balloonlike forms. Masculine lips tend to be very thin, especially the top lip, and are drawn a bit more angular and flat.
- During the Renaissance, the delicate shape and curve of the upper lip was thought of as a "Cupid's bow" as it can resemble the shape of a recurve bow.

EMOTIONS
SMILES

Smiles: Some are subtle, some awkward, others deliberately toothy and fierce, and some of the best smiles come from the practiced and articulate mouths of actors and comedians. Smiles can make our characters express joy, laugh and giggle, even sneer or smirk derisively, but they all start by drawing the corners of the mouth upward.

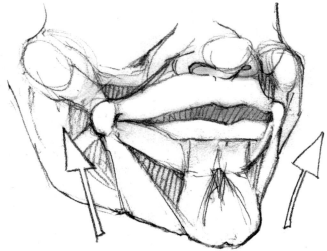

ANATOMY OF A SMILE
Like the muscle map shows, a smile is commonly formed when the cheek's zygomatic major, risorius and orbicularis oris lift the corners of the mouth upward.

 LAUGHING EYES

When the eyes are laughing, a wide smile can be detected without seeing the smile at all. Cover up the nose and mouth with your hand, and notice how the upturned cheeks and eyelids still tell the audience she's smiling.

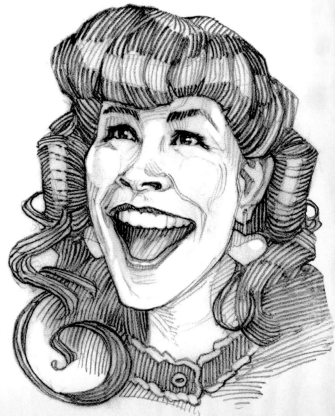

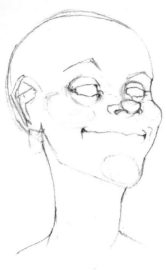
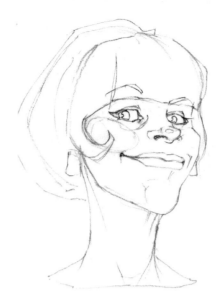
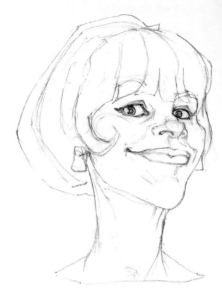

1 Measure the Proportions

Start by lightly roughing in the forms and shapes of the face: skull, neckline, cheeks and chin, eyeballs, eyelids, staggered brow line, tip of nose, ear and earring. (Notice how I sketch through the ear shape, even though the hair will eventually cover it.) Then, sketch in those important corners of the mouth with a comma shape along with the line between the lips.

2 Sketch the Features

Always check your proportions for the eyes, nose and mouth. Better to fix your drawing before you've added a lot of detail. Rough in the shapes of the bangs and curls of the hairline, making sure to extend the hair outside the surface of her skull. Further define the shapes of the eyelashes and the irises, the shapes of the upper and lower lips, and the collar line.

3 Develop the Features

Softly darken the shapes of shadows around the eyelids and eyelashes. Further define the pupils, divide the bangs into smaller strands, and begin to smudge in some tone with the side of your hand or fingers. Take another look at the muscle map, and place the smooth shadow lines that run from each nostril to the corners of the mouth. Be very careful to keep these lines and tone soft and light, especially when working on a female character.

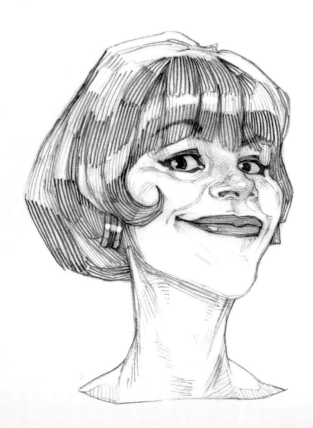
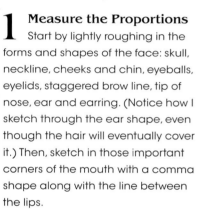

4 Add Final Details

Finish by darkening in the areas of shadow with a combination of hatched line and smudged tone. Then erase through the smudging and line with clean highlights. Notice how the face becomes filled with contrast once you darken the brows, lips and lashes.

FROWNS

Even though frowns are the polar opposite of smiles, they are similar to smiles in that they're seen on every possible character archetype. Frowns can reveal everything from subtle fear and disappointment to stern and deliberate anger, and sometimes the resting face of a serious hero or brutal villain will never change from anything but a natural frown.

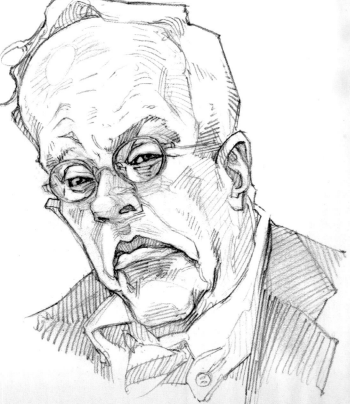

FROWN ANATOMY
Like the muscle map shows, a frown is formed when the jaw's triangularis and risorius and the orbicularis oris turn the corners of the mouth downward.

FROWN EFFECTS
A frown will often draw the lower eyelids down slightly more, and flare the nostrils a bit. Frowns can also lengthen the surface of the lips, while creating jowls under each corner of the mouth.

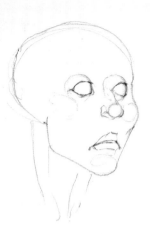

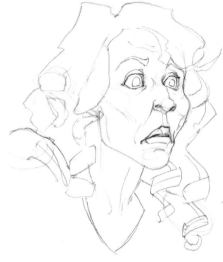

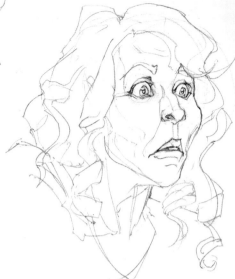

1 Measure the Proportions
Begin by drawing in the proportions of the head and face: cranium, jawline, eyes, tip of the nose, cheeks and lips. Sketch in the line between the lips, turning the corners of the mouth down into a proper frown.

2 Sketch the Features
Lightly sketch more emotion in to the face: inverted eyebrows, eyelashes and irises within each orbit. Notice the highlight edge from the Wide Eyes lesson. Also, start to lightly sketch in the major shapes of the hair and its curls. Notice how the curls are ropelike and spiral into thick shapes, not individual strands of hair.

3 Develop the Features
Place the pupils and their highlights in the irises, and start to darken the lashes. Lightly define the smooth areas of shadow that will form the frown, while darkening the shapes of the nostrils and mouth.

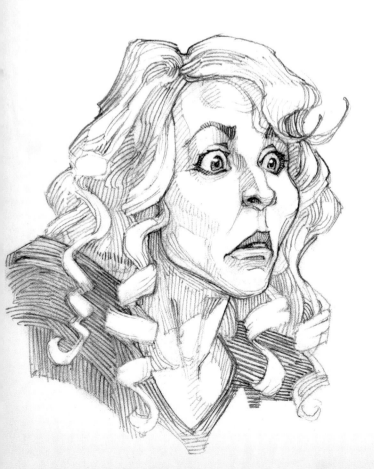

4 Add Final Details
Finish by darkening the shapes of shadow with hatching or smudged-in tone, then erase the highlights of the face and hair. Remember to keep your marks around a female character's face and neck light and delicate.

LIPS PURSING

Lip pursing is common in irate or judgmental characters. The pursing of the lips can indicate a literal tight-lipped or conciliatory state. Perhaps your heroine is hiding something, holding in a laugh or a cry, is in the beginning of pouting, distaste, anger or frustration. Sketch the lips thinner, smaller and tucked tighter into the teeth.

EMOTION LIST
1d20 + 1d4

2. Embarrassed
3. Anger
4. Timid, Bashful, Coy
5. Giggling
6. Derision, Bored
7. Smiling - Smirk
8. Stressed, Disgust
9. Fear
10. Thoughtful, Contemplative
11. Deadpan
12. Berserk
13. Smiling - Insane
14. Pining, Forlorn
15. LOL
16. Shock, Surprise
17. Gape, Gawk
18. Relief, Ease of Mind
19. Sneering
20. Paranoid, Shifty
21. Bliss, Joy
22. Confusion
23. Sad, Crying
24. Stern, Pouting

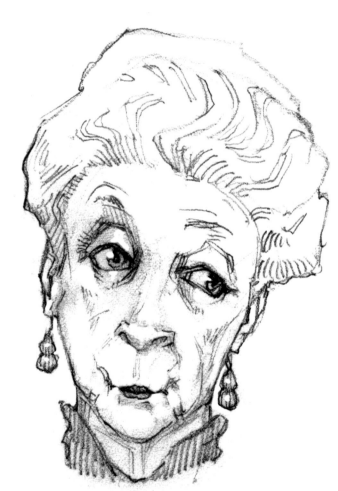

LIP PURSING MUSCLES
Like the muscle map shows, lip pursing happens when the obicularis oris and mentalis muscles tighten the lips, while the triangularis muscles pull the corners of the mouth downward.

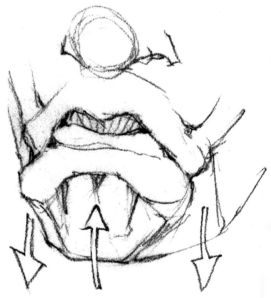

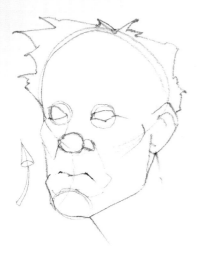 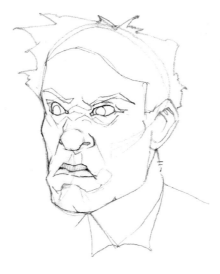 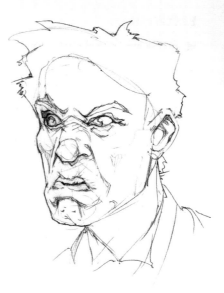

1 Measure the Proportions

Begin by measuring in the proportions of the face. Draw the line of the lips, paying attention to how they are tucked closer to the teeth, thinner and shorter in length, and how the extension of the chin helps purse the lips inward.

2 Sketch the Features

Sketch in more details forming the shapes of the eyes, brow, nose and lips. Notice the shape of the nostrils, and the wrinkles of the aggressive brow forming between the brow and the bridge of the nose.

3 Develop the Features

Start darkening the wrinkle lines surrounding the eyes and lashes. Sketch the wrinkles that radiate from the center of the pursed lips as well as the wrinkles that droop down from the nose and chin. Notice the bumpy texture on the chin, indicative of the raised mentalis muscle.

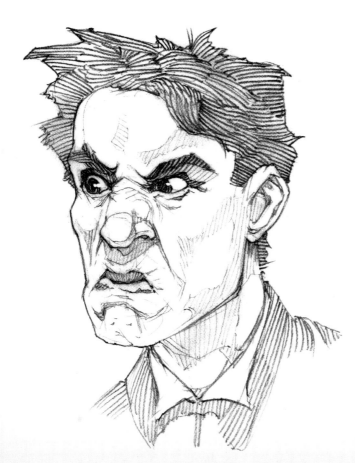

4 Add Final Details

Darken the irises and pupils, and erase the bright highlights. Mark areas of shadow, and fill them in with smudged-in tone and directional line hatching.

EMOTIONS
DUCK FACE

Here we have the puckering or pushing of the lips outward from the teeth. It can show your character in the beginning of distaste and anger, but it can also be used for a lower-lipped-pouty fear or sadness, kissy-face affection, and derisive or indifferent rock-star vamping. In all of its forms, whether used to show inward contemplation or extroverted emotion, duck face is a show of confident and strong emotions.

PUCKERING MUSCLES

As the muscle map shows, the triangularis, zygomatic major and risorius pull the corners of the mouth inward, but lip puckering occurs when the obicularis oris tightens and extends, pushing the lips outward. The obicularis oris can be sketched forming a cone-like shape from the teeth outward, and the lips themselves can be sketched thicker and larger.

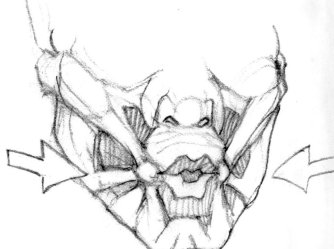

38

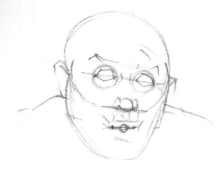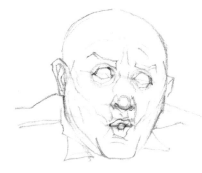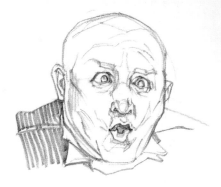

1 Measure the Proportions

Begin by measuring the proportions of the head and face. Sketch the inverted lines of both eyelids and eyebrows. Draw in the line of the lips, paying attention to their shorter length and the way the extension of lips forms an oval in the center.

2 Sketch the Features

Sketch in more details forming the shapes of the eyes, brow, ears, nose and lips. Notice how sketching in lines that extend outward from the center of the lips, start to extend and pucker the lips, but remain the same basic five shapes discussed in the Lips and Jawline lesson.

3 Develop the Features

Place the crossed irises inside the eyelids, and start lightly smudging in areas of shadow, redefining and darkening the wrinkle lines surrounding the eyes, lashes and brows. Concentrate on the wrinkles that radiate from the center of the lips.

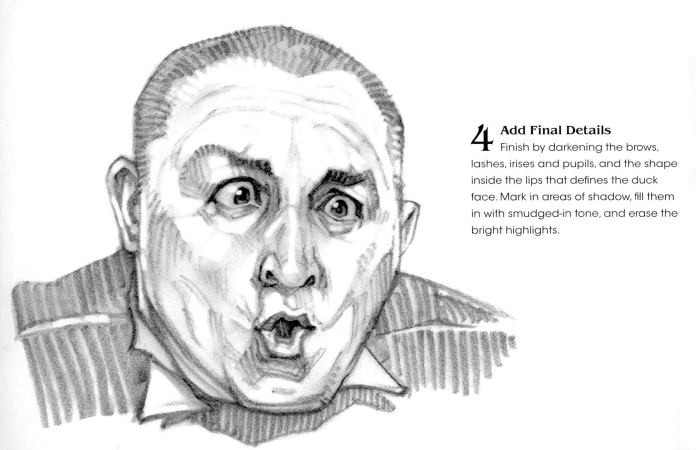

4 Add Final Details

Finish by darkening the brows, lashes, irises and pupils, and the shape inside the lips that defines the duck face. Mark in areas of shadow, fill them in with smudged-in tone, and erase the bright highlights.

TEETH BARING

Even though baring your teeth is an inherently visceral gesture (because of its aggressive behavioral ties to the animal world), toothy grins and smiles can be seen as cheeky or silly behavior as well. If you want your character to act berserk, or if you want to greet your audience with a big enthusiastic smile or perhaps with childlike sarcasm, peeling your character's lips back to reveal more of their teeth might be the answer. Just as the white of the orbits heightens the intensity of emotion and contrast with wide eyes, showing more of the white teeth will intensify whichever emotion you're after.

EMOTION LIST
1d20 + 1d4

2.	Embarrassed	14.	Pining, Forlorn
3.	**Anger**	15.	LOL
4.	Timid, Bashful, Coy	16.	Shock, Surprise
5.	Giggling	17.	Gape, Gawk
6.	Derision, Bored	18.	Relief, Ease of Mind
7.	Smiling - Smirk	**19.**	**Sneering**
8.	**Stressed, Disgust**	20.	Paranoid, Shifty
9.	Fear	21.	Bliss, Joy
10.	Thoughtful, Contemplative	22.	Confusion
11.	Deadpan	23.	Sad, Crying
12.	**Berserk**	24.	Stern, Pouting
13.	**Smiling - Insane**		

THINK TEETH, NOT TOOTHS

Teeth needn't be individually drawn out, one by one. Rather, think of them as a whole shape without a line for each tooth.

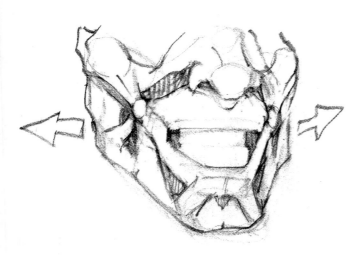

MOUTH MUSCLES

The muscle map shows how the lips are peeled back to bare teeth. The zygomatic major and risorius pull the corners of the mouth back, while obicularis oris, triangularis, angular head muscles (and even the sternocleidomastoid and scalene muscles of the neck) aid in peeling both upper and lower lips from their normal position. The gums will sometimes show, and the nostrils will often flare as the muscles of the angular head lift with the zygomatic major.

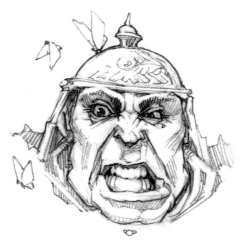

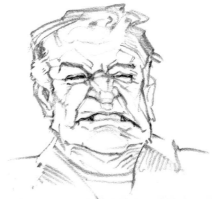

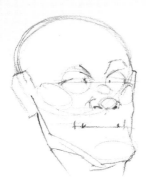

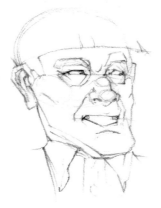

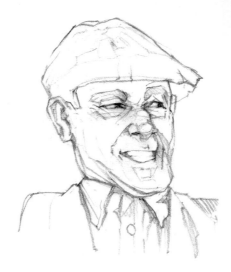

1 Measure the Proportions

Begin by measuring the proportions of the face. Draw the line of the teeth, the corners of the mouth and the aggressive brow line.

2 Sketch the Features

Sketch in more details, forming the shapes of the slightly sock-eyed eyes, brow, nose and teeth. Pay attention to the way pushing the chin forward helps extend the expression, as does squinting the eyes.

3 Sketch the Features

Start darkening in the wrinkle lines surrounding the eyes, brows, corners of the mouth and neck. Smudge in smooth shadows and areas to erase from. Sketch the hair and costume, noticing the tight collar and the wrinkles of the neck radiating from where it pinches.

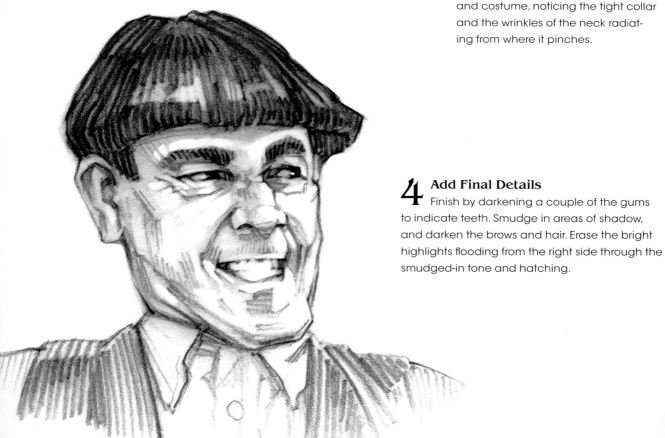

4 Add Final Details

Finish by darkening a couple of the gums to indicate teeth. Smudge in areas of shadow, and darken the brows and hair. Erase the bright highlights flooding from the right side through the smudged-in tone and hatching.

THE EMOTION-ACTION GAME

I'll sometimes use this game on a preexisting character to explore a wide range of emotional states for a character continuity sheet. It's also fun to simply let a whole new character develop from the roll, as I've done with these two characters. Let's play!

- Roll six words from the emotion list.
- Roll another six words from the action list.
- Let your Imagination run wild, and create a character by free associating with one word from each list.

The first group of words I chose were 17 Gape, Gawk and 14 Jump, Jive, Wail. After searching just those words, a couple pictures of amazing dancers with 1940s tuxedo costuming came up. I mashed a couple of the poses together, changed the facial expression to a smiling wide-eyed gawk, and this 1940s swing dancer sprang out.

EMOTION LIST
1d20 + 1d4

2.	Embarrassed	14.	Pining, Forlorn
3.	Anger, Distaste	15.	LOL
4.	Timid, Bashful, Coy	16.	Shock, Surprise
5.	Giggling	17.	**Gape, Gawk**
6.	Derision, Bored	18.	Relief, Ease of Mind
7.	Smiling - Smirk	19.	Sneering
8.	Stressed, Disgust	20.	Paranoid, Shifty
9.	Fear	21.	Bliss, Joy
10.	Thoughtful, Contemplative	22.	Confusion
11.	Deadpan	23.	Sad, Crying
12.	Berserk	24.	Stern, Pouting
13.	Smiling - Insane		

ACTION LIST
1d20 + 1d8

2.	Smash	16.	Meander, Shuffle
3.	Drenched by Water	17.	Spin, Whirl
4.	Blown by Wind	18.	Jump, Dart, Dash
5.	Shove, Drag	19.	Melted, Glowing, On Fire
6.	Sneezing	20.	Squished in Crowd
7.	Crouched for Attack	21.	Heave, Lift
8.	Hang, Climb, Plummet	22.	Thrash Metal Dance
9.	Proclaim, Explain	23.	Snooping, Listening
10.	Disco Dance	24.	Chop, Dig
11.	At Attention, Slouch	25.	Balance It on Head
12.	Grabbing, Pushing	26.	Flick at, Pick at
13.	Kicking, Punching	27.	Creep, Tip-Toe
14.	**Jump, Jive, Wail**	28.	Shoot, Slash
15.	Absorb, Eat		

GAWKING KARATE CAT
If no ideas spring from the words themselves, do a photo reference search. First search the emotion and the action words by themselves. Then search those keywords in a sentence, "Gawking Kicker Puncher" may be just a few clicks away from "Gawking Karate Cat."

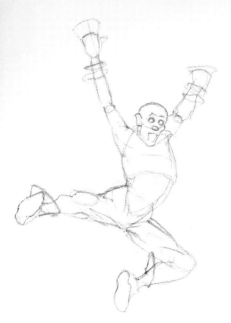
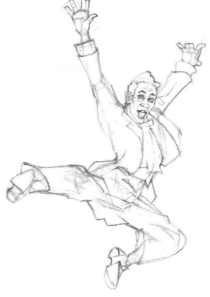
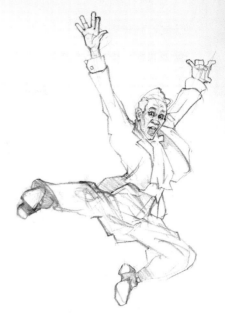

1 Measure the Proportions

Begin by measuring the proportions of the entire figure and face: circles for the cranium, eyes, tip of the nose and gaping mouth. Then draw the shapes inside the costume: limbs, elbows, knees, hands and shoes. Also lightly sketch the cuffs around the pant legs and shirt-sleeves.

2 Sketch the Features

Sketch in more details forming the specific shapes of the gawking expression: individual fingers, shoes and floating costume. Notice how sketching in the figure underneath the costuming helps place some of the wrinkles and details in the tuxedo.

3 Develop the Features

Start to darken some of the details of the face: the wide eyes, gaping smile and the flow of costuming. Map out the contrast you can push in the expression and in the shapes of the costume: the light of the shirt, tie and cuffs next to the dark of the coat and pants. Then carefully darken those shapes, building the contrast.

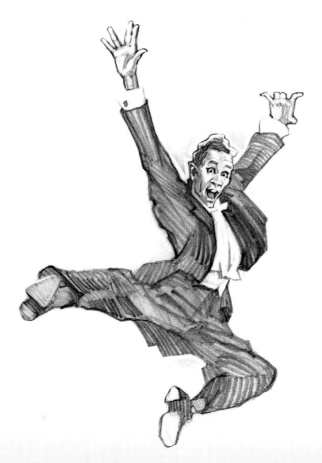

4 Add Final Details

Finish this exuberant 1940s swing dancer by drawing in the darks of the mouth, lashes and pupils. Smudge in tone or dark hatching inside the shapes of the coat and slacks. Then erase the highlights from that tone on the right side of the face, shirt and tie.

THE EMOTION-ACTION GAME

The second group of words I picked from the action and emotion lists were 19 Sneering and 19 Melted, Glowing, On Fire. This character was formed after finding a good picture of a sneer, then matching a snapping hand gesture to the pose. I focused our attention with the interaction between eyes and hand, then created a ball of fire exactly at that point. Sometimes very little is needed to create a memorable character with nothing more than two words.

BEYOND HUMANITY

Explore more than just humans. Sketch some half-humans, Greek gods, aliens, even thoughtful and contemplative zombies.

You can create more depth to your character when you think about a scene or the reasons behind both words. Ask questions about the specific situation they might be in and how you can capture that scene. Why are they feeling that emotion? What happened leading up to that emotion, and how will that affect their action?

If you roll 10 Thoughtful, Contemplative and 15 Absorb, Eat, and you make your character a zombie, then he might be struggling with the fact that he eats brains. Vegetarian Zombieman is born!

EMOTION LIST
1d20 + 1d4

2. Embarrassed		13. Smiling - Insane
3. Anger, Distaste		14. Pining, Forlorn
4. Timid, Bashful, Coy		15. LOL
5. Giggling		16. Shock, Surprise
6. Derision, Bored		17. Gape, Gawk
7. Smiling - Smirk		18. Relief, Ease of Mind
8. Stressed, Disgust		**19. Sneering**
9. Fear		20. Paranoid, Shifty
10. Thoughtful, Contemplative		21. Bliss, Joy
11. Deadpan		22. Confusion
12. Berserk		23. Sad, Crying
		24. Stern, Pouting

ACTION LIST
1d20 + 1d8

2. Smash	16. Meander, Shuffle
3. Drenched by Water	17. Spin, Whirl
4. Blown by Wind	18. Jump, Dart, Dash
5. Shove, Drag	**19. Melted, Glowing, On Fire**
6. Sneezing	20. Squished in Crowd
7. Crouched for Attack	21. Heave, Lift
8. Hang, Climb, Plummet	22. Thrash Metal Dance
9. Proclaim, Explain	23. Snooping, Listening
10. Disco Dance	24. Chop, Dig
11. At Attention, Slouch	25. Balance It on Head
12. Grabbing, Pushing	26. Flick at, Pick at
13. Kicking, Punching	27. Creep, Tip-Toe
14. Jump, Jive, Wail	28. Shoot, Slash
15. Absorb, Eat	

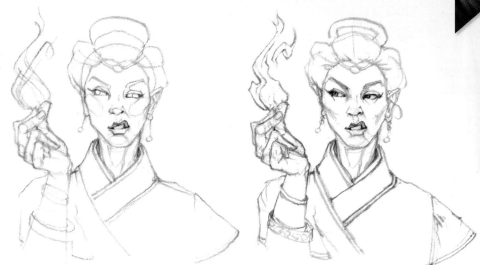

1 Measure the Proportions

Begin by measuring in the proportions of the face: circles for the cranium, eyes, tip of the nose, jaw, ears and the sneering upper lip of the mouth. Then sketch in the snapping gesture of the hand, including each digit and the knuckle joints surrounding the ball of flame. Notice how I've drawn through the clavicle and neck muscles to support the gesture and edges of costume even though it won't be visible in the final drawing.

2 Sketch the Features

Lightly sketch more of the sneering emotion in the face, including the upper teeth and bottom lip, aggressive eyebrows, eyelashes and irises. Start to lightly sketch in the major shapes of the hairstyle, kimono costuming and ellipses to form the cuff and ornament. Also sketch in spiraling guidelines for the flames to follow as they spin from the ball of fire.

3 Develop the Features

Erase the proportion guidelines and circles to smooth out the skin texture. Avoid excessively darkened texture on her skin. However, notice that darker eyelashes on the outside corners of the eyes and irises inside create more contrast and depth in the face. Also, notice how the guidelines help in the spiraling of the flame.

4 Add Final Details

Finish by darkening in the shapes of shadow with hatching or smudged-in tone, then erase the highlights of the face, hand and glowing fire. Remember to form some dark smudging or line behind the ball of fire so that it glows from out of that dark, and keep the marks around the face, neck and hand light and delicate.

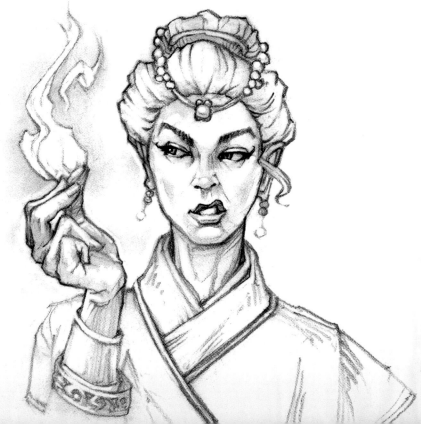

CHAPTER 3
BEHAVIOR & ARCHETYPE

They show expression, so now we'll give your characters
motivation! Next up, we cover the expansive realm of behavioral
posturing and theatrical archetype. Learn how to make your
characters virtuous, villainous, old or young, cute-ish or brutish.

HANDS & FINGERS

Our hands have the ability to tell stories without the help of our faces or spoken language. Characters can speak very dynamically through their hands alone, and the more we learn about the complexity and subtlety of hand gestures, the more believable our characters become. So, let's begin this journey with the building blocks of human behavior: fingers and hand gestures.

As with facial features, we can find our style of sketching gestures by looking at models and anatomy reference (like the one supplied at the end of the book), but also by mimicking other artists. I've always been intrigued by the hands drawn by Victor Ambrus, J.C. Leyendecker and Egon Schiele. All three illustrate hands differently, but all three structure their hands with specific guidelines that further the movement of their characters.

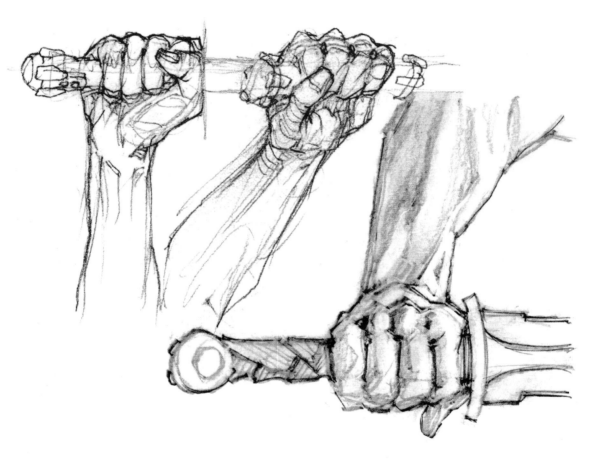

THE GROUPING & SEPARATION OF FINGERS
Sometimes photo reference or even a model will give you a boring hand gesture, or what I call a "club hand." All the fingers are stuck together into one mass, giving you little to move your viewer's attention. These hands can stop your movement flat. Now, this can be good when you need a strong hand gripping the hilt of a weapon. However, even though it lacks the angular strength of the fist, the repetition that separated fingers give us will always be the most interesting hand gesture to our brains. Here are a couple things to think about when you're drawing hands:

- Separating or splaying the knuckles and fingers aids in the direction of movement and gives the hand a more interesting outline. This can be done by subtly changing the direction of one or more fingers, or breaking them up to fan out, creating a visual pattern to direct the eye.
- Try grouping knuckles and fingers together to form a more interesting internal shape. This can be done by erasing the lines between fingers and knuckles, combining fingers into one whole shape of light or shadow.

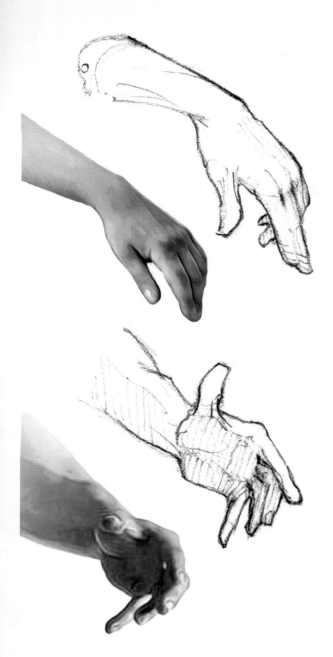

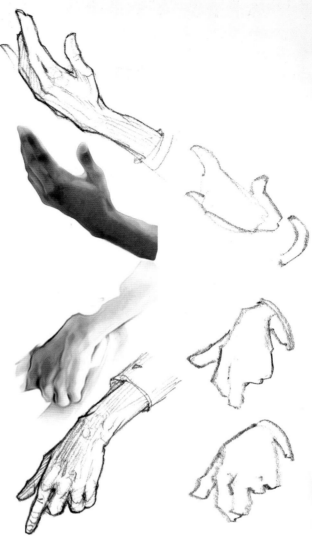

SEPARATING FINGERS

Notice on the top hand that I'm extending and separating the thumb and index finger while grouping the index and middle fingers with only a dot of shadow to separate them. I've even let the tips of two more fingers splay out from behind.

On the lower hand, I've grouped the middle and ring fingers while further separating and splaying the pinkie, index finger and thumb.

GROUPING FINGERS

Even though the reference for the top hand isn't bad for a receptive behavioral hand gesture, and the tips of the fingers are quite dark, it still might gain from the grouping of those first two fingers in order to extend the gestural movement.

On the lower hand, notice how I'm extending and separating the thumb and index finger of this club hand, while grouping two fingers and two knuckles. The viewer still understands the "gripping of fabric" gesture, but now the hand becomes a more graceful and interesting shape.

Even though these are fairly realistic gestures, the same method of grouping and separation can be applied to a more simple and free style of drawing hands. Some of my favorite hands have been inked by Bill Watterson, who can create a very expressive hand gesture in milliseconds. When simplifying and abstracting a hand this much, consider the whole shape of the hand as if you were sketching a glove or a mitten.

GESTURES

The communication of hand gesture is an infinitely complex subject, and although I mention a few different sorts here, a good character artist will make the observation of subtle interactions between the head and hands a lifetime goal. There are signs and symbols where our hands perform a systematic language, or the delicate complexity of baton gestures (like pointing or hand chopping) to punctuate emotion or describe particulars of a scene that your character is trying to re-create. There are also shielding gestures, bringing our limbs forward to defend us whenever we see danger. Or, grooming gestures, like the face plant, stroking the chin and scratching our head, where we unconsciously try to displace our discomfort.

Hand gestures will change drastically from country to country, and even from neighborhood to neighborhood, but they can be crucial for endearing our characters to their audience. Consider using this challenge for any character's torso pose, and they'll become more memorable.

HAND GESTURE CHALLENGE

Choose one character you've created so far, and sketch a couple versions of them performing at least two of these hand gestures. This challenge will expand your character's range of behavior and impress your audience. Don't expect to capture hand gestures without photo reference! Look up some photos of others in similar hand poses and adapt them to your sketch.

HAND GESTURES LIST
1d8 + 1d20

2. Okay	16. Stroking Chin
3. Pointing, Directing	17. Pistols - That Guy
4. Calm Down	18. Crazy - Finger Swirl
5. Kneading Hands	19. Raised Fist - Solidarity
6. Shushing	20. Raised Fist - Provoke
7. Crossed Fingers - Luck	21. **Beckoning Finger**
8. **Face Plant in Hand**	22. Chin in Hand
9. Military Salute	23. Fist Bump
10. Peace	24. Rubbing Temples
11. Palms Pressed - Praying	25. Finger Snap
12. Thumbs Up - Down	26. Shrugging Lifted Hands
13. Crossed Arms	27. Scratching Head
14. Metal Horns - Evil Eye	28. Clawlike Attacking
15. Cut Throat	

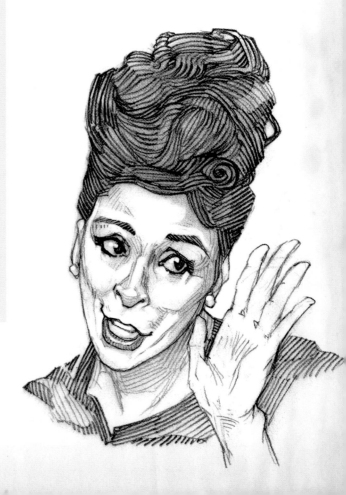

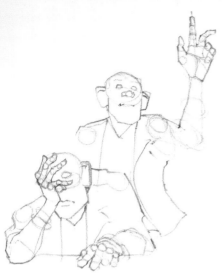
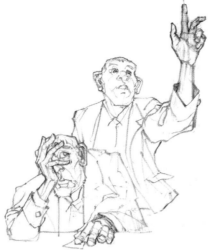

1 Measure the Proportions

I chose Face Plant in Hand and Beckoning Finger for my two hand gestures, and combined them with this bald, big eared, lanky, childlike adult archetype character.

Begin by directing the major movements and proportions of the emotions and hand gestures: shoulder to shoulder movement, head direction, and the shapes behind the knuckles and fingers. Notice the size of the craniums and ears and how much that affects the characters and their gestures.

2 Sketch the Features

Sketch more details into the faces, hands and costumes. Keep your sketch very light, further defining the tips and knuckles of each finger, and the three pads of the palm. Notice the line of sight will depend on where you place the irises in the eyeballs, and the cuffs of the shirt and coat will drop down the farther the hand gesture is raised.

3 Add Final Details

Darken and outline the shapes of the costuming, faces and fingers. Finish the face plant and beckoning gestures by grouping fingers, smudging in tone, erasing highlights and further darkening his facial expression.

BEHAVIORAL MASH-UP CHALLENGE

Same as the Hand Gesture Challenge, but play with character juxtaposition! It's a hallmark of humor to surprise the audience with the exact opposite of what they're expecting out of your character. Look for hand gestures that are completely unlike your character. You can make just about any character funny by giving them hand gestures that they would never ordinarily use. Chances are slim that the Queen Mum would ever wave you hand pistols!

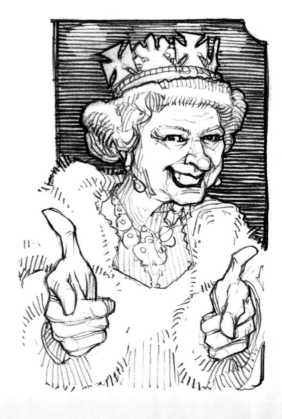

BEHAVIOR & POSTURE

The more we learn to observe human behavior, the more we can add to the emotional depth of our characters. Our perception of subtle peculiarities, individual "tells" and quirks will have direct impact on who our characters become and how memorable they will be. When you're observing, look out for these traits to mimic.

DOMINANT BEHAVIOR
Present in insulting and argumentative characters. Many baton gestures (used to punctuate language) can be seen as dominant behavior, especially when the palms are facing down or fingers are pointing. Leaning into or raising or expanding the body to tower over another are also signs of aggressive or dominant behavior.

PROTECTIVE BEHAVIOR
Introverted or closed behavior can be shown in characters with a general inward turning of the body, including head and chin tucked in; slumping or hunching shoulders; hands tucked in pockets; pelvis tucked in (like tail between legs); legs, feet and knees turning inward; sitting with the ankles locked. Bowing, kneeling and the curtsy to lower the line of sight are also signs of submissive or protective behavior.

RECEPTIVE BEHAVIOR
Receptive behavior can be shown in characters with a general outward expansion of the body. Posture and gestures that open the body up include head up, shoulders back, chest out, hands at or above the belt line, and often palms facing up to indicate being receptive to what's being said or done. Attentive, empathetic, but extroverted.

PERSONAL BARRIERS & SHIELDING BEHAVIOR
Our limbs will sometimes create a personal barrier. Crossed arms or leaning away from words or actions is an easy way of depicting frustration, and can show our character's unease or discomfort. Props such as a coffee mug or desk can also be used as barriers. Bringing a handbag or phone in front of the conversation can be like placing a shield in front of your character.

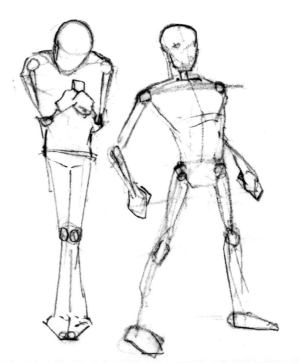

WIDE STANCE
A cowboy confidence and swagger can be shown in your characters with both feet and elbows spread out and planted firmly, shoulders back and strong symmetrical posturing. This posture will depict bravado and a sense of uber confidence in our characters.

DIRECTING MOVEMENT IN POSTURE

Not every photo will perfectly fit your needs. Even when shooting reference yourself, what you see isn't necessarily what will make the best illustration. I'll often "Frankenstein" multiple poses together in Photoshop by cutting and pasting with the transform tools, puppet warp and liquify filters. Those tools are helpful in manipulating a photo long before I start a sketch. But let's study a couple ways we can achieve better movement simply by observation.

- Contrapposto is one of the best ways to direct movement. We unconsciously seek out the line between the shoulders and the line between the hips. More weight is normally being placed on one side of the body, thereby shifting and juxtaposing the lines between shoulders, hips and knees. Pushing contrapposto can direct your audience through your character's pose.
- Line of sight (the direction your subject is looking) has an immediate effect on the viewer's attention. So, we can direct movement simply by pointing our character's head in the direction we want folks to look.
- Direction and angles of the head, neck, shoulders, hips, limbs and fingers lead the attention of your audience. The more limbs and hands present, the more opportunity for you to direct your audience exactly where you want them. A fun design trick is to pick a central point, then radiate as many of those angles out from that central point as you can.
- Shape of hair can not only extend and reinforce movement, but it can also give the audience an idea of the wind direction and your character's habitat and climate.

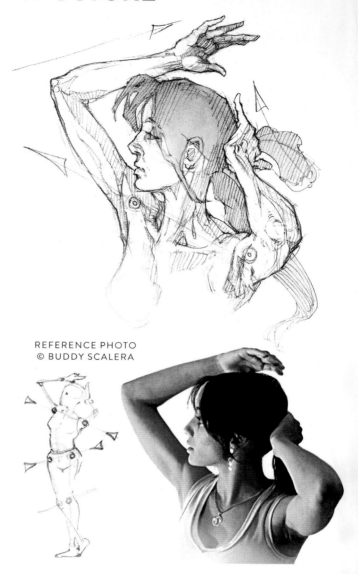

REFERENCE PHOTO
© BUDDY SCALERA

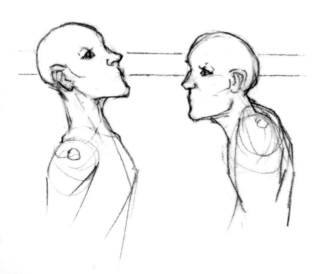

RAISING ONE'S LINE OF SIGHT
When someone purposefully lifts their eye level above another's, it indicates authoritative judgment and superiority. Nose in the air, like there's something foul beneath the nose, or raising your character's line of sight, may give them an air of posh judgment. Both wild and domestic animals will perform this same behavior. Sniffing superior to assert authority.

Notice what's been changed in this pose to further movement:
- Outstretched fingers on both hands have extended the direction of either arm.
- Added contrasting negative shapes by changing the shape of the hair.
- Angles of the head, shoulders, hair and the line of sight have been changed to radiate out from the bottom right corner of the torso.

BODY FORMS

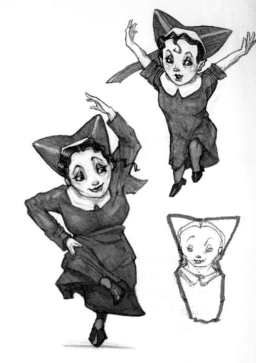

When designing characters for film and video games, it's important that they not get confused with one another when they appear quite small or when moving quickly on screen. This is why some studios will start their characterization process by designing with shapes instead of fully rendered sketches. By playing with shape first, we can explore far more diverse variations on ideas, without spending a ton of time on rendering elements of character that may eventually be trashed.

BODY FORMS CHALLENGE

Using apophenia (see chapter 1), this challenge tests our mind's ability to fill in the blanks. We'll use our imagination to create characters from inside a simple contour, then flesh them out using the simple shape as a guide! This is also our first character continuity sheet (a form to serve as a standard for a team working with the same character). It will give your audience an idea of your consistency in sketching the same character in two different poses and also tell them how you can conceptualize from a simple shape into a moving character.

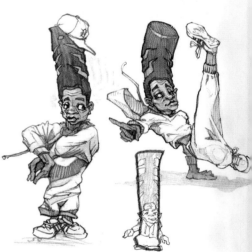

START WITH THUMBNAILS & PHOTO REFERENCE

Brainstorm five to ten thumbnail sketches on the Body Forms Challenge Sheet (IMPACTUniverse.com/FGCbonus). Keep them simple and small, and don't worry about breaking out of the shapes if you need to create limbs or props. If nothing's appearing for you, move on to another shape or flip the sheet upside down for a new perspective. Notice how the placement of the head and shoulders can inform the behavior of your character. Also notice how the contours of shape might indicate costume or occupation, cuffs, collar lines, hats and hairstyles. Perhaps two or more will start to interact with each other the further you go.

Once you have a couple body forms you'd like to explore further, pick two of your favorites and gather some photo reference for similar characters in action poses. For my Tudor-habited nun and an old-school breakdancer with an extreme high-top fade, I looked up dancing nuns and 1980s hip-hop breakdancing to go along with the hairstyle conjured by the basic shape.

MAKE THEM MOVE

After you've gathered photo reference, sketch two action poses for both of your characters. The simple body forms you created from shapes will inevitably look a bit rigid, so now's your chance to make them move!

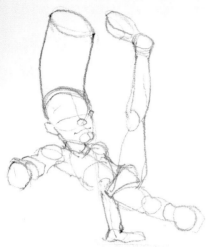 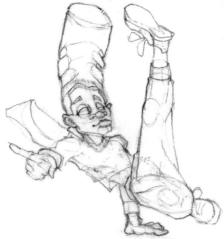 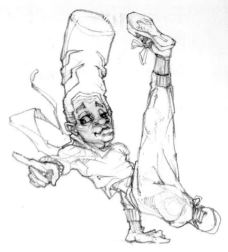

1 Measure the Proportions

Begin your breakdancer by lightly sketching the proportions of the body: head and hair, a few facial proportions, shoulders, pelvis, limbs, hand shapes and shoes. Draw through to help place the body's weight in a believable dance move.

2 Sketch the Features

Then start to sketch in the elements of his facial expression: nostrils, lips, ears, eyebrows, passive eyebrows and eyelids. Add more of the details to hand shapes and shoe shapes, and start to place his costume around his body. Lightly sketch the ellipses that will form his hoodie and 1980s baggy trouser cuffs, more of his classic high-top fade hairstyle, while erasing the body form underneath.

3 Develop the Features

Finish his confident passive brow facial expression by adding more darks around the eyelashes, irises, nostrils and upper lip, smudging in some skin tone to erase from. Start to add more details to his costume, following the ellipses you've placed for the cuffs, and notice how the wrinkles radiate out from the areas bending most: pelvis, neck, armpits, waist and belt line.

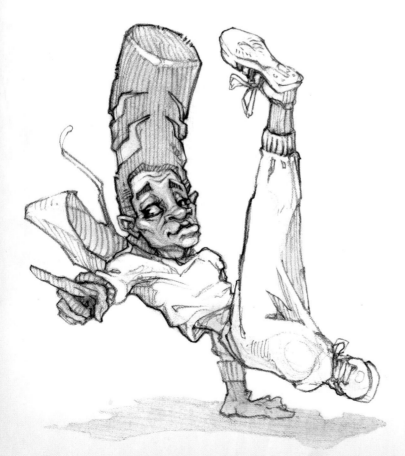

4 Add Final Details

Finish our high-topped breakdancer by smudging in tone, then erasing highlights from that tone. Make your darkest lines and shapes where you want the audience to look first: his eyes, shoes, hands and of course his giant hair shape, influenced by the initial thumbnail sketch.

THEATRICAL ARCHETYPES

The planet's most brilliant philosophers and psychologists have been studying this subject since Aristotle. Whether the categories and parameters come from Immanuel Kant's, Arthur Schopenhauer's or C.G. Jung's ego archetypes, they hold this in common: Archetypes are the repeating character roles and personality traits that have filled our literature and mythologies, common across the globe, since humanity first started telling stories. We can identify with archetypes through the many characters in the books we've read, films and television shows we've watched, but we can also see bits and pieces of these archetypes in the folks we know and perhaps even in ourselves.

This is by no means a complete list. I've mixed them mainly from Jung and Joseph Campbell's *Hero's Journey* archetypes, but adopting the character traits of theatrical archetypes can be one of the most powerful tools in creating memorable characters. By mimicking any one of these character archetypes, we can build our characters from the success of countless writers, performers and creatives throughout history and those yet to come!

ARCHETYPE LIST
2d6

2. Hero/Heroine	8. Shapeshifter/Shadow
3. Rebel/Antihero	9. Adultlike Child
4. Childlike Adult	10. Trickster
5. Caregiver	11. Villain
6. Wise Old Guide/Mentor	12. Sidekick
7. Virtuous or Innocent	

HERO/HEROINE

Here is your main protagonist. We follow the success or failure of the classic hero's journey, how they prove their courage by fighting off the villain, and how they learn and grow from it. Hero/heroine archetypes show strength and virtue, and often have bright features that represent their light side. Examples: Bilbo and Frodo Baggins, Luke Skywalker, Harry Potter, Pooh Bear.

SIDEKICK

This archetype can often be comic relief and shares the quest of the hero/heroine. They might not share the spotlight of the hero/heroine, but when they're most in need, the trusty sidekick archetype will reveal their true strength. Examples: Robin, Samwise, Ronald Weasley, Piglet.

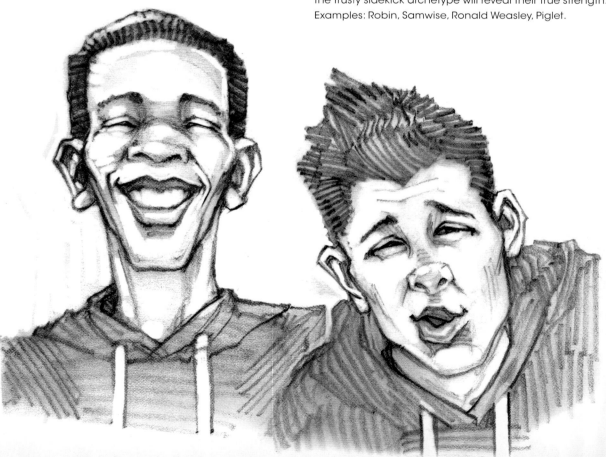

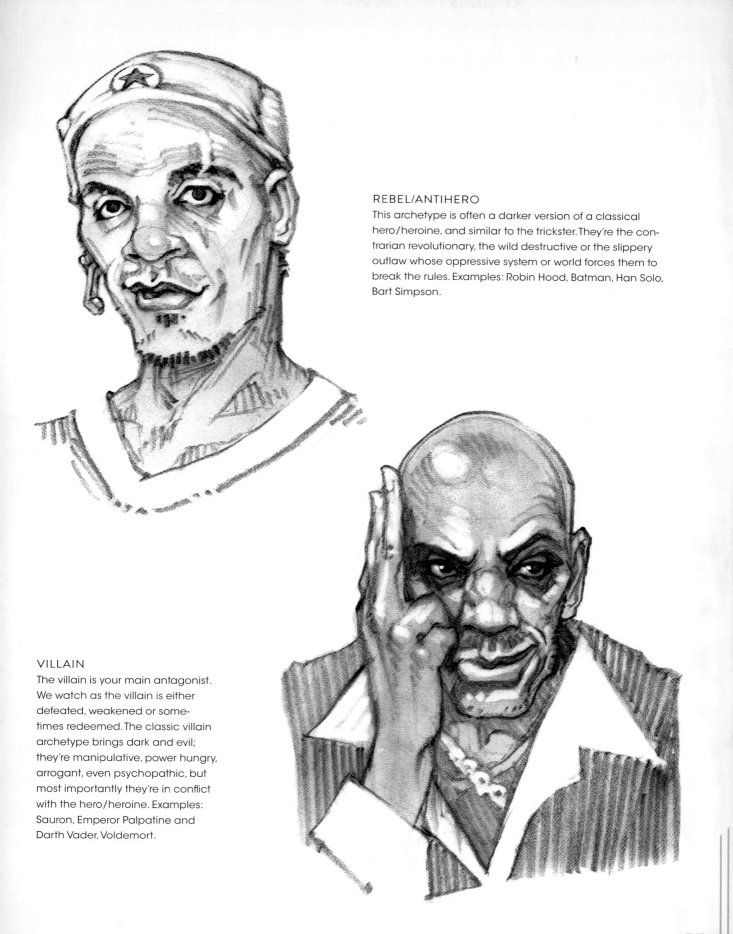

REBEL/ANTIHERO

This archetype is often a darker version of a classical hero/heroine, and similar to the trickster. They're the contrarian revolutionary, the wild destructive or the slippery outlaw whose oppressive system or world forces them to break the rules. Examples: Robin Hood, Batman, Han Solo, Bart Simpson.

VILLAIN

The villain is your main antagonist. We watch as the villain is either defeated, weakened or sometimes redeemed. The classic villain archetype brings dark and evil; they're manipulative, power hungry, arrogant, even psychopathic, but most importantly they're in conflict with the hero/heroine. Examples: Sauron, Emperor Palpatine and Darth Vader, Voldemort.

CAREGIVER

They are the parental nurturers and the compassionate protectors. Caregiver archetypes are sometimes overly trusting characters, sometimes martyrs, but always kindhearted and unselfish in their task to help the hero/heroine through their journey. Examples: Aunt Beru, Galadriel, Professor McGonagall.

TRICKSTER

The trickster archetype is a slippery fool, or a suave and roguish jester, often filling the role of comic relief. They excel at getting into trouble, then, cunningly or unwittingly, getting out of it. Often facing something or someone more powerful, they use their charm and wits to subvert that power. Examples: Han Solo, the Weasley Twins, Merry and Pippin.

VIRTUOUS OR INNOCENT

The classic virtuous archetype stands for what's right and good. They're driven by faith, romance or utopian dreams. Their naive innocence can be cause for conflict, and their innate moral compass can inspire greatness. This archetype can be captured by the villain and rescued by the hero/heroine, but is somehow still unwavering in their virtue. Examples: Ginny Weasley, Maid Marian, Snow White, Ned Flanders.

SHAPESHIFTER/SHADOW

This character can be a shadowy, confusing sort. Somewhere through the storyline they go through a dramatic change or switch sides from good to bad or bad to good. They're two-faced and deceptive, but will they be the villain's henchman or the hero/heroine's secret ally? Examples: Professor Snape, Gollum, Lando Calrissian, Sideshow Bob.

CHILDLIKE ADULT

Like the trickster, this character can fill the role of comic relief. Childlike adults never grow up, have hearts of gold, and are often gentle giants, oafish, dopey and clumsy. They can also be as reckless as the trickster, having a soft spot or delicacy for something or someone, but are separated by being inherently less clever and lucid. Examples: Treebeard, Chewbacca, Hagrid, Tigger.

ADULTLIKE CHILD

Somewhat opposite the childlike adult, the adultlike child archetype is wise beyond their years. Despite their appearance or age, this no-nonsense character will perform great feats of strength or prove intellectually superior. At best they easily do something adults cannot, and at worst throw a tantrum they've not grown out of. Examples: Éowyn, Hermione Granger, Princess Leia.

WISE OLD GUIDE/MENTOR

Sometimes a scholarly and philosophic swordsman, other times a charismatic alchemist. The wise old guide archetype is herald to a special knowledge important to the journey ahead. They mentor and train the hero/heroine with their wisdom before battling the villain. Examples: Gandalf, Professor Dumbledore, Obi-Wan Kenobi, Yoda.

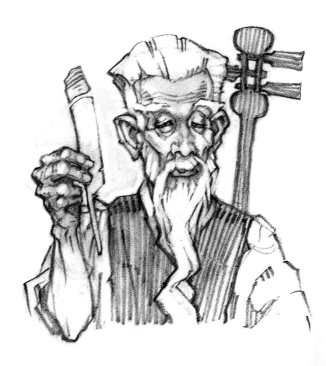

VIRTUE & VILLAINY

What makes the classic hero/heroine or virtuous arche-type look like they stand for what's right and good? What makes our villainous or shapeshifter characters appear deceptive or untrustworthy? A good actor will be able to change certain aspects and traits of their face at will to fit any role. By studying these traits, we can do the same with our characters.

Our personal appearance obviously has no bearing on the qualities of our own thoughts, words and deeds, but, when creating characters, there are a couple tricks and generalizations to tell your audience what role your character will play.

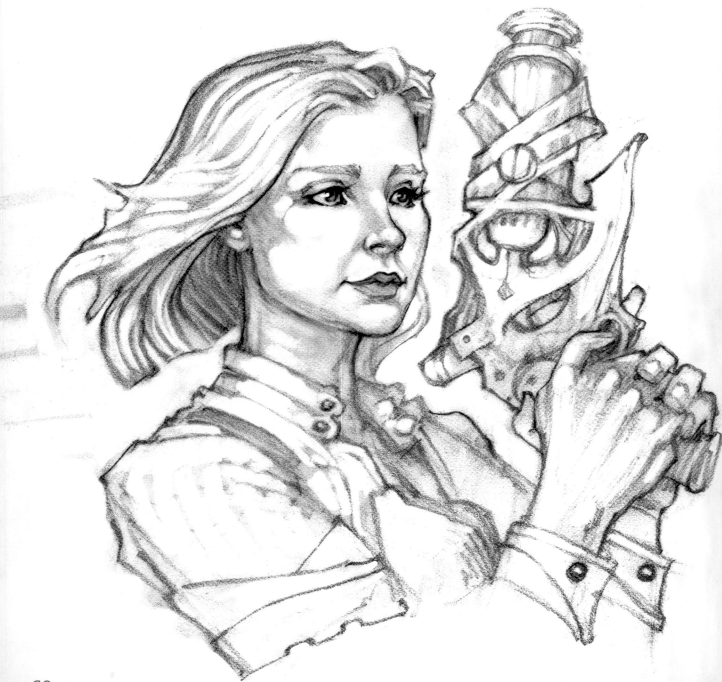

VISUALLY VIRTUOUS

Facial traits seen to be more virtuous or trustworthy:

- **Symmetry:** Our unconscious mind craves symmetrical smiles and level jaw positions in our virtuous characters. So they will often have a smile when the mouth is in resting position, but, even when in a frown, they might keep the corners of their mouths level to each other.
- **Eyes:** Keep the eyeballs clear with slightly raised lids. We want virtuous characters to look us in the eye, so three-quarters of the iris should appear in your character's resting position. The outer corners of the eyelids might be slightly drawn down, and the eyebrows may appear thin, light, at level angles and slightly raised.
- **Hair:** The classically virtuous have relatively bland, status quo hairstyles for their time period. Combed hair, well-kept appearance, with smooth or clean-shaven faces.

- **Light:** Possibly the most effective way of thinking about making your character appear more trustworthy is bringing more light into their features. The fewer direct shadows and the more ambient and blurry light you can give their facial features, the more virtuous your character will become. Regardless of the skin tone of your character, larger features will bring more light into your character's face. Give your virtuous characters fuller, brighter, perhaps dopey or babylike features: large ears, eyes, teeth, fuller lips and smoother skin.

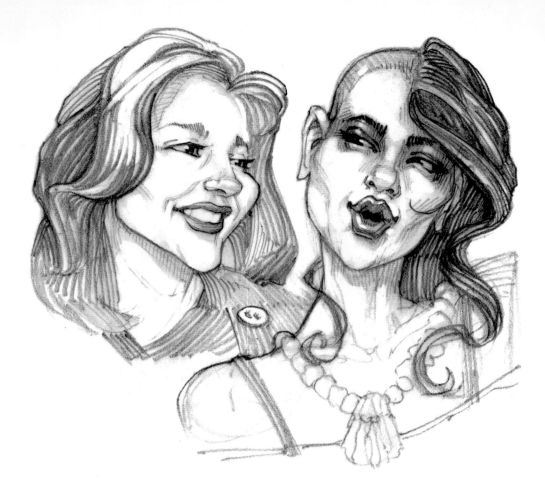

DUAL PERSONALITIES

These twins were sketched from the same model. They have identical proportions, but there are a few major differences in personality that are instantly apparent to the audience.

Notice the use of ambient light on the left. There are enough shadows to define the features, but I've opened up big highlights running into each other on both the face and hair. This makes the twin on the left look more virtuous.

On the right, our trickster twin shows both the virtuous traits of larger, childlike lips, nose and ears, while also gaining darker shadows behind the eyes and brow, darker lips and a more inventive hairstyle. Study the intricacies of what makes someone look more or less trustworthy, and you can adapt your characters to any different archetype you'd like them to be!

VISUALLY DECEPTIVE

There are character archetypes that play their roles somewhere between classically good and evil: rebel, adultlike child, shapeshifter and trickster. Because they exist between the sides of villainy and virtue, we can effectively portray them with attributes from both sets of physical traits. These archetypes can also gain from contradictory behavior and gesture. Like the confused, staggered position of the brow line, or things happening on one side of the character that are opposite to the other side. Gestures involving one palm up and one palm down, a limping gait, winking or mocking gestures beg the audience to notice the subtle asymmetry inherent in contradictory or visually deceptive behavior.

BOTH GOOD & EVIL

A helpful tool for shapeshifter archetypes is virtuous/villainous juxtaposition. Whether inherent or serendipitous, any classically villainous character that receives virtuous behavioral traits can physically show their inherent polarization. Similarly, any classically virtuous character receiving villainous behavioral traits may seem visually deceptive. Perhaps your doctor character insists on wearing all black or your thief character also likes to hand out free gum.

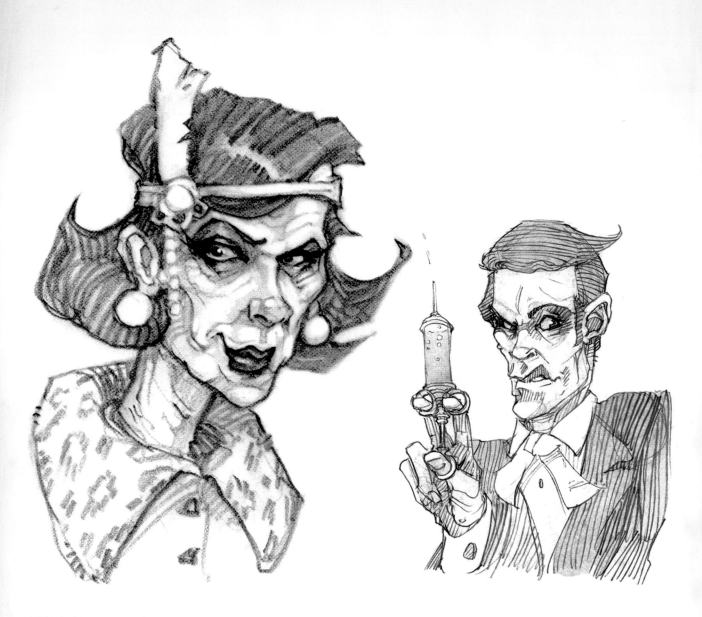

VISUALLY VILLAINOUS

These facial traits are seen to be more villainous:

- **Asymmetry:** Articulate and uneven smirks or jaw positions are perfect for making your character appear villainous and less trustworthy.
- **Eyes:** Villains often have darker whites of the orbit or darkened eyelids, where very little of the orbits shows in resting state. Sometimes the eyes are obscured completely with sunglasses. Villains' resting features tend to be tighter, more articulate, their irises are sometimes smaller, more beady and intense, and often shift in contradictory directions. Give your villain more of a brow "shelf" to form deep shadows on his features, darker or coarser eyebrows, deep sunken orbits and a wrinkled or aggressive brow line in resting state.
- **Hair:** Some villains have unkept hair or a beard, while others have a meticulously kept costume, ornament, hairstyles and facial hair. A classical villain with a wild, inventive hairstyle or facial hair, or who is completely bald, will be viewed as less trustworthy.
- **Dark:** The most effective way for your villain to appear less trustworthy is bringing more dark into their features. Placing dark around the eyes almost instantly makes your character gain a sense of villainy, as do signs of hardship such as pockmarks or a grayish pallor to the skin.

ARCHETYPE OCCUPATION CHALLENGE

This challenge is an equation for a character with instant history—just add water! To create interesting and memorable characterizations, think in terms of what your character might do and exactly how they might do it. Think about surrounding props and adding quirks to your characters for surprising details.

The Occupation List will help build your character's costuming and behavior. Think about the kind of costume each occupation might be wearing and what kind of pose or action would be suited for their specific work or habitat. Then pick five to six occupations. You may pick a couple occupations that seem likely to suit your archetype, or pick a couple that are completely silly and contradictory to the archetype.

Then look up photos of your occupations to influence the details of behavior in your character and sketch your ideas. Sometimes just looking at photos of a particular occupation will give me better ideas, more specifics I might have never known about without doing a little photo research.

Roll or pick two archetypes, and review earlier in this chapter to get a better understanding of the roles your character might play, and how they might react to any of the professions and occupations you may give them.

For a bit of extra science fiction and fantasy fun, roll or pick one modifier for your character. This can often change the dynamics of your character into something quite unique, but don't let this extra roll confuse your character. Their archetype should remain clear to your audience.

OCCUPATION LIST
Look Through and Pick

- Air Flight - Pilot / Stewardess
- Astrologer / Alchemist
- Astronaut / Space Traveller
- Athlete - Golfer / Skier
- Athlete - Olympic Medal
- Athlete - Pro Ball
- Athlete - Street / Park
- Athlete - Wrestler / Boxer
- Big Top Circus Performer
- Bishop / Pope
- Craft - Carpenter / Potter
- Craft - Smithy / Mason
- Craft - Tinker / Cobbler / Tailor
- Dancer - Ballet / Ballroom
- Dancer - Night Club / DJ
- Dancer - Swing / Sock Hop
- Driver - Bus / Taxi
- Farmer / Gardener

- Food - Baker / Pizza
- Food - Barista / Waitress
- Food - Butcher / Milkman
- Food - Chef / Pastry
- Food - Green Grocer
- Food - Short-Order Cook
- Gangster / Thug
- Gumshoe, Detective
- Harajuku / Goth
- Judge / Magistrate
- King / Queen
- Knight / Warrior
- Lab Coat Chemist / Scientist
- Librarian / Professor
- Lumberjack / Hunter
- Mayor / City Official
- Medical - Doctor / Nurse
- Military - Command

- Military - Soldier
- Mortician / Undertaker
- Musician - Classical / Conductor
- Musician - Jazz / Hip Hop
- Musician - Rocker
- Nerdy / Nebbish
- Plant Worker / Hardhat
- Police / Firefighter / Postal Worker
- Priest / Nun / Cleric / Rabbi
- Rancher / Cowboy
- Royal Courtier / Jester
- Samurai / Ninja
- Seafaring - Captain / Fisherman
- Shaman / Tribesman / Hermit
- Shop Mechanic
- Toreador / Horse Jockey
- Town Crier / Lamp Lighter
- Train Conductor / Ticket Taker

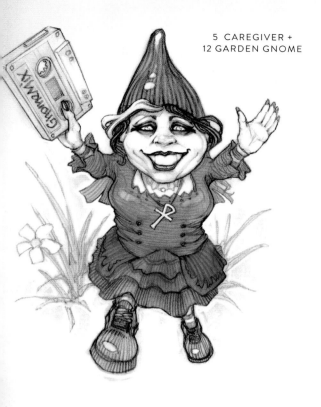

5 CAREGIVER +
12 GARDEN GNOME

ARCHETYPE LIST
2d6

2. Hero / Heroine
3. Rebel / Antihero
4. Childlike Adult
5. Caregiver
6. Wise Old Guide/Mentor
7. Virtuous or Innocent

8. Shapeshifter / Shadow
9. Adultlike Child
10. Trickster
11. Villain
12. Sidekick

EXTRA :: SF & FANTASY MODIFIER LIST
2d6

2. Dwarf / Elf
3. Superhero
4. Sasquatch / Werebeast
5. Space Alien
6. Frankenstein
7. Mermaid / Merman

8. Witch / Wizard
9. Zombie / Undead
10. Fairy / Fae / Angel
11. Vampire / Ghost
12. Garden Gnome

3 REBEL / ANTIHERO +
SEAFARING - CAPTAIN / FISHERMAN +
4 SASQUATCH / WEREBEAST

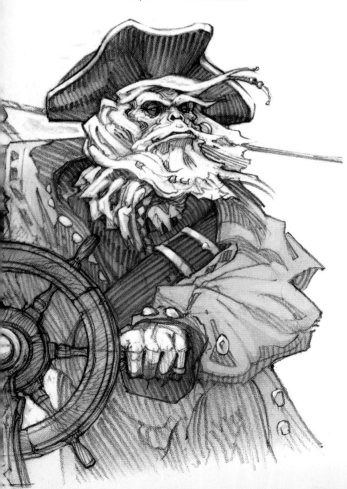

 PROPS & COSTUMES

Occupational props and costume should give your audience an instant idea of what your character does, but can also speak to their archetype and behavior. Remember that a caregiver/baker might be easier to conceptualize from photo reference, but don't pass up your chance to draw a caregiver/goth/garden gnome!

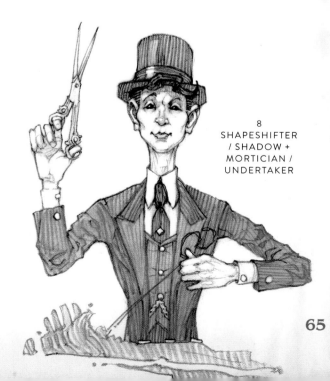

8
SHAPESHIFTER
/ SHADOW +
MORTICIAN /
UNDERTAKER

AGING

Aging your character suggests there's more experience to be gained from our wise old guide archetype, stronger empathy from our caregivers, and more respect and complexity than in just about any other character we might dream up. Age inherently gives any character a longer visual history.

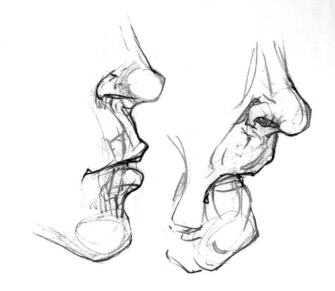

NOSE & MOUTH

Bone loss in the teeth and jaw gives way to facial shrinking and subsequent formation of jowls and laugh lines; sagging of the columella, philtrum and tip of the nose; and thinning lips. As the drooping and sagging of the nose occurs with age, so does the inward puckering of the lips. The planes of the face that once formed a convexity now form a concavity.

ASPECTS OF AGING

Here are a few ways to reveal some of your character's visual history without having to say a word:

- **Eyes:** Pay attention to the descent of the brow, the puffing and sagging of the outer lids, the sinking of the eyeballs in the orbits, and crow's feet along the eyelids and zygomatic arch.
- **Hair:** Hairlines recede. Hair will thin and silver, but will also grow more coarse and bushy, in terms of facial hair or eyebrows, which can be used for comedic effect (outrageous growth of hair from ears, back and so on). The silvering of hair will also create a slightly lighter 5 o'clock shadow tone on males, which is more apparent with darker skin tones.
- **Skin texture:** The patterns and textures in any character's skin play a big role in their visual history. Like costuming can tell the viewer about personal style, habitat and climate, so can the ways in which wrinkles drape from muscle groups tell folks something about their physical and emotional development. Laugh lines around both eyes and corners of the mouth, blemishes, moles, warts and age spots can also show aspects of aging. When illustrating in color, paler, more translucent skin forms with age, but blushing and redness toward the extremities will often become darker, less saturated and cooler in hue. Line hatching can also easily be seen as wrinkled skin. Resist the temptation for too many wrinkles, especially on female characters.

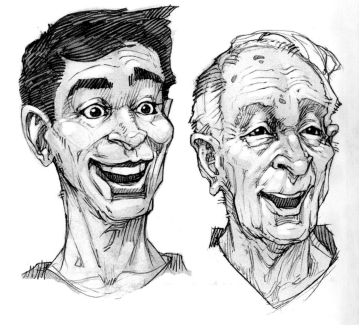

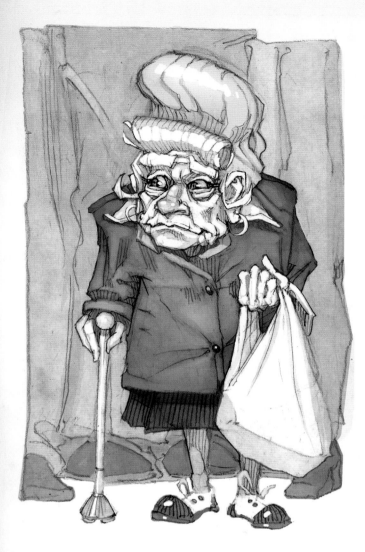

POSTURE & VISUAL HISTORY

When designing elderly characters, you're portraying the whole of their visual histories. A peculiar intricacy can be very important to what endears us to any character, so when sketching a full body pose, consider:

- Hunching shoulders or raising the shoulder line
- Hindered mobility or limp
- Bent or swollen knuckles on fingers or joints on limbs
- Familiar or repeated gestures or posture

Think about how those gestures might affect your character's appearance. Gestures to consider include: trousers cinched way up to the rib cage, the constant grooming of a wig, hunching in to hear or straining to read. Another option might be portraying your aging character with the habits or actions of a teen or young adult.

Along with posture, also think about hairstyles, costume and props. They all can go a long way to portraying age. Examples include: wearing dress socks to the beach, wearing outdated patterns and colors, hats, giant glasses, cigarette holders, belt buckles, political or military regalia, and so on. Focusing on the fashions and cultural sentiments of any older time period can be one of the best ways to show behavioral age.

SKIN AGING

The science behind aging skin starts with a loss of mass in bone structure. This leads to overall shrinking of the skeletal structure, which in turn results in a combination of sagging, wrinkling and puckering in skin textures. Consider skin wrapped taut around an object at first, then as the mass of that object shrinks, the skin slowly sags around and wrinkles into that smaller object. Notice how the skin slowly sags and drapes over the skull and sinews of muscle.

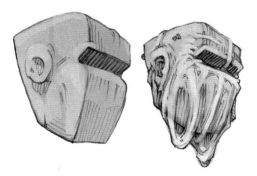

FOLLOW THE HOLLOWS

Another good rule of thumb is to "follow the hollows" of the skull and divots between the muscle groups. Try drawing a skull first, then slowly erase areas of skin to get a better idea of how those shadows form.

YOUTH

Apart from wise old guide and childlike adult, any archetype could be portrayed by a younger character. Youth can add to a character's air of optimism, virtue and enthusiasm, but can also add to their naiveté and inexperience. One of the adultlike child's most endearing qualities is the juxtaposition of how their youth is perceived and how adult they become.

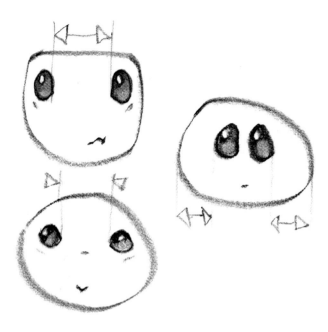

EYES
Children's almost adult-sized irises will often appear quite large inside rather puffed eyelids. This leads to very dark eyes contained within full lower lids and thin upper lids. There can also be a lot of space on either side of the eyes and in between the eyes.

YOUTHFUL EFFECTS
Youth will generally make your characters more adorable and cute, healthier, more innocent and receive almost instant empathy from the audience.

ASPECTS OF YOUTH

Here are additional visual tricks to help make our characters appear younger.

- **Ears:** Infants' ears are small and positioned tight to the skull. Then, as they grow, they can slowly turn out from the head, appearing quite large in comparison.
- **Brows:** Eyebrows, like any newly formed hair, are thin and wispy. Darker hair will appear very light, or even invisible, giving way to the muscles of the brow. Youthful emotional states are often very awkward and articulate because of the lack of hair.

- **Nose and Mouth:** Button noses appear tiny and upturned. Lips are quite small, but bulbous and rounded, often with a pouty lower lip. Cheeks are full and rounded rather than showing any signs of zygomatic arch.
- **Skin Texture:** Since hair is very thin and fair, youthful skin appears smooth and unblemished. Use as little texture as possible when drawing. When illustrating with color, young skin will be pink and blushing toward the extremities of the cheeks, nose, eyelids and chin.

OVERSIZED FEATURES

Youth are in the very beginning chapters of their visual history. Being behaviorally clumsy and bumbling is often a youthful attribute, as is having limbs and features that the character hasn't yet grown into. For example, a puppy may have massive paws or head, indicating it still has a bit to grow yet. In adolescence, limbs can appear quite thin and lanky. Larger, babylike features can also help your character unconsciously seem a bit more trustworthy.

WHEN I'M 64 CHALLENGE

This two-part challenge can show the audience your strength in mimicry and juxtaposition of character traits. If you're successful in picking out features for your target character that will easily show aging or adolescence, you will really impress another fan of that same target character.

Here's how to play:

- Pick a target character. Yours could be from a fairy tale, maybe a superhero, video game character, or perhaps a product icon or break-fast cereal mascot. They should be fictional and recognizable to a large audience, someone that folks just won't mistake for anyone else.

- Then sketch two versions of that target character. Try one who's getting a bit long in the tooth or elderly, and try an adolescent or baby version.

- Visually explore your target character's story-line, details of their history or future. Try to tell an interesting story that will mean something to your audience. Perhaps an aging Ron Weasley is setting rat traps, an old Wonder Woman is knitting a golden lasso, or a young Medusa has turned her lollypop to stone. Surprise viewers with a twist only a fan of that target character would know.

- Visually explore the sensibilities of the young and the old and the props they might use. You might capture the grumpy, stubborn attitudes sometimes seen in older folks, along with props that show their age such as a cane, walker or ear trumpet. Depict them engaged in stereotypical pastimes of the elderly such as fishing or knitting. Also think about the quali-ties of youth in terms of developmental props: candy, toys, playgrounds and so on, or the bratty, mischievous behavior sometimes seen in younger folks.

TARGET CHARACTER: PYROMANTIS
Meet the PyroMantis, a supervillain not to be trifled with. Born from an alien planet of insectoids, he can lift one hundred times his weight and hit you with beams of molten flame! You could of course use any character, but I created this comic book villain archetype to give us an example for the next challenge.

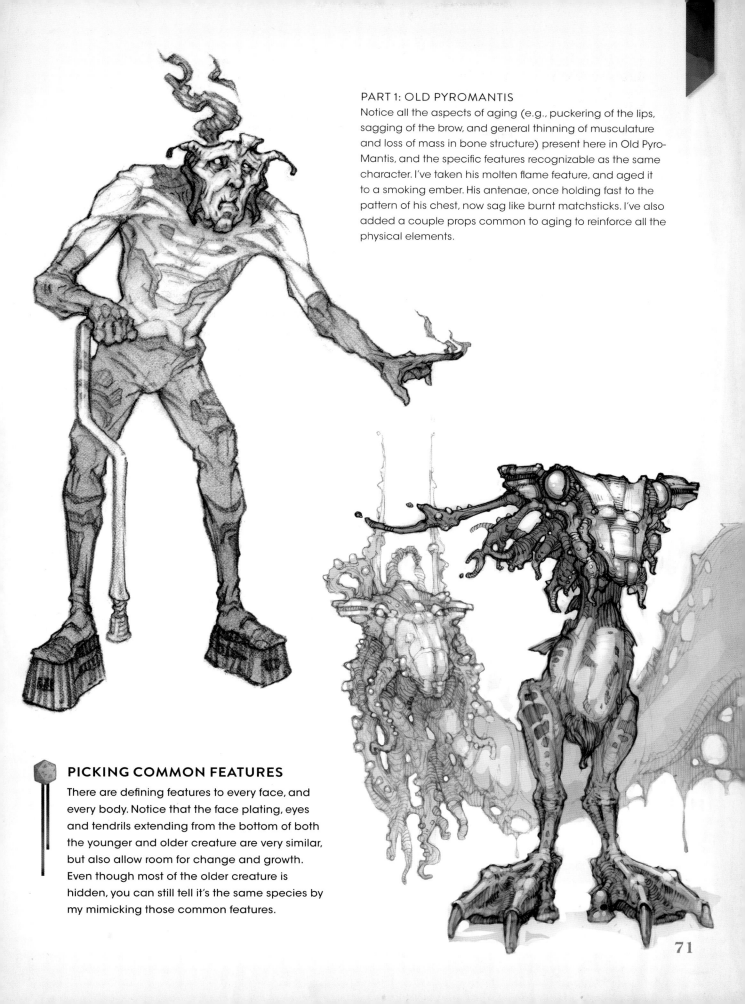

PART 1: OLD PYROMANTIS
Notice all the aspects of aging (e.g., puckering of the lips, sagging of the brow, and general thinning of musculature and loss of mass in bone structure) present here in Old Pyro-Mantis, and the specific features recognizable as the same character. I've taken his molten flame feature, and aged it to a smoking ember. His antenae, once holding fast to the pattern of his chest, now sag like burnt matchsticks. I've also added a couple props common to aging to reinforce all the physical elements.

PICKING COMMON FEATURES
There are defining features to every face, and every body. Notice that the face plating, eyes and tendrils extending from the bottom of both the younger and older creature are very similar, but also allow room for change and growth. Even though most of the older creature is hidden, you can still tell it's the same species by my mimicking those common features.

PART 2: BABY PYROMANTIS

I've left the third stage of this challenge without too many defining features or props so you can add your ideas to it, like a template. Perhaps your supervillain will be a baby Darth Maul with a lightsaber, a baby Voldemort with a broken wand, or your own character who's not a villain at all.

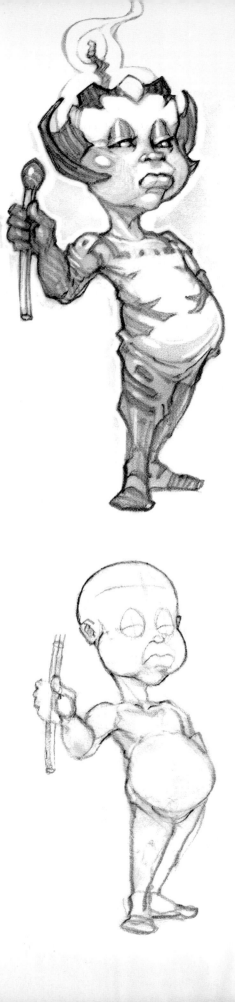

1 Measure the Proportions

Begin by measuring the proportions of this baby supervillain. Draw a larger cranium, chubbier cheeks and belly. Place shapes for the thinner limbs and shorter body.

2 Sketch the Features

Sketch more details into the head: passive eyelids, frowning lip line, ears and the tip of the nose. Keep your lines smooth and round, and sketch in the thumb, knuckles, shoulder deltoids, clavicle and the rest of the pose.

3 Develop the Features

Place the irises, eyelashes, nostrils and lips. Notice how the line of sight solidifies the pose and directs attention to what he's holding. Lightly smudge a bit of tone into the whole figure, then finish your baby version by erasing the highlights from within that tone.

PYROMANTIS CONTINUITY SHEET

Here's the whole gang with both older and younger versions of the PyroMantis completed for the challenge! This kind of continuity sheet might be used for an episode involving time travel, but when you use a more recognizable character, your fan art will show your diverse abilities in making any character younger or older.

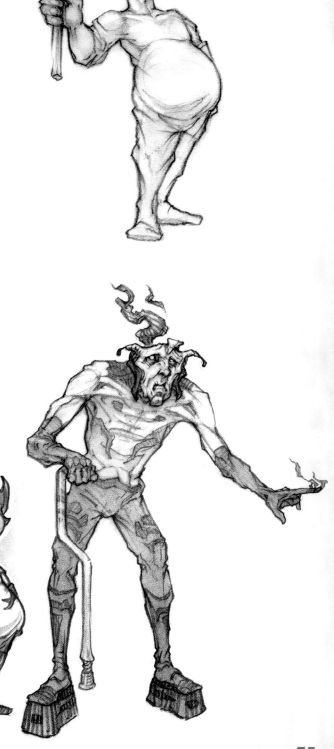

CUTE BRÜT CHALLENGE

This challenge is always good for a laugh. It plays around with our sensibilities and flips our expectations into unexpected outcomes. Since the Cute Brüt Challenge is based in satire and role reversal, it works best when you push humor into your scene. If there's a cute character or a brutish character you don't see on the lists, add it!

Sketch two characters acting in ways opposite to their roles or assumed behavior:

- Pick a brutish character, perhaps an eternal child archetype. Then place the character in one of the cute actions.

- Dream up a young character, perhaps adult-like child archetype, but not older than a teenager. Then place them in one of the Brüt actions that's hilariously sinister or beyond their years.

BRÜT ACTIONS LIST
1d20

1. Diffusing a Bomb
2. Yelling Into Phone at Desk
3. Dressed to the Nines
4. Police Mugshot
5. Football Linebacker
6. Handcuffing Someone Giant
7. Shooting a Giant Gun
8. Reading an Enormous Book
9. Cutting Down Giant Trees
10. Riding Giant Motorcycle
11. Leather Jacket and Spikes
12. Next to Giant Weapon
13. Cracking into a Safe or Vault
14. Amongst Hunting Trophies
15. In Police Line-Up
16. Mad Scientist in Lab
17. Tattooed
18. Working Out With Weights
19. Driving a Tank
20. Pointing and Swearing *@#$!!

VIKING PLAYING HOPSCOTCH

Facial expression can make all the difference. I sketched this Viking with a smile, but it might be funnier to give him an aggressive brow, screaming like he's on the attack. The fact that he's in the goofy pose on a hopscotch course is enough to make the Cute Brüt punch line.

BRUTISH CHARACTERS LIST
1d20 1d4

2. Ogre or Giant	14. Superhero
3. Mythical Death	15. Supervillain
4. Rugby Player	16. Warrior
5. Sumo Wrestler	**17. Longshoreman**
6. Prizefighter	18. Sheriff or Marshal
7. Mechanic	19. Corporate Boss
8. Butcher	20. Linebacker
9. Yukon Explorer	21. Lumberjack
10. Gang Member	22. Biker
11. Big-Game Hunter	23. Men in Black, Security
12. Hairy Kong Man	24. 1930s Gangster
13. Viking	

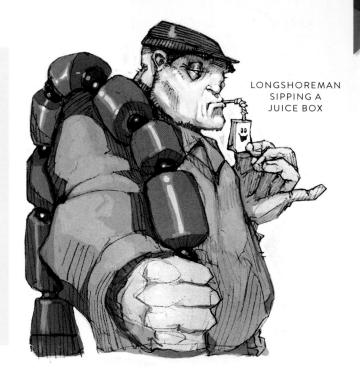

LONGSHOREMAN
SIPPING A
JUICE BOX

CUTE ACTIONS LIST
1d20 1d4

2. Pigtails and Braids
3. Tutu or Ballet Poses
4. Tiny Propeller or Ball Cap
5. **Sipping Juice Box**
6. Cupcakes and Crisps
7. Playing Hopscotch
8. Jumping Rope
9. Feeding Tiny Pet - Butterflies
10. Matchbox Cars
11. Miniature Tea Party
12. Blowing Bubbles
13. Flower Petals (Loves Me Not)
14. Lollypops or Cute Candy
15. Cheerleading Pom-Pom
16. Blowing Dandelions
17. Jungle Gym - Swing Set
18. Highchair or Safety Seat
19. Crying or Tantrum
20. Stuffed Animal Squeeze
21. Puppet Costume
22. Knitting
23. **Silly Pajamas**
24. Bubblegum Bubble

OGRE OR GIANT IN
SILLY PAJAMAS

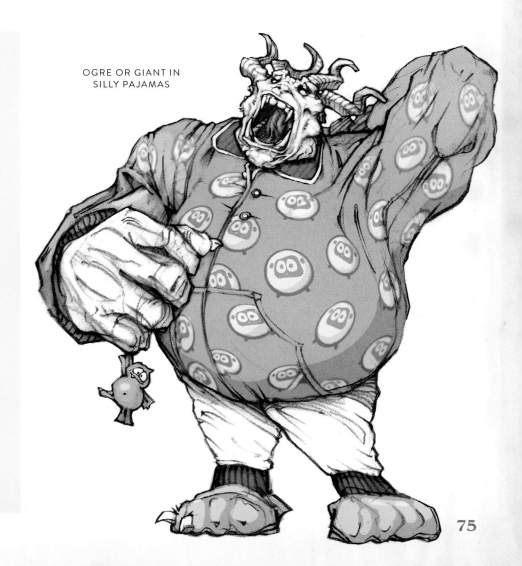

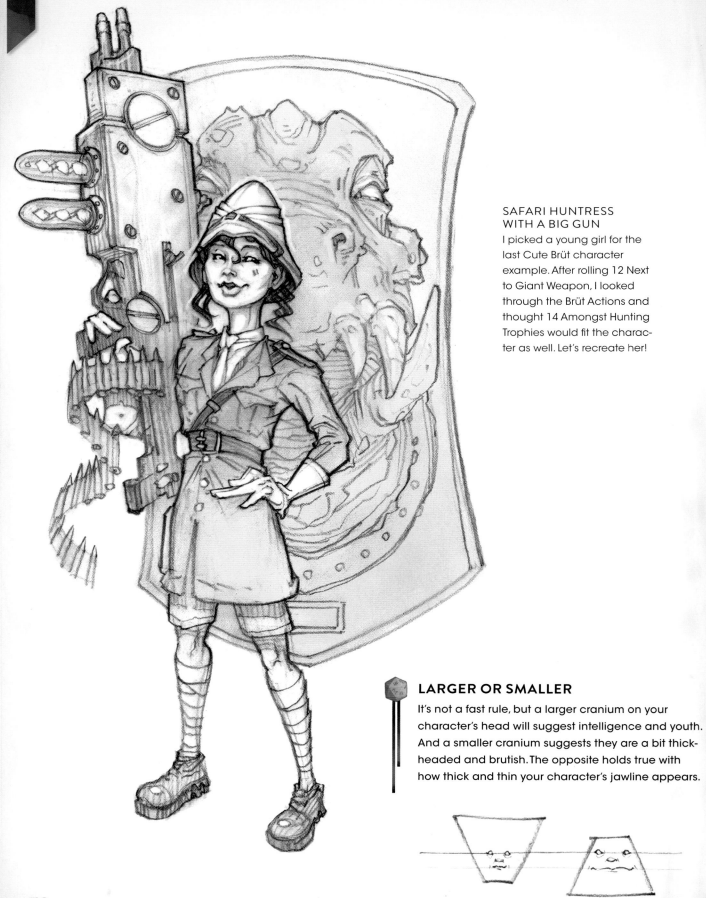

SAFARI HUNTRESS WITH A BIG GUN
I picked a young girl for the last Cute Brüt character example. After rolling 12 Next to Giant Weapon, I looked through the Brüt Actions and thought 14 Amongst Hunting Trophies would fit the character as well. Let's recreate her!

LARGER OR SMALLER

It's not a fast rule, but a larger cranium on your character's head will suggest intelligence and youth. And a smaller cranium suggests they are a bit thick-headed and brutish. The opposite holds true with how thick and thin your character's jawline appears.

1 Measure the Proportions

Start by sketching in the frame of a young girl. Draw a larger head that's slightly lifted, a shorter torso and pelvic girdle, narrow hips and thinner limbs to show her age. Sketch in both arms, then sketch the basic dimensions of her gun, making it as tall as she is or bigger to push the juxtaposition. Notice that the pose is a wide stance to make her more confident while she's lifting that huge gun like it's no weight at all.

2 Sketch the Features

As she started to develop, I looked up 1920s British officer uniforms and safari hunters to form her costume. Lightly sketch her helmet, lowered lids and lashes, and other confident facial features. Place ellipses to indicate the hemlines and cuffs of her uniform. Lightly sketch more of her weapon, making sure the gun always suits her pose. Then add in more of the gun's details: grips, bullet ribbon and barrels on top.

3 Develop the Features & Add Final Details

Start to sketch the final darker marks. Add more details to the safari helmet and costume, and remember to follow those ellipses you placed around the leg wraps, shorts, jacket hemline, belt and glove cuff. I've included some perspective guidelines, placing the horizon line at around shoulder height to help finish the giant weapon.

Finish by smudging in tone, then erasing highlights from it. Add a giant trophy to show how small she is. My trophy was a lightly sketched dinosaur head, but perhaps your safari huntress's trophy is a giant shark or insectoid.

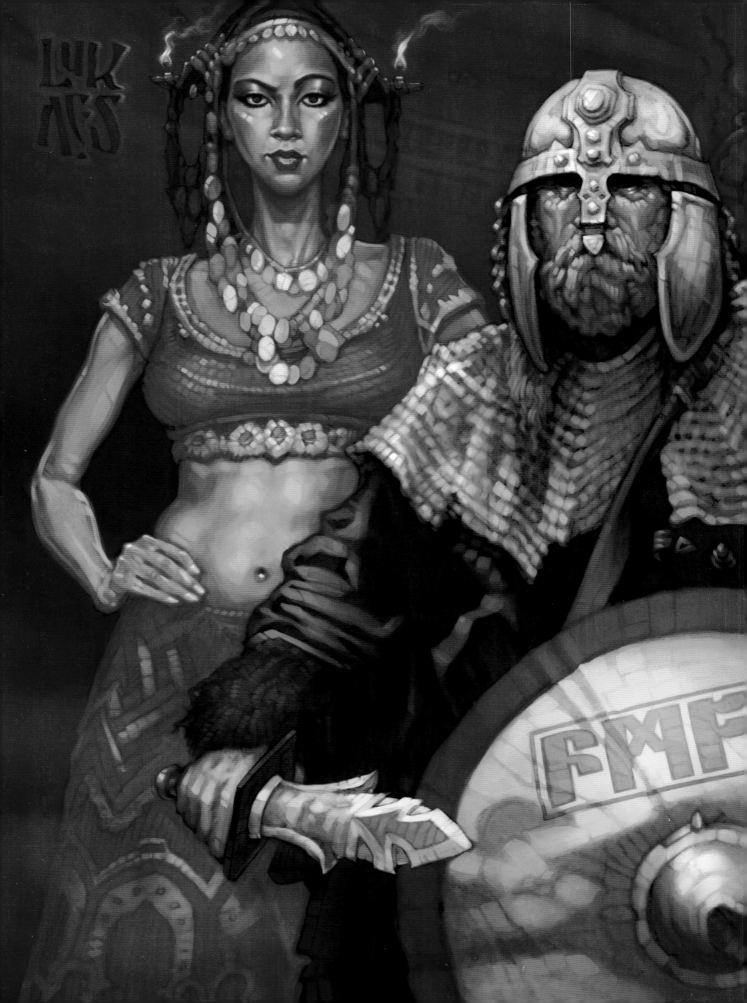

CHAPTER 4
COSTUME & CULTURE

What do you do with a planet's worth of cultural intricacies and traditional costuming as old as time itself? Mix them into something brand new. This chapter holds challenges to create unique costumes from once upon a time, to all over the world.

COSTUME DESIGN

As with anatomy, you can never really know enough about costume and trending fashion. You might find better results using the techniques from the Body Forms Challenge (see chapter 3), keeping elements of costume pared down to simple shapes, or you might want to reach for far more detail than you'll find here. Either way, there's always more to learn about rendering costume. There are hundreds of techniques for costume design, and even more when you consider all the complexities of pattern and ornament. I have a couple explorative games in store, but we'll start with some aspects of movement and function that have worked for me in the past.

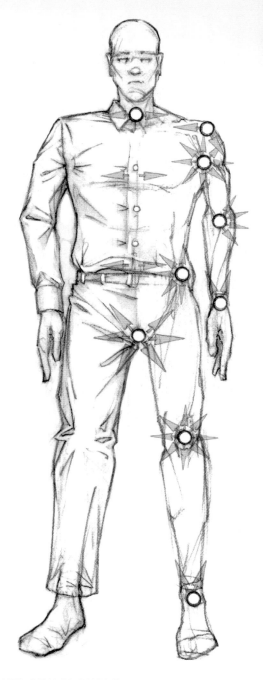

FABRIC FORCES
Fabric hanging from one point creates folds and wrinkles that radiate from that point. The main forces affecting fabric are gravity and the places where the fabric clings or is fastened. Notice the button stretch marks also forming in the directions they're experiencing tension.

POINTS OF MOVEMENT
Wrinkles radiate out from the major points of movement. Here are the common joints of the body from where those opposing forces compress and stretch: the collar line, shoulders, armpit joints, elbow joints, wrist joints, belt line, pubic, knee joints and ankle joints. When sketching your character's pose, pay attention to where the wrinkles stretch or drape from.

This diagram isn't to say wrinkles are systematic. In fact, they should look random and placed rather unevenly. It's a starting point for navigating your photo reference and will help your ongoing study of costume design.

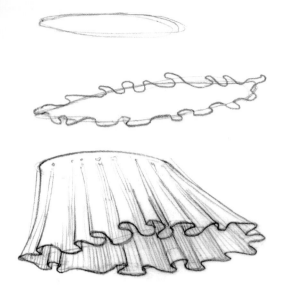

FLOWING FABRIC

Here we see the forces of both gravity and momentum at work. Gravity drapes fabric at the ends or hemlines in a similar way when it hangs along a band or belt line. This is a good technique to use for elements of costume from skirting and free-hanging fabric to ruffled cuffs, collars and fringe.

1. First create two ellipses, one larger than the other. Then draw a meandering line filled with S shapes. Make sure that the curvy line follows the ellipse and doesn't cross over itself.

2. Find the edges of the curving line, and connect each of them to the upper ellipse. The once meandering and random line becomes the outermost edge of your draping costume element.

DRAPING WRINKLES & FOLDS

Fabrics are the building blocks of costume, and, although there are many ways of documenting the intricacies of wrinkles and folds, the best way to learn is through observation and practice. Look to the Baroque sculptures of Gian Lorenzo Bernini or Jean-Baptiste Carpeaux, and study the treatments they gave to fabric and hair. Pay attention to the many forms of handcraft, and the traditions behind clothing production. Fold and drape a white bedsheet over the edge of a table and sketch it from a couple different angles. Notice that the kind of marks you make to document fabrics and costumes will also change depending on the scale in which you're sketching. There are physical rules to how fabric will sit and stretch over the figure, but you should create your own way of making marks when it comes to concepting costumes. The marks you grow fond of will become second nature to you after a while.

TWISTED FABRIC

We again see both gravity and momentum at work, but now with two stronger opposing forces inside the fabric. Try to spot exactly where those points of force are located and which directions they are tugging wrinkles and folds between. Fabric will create wrinkles and folds between those opposing forces almost like connecting the dots. Fabric can also create a kind of zigzag folding when compressed. This occurs more often in thicker materials and leather, zigzagging on one side of the fabric, and smooth on the other.

LAYERING & INCISING

Layering and incising are a fun way of thinking when you're creating new and interesting costumes. Layering is a great technique to use by itself for elements of costuming such as robes and vestments or for colder climate costuming. Generally, it's a matter of placing layer upon layer of material over the different portions of the body, but layering can be far more complex.

Here are a few things I like to consider when developing those layers:

- Think of the different thickness of each layer as you stack them over one another. Will they be made of thin silk, felted fabric or thick fur?

- Think about the gaps between layers. What kind of shadows will they cast and what kinds of patterns will they create? Does each layer fall at equal distance from the next, or do the gaps slowly increase in length or decrease?

- Think about the contrast in your layers, dark next to light. A patterned fabric next to a solid? Velvet next to reflective metals?

- How do those layers stack on top of one another and in what direction? From above, where gravity will hold them in place with just a clasp? Or from beneath, where each layer might have to be sewn, riveted or belted around body parts?

- Do the angles and hems of the layers stay perpendicular, or do they stagger or braid across each other? Perhaps the layers even stack up into a pinecone pattern in areas.

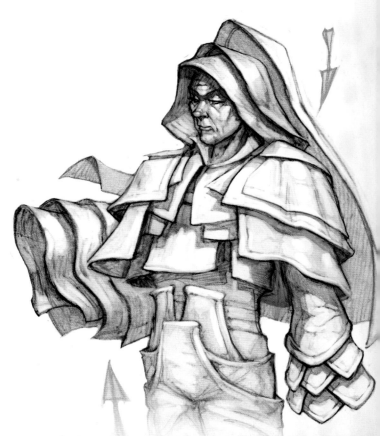

ROBES & VESTMENTS
Here are a number of different layering forms based in the Tudor period (approximately). Notice how layering can lend your costume both a sense of ceremony and formality but also provide hints to which world culture your character might belong.

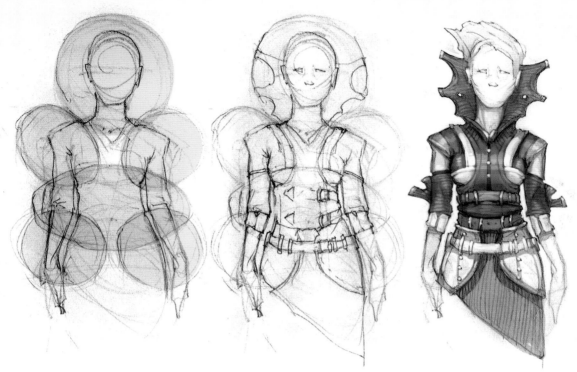

LAYERING, THEN INCISING

Once you've practiced draping layers over and across your characters' pose, think about how you might cut shapes into those layers of fabric. Here we see layering and incising working in conjunction with each other. Notice the circular and elliptical guidelines that stretch across the figure, to both layer and incise by. I used symmetrically placed preliminary shapes for this 1980s villain costume, but a set of angular shapes asymmetrically placed may also produce interesting results.

The goal of this technique is to conceptualize with two modes of thinking to create fun new costume design: layer up, then cut through. Notice how I use those fairly random preliminary guidelines to form parts of the costume by layering and incising. Some of the lines through the torso spread out into the belt line and bicep cuffs. Similarly, I formed the collar by cutting smaller shapes into the halo-like circle layer. There are an infinite variety of combinations with just these two modes of thinking. So, give the world a design it's never seen before!

GIVE INCISING A TRY

As you develop shapes with layers of costume, think about the shapes that could be cut into large sections of those layers to reveal what's just underneath.

- Think of this simple form as a piece of costuming, a shoulder cover or tassets over the hips.
- Visually lay down a layer or two of material.
- Then cut a shape out to form a more interesting section of costume.

- Create a sewn hemline to follow your cuts. Perhaps you cut out shapes that increase or decrease in size to form a pattern.
- Notice how cutting out in the top layer changed the major shape of that piece of costume, while cutting out shapes in the lower layer created a pattern of ornate flaps running along the fabric's edge.

CULTURAL STYLE GAME

The mixing of culture has long been the driving force for some of the most beautiful genres in art history. The ways in which we juxtapose and unify our cultures through multiculturalism can be very powerful in telling our characters' visual history and region, but the more we research other world cultures, the more aware we can become about the big, beautiful sphere we all share!

- Pick an occupation
- Roll or pick a cultural style at random
- Research the culture, styles and customs
- Sketch a character with aspects of the culture and occupation

CULTURAL STYLE LIST
1d20

1. North Amer Indigenous
2. Middle Eastern
3. Spanish, Latin
4. African
5. Central American
6. Japanese
7. Chinese, Tibetan
8. Thailand
9. Indian, South Asian
10. Nordic, Euro, Scandinavian
11. Southern Mediterranean
12. Egyptian, Mesopotamian
13. French
14. Russian
15. Korean
16. Caribbean, Islander
17. Nordic, Inuit, Viking
18. Polynesian, Islander
19. Austro-German
20. Australian, Aboriginal

9 SOUTH ASIAN ALCHEMIST

REFERENCE PHOTO RESEARCH

When researching photo reference, don't just look up the geographic region. Research elements of cultural tradition or religious ceremony. Some of the most diverse costumes are tied to culturally historical ritual, so find those rites of passage or annual festivals. Look up the cities where they take place, what they're for, and then use those keywords to research costume.

For this Indian monk, the festival of Diwali came up, so I used candles similar to those present in that tradition. Think about the written language of the culture. A word or letter of another language can turn the viewer's attention or change the context of an occupation. Cultural connotation can also be shown with design patterns. Scottish tartan, African mud cloth or Indian paisley all speak to specific cultures you can combine. When sketching, try to match the facial features typical of the people in your cultural style roll.

THE BAIT & SWITCH

This technique can be a very helpful tool in more than just character design and can also be the answer to a great many visual problems. You basically set the audience up to notice something that's comfortable to them, and then switch it out somehow to look slightly different. Your character's "costume bait" might be associated with their occupation. For example, my aboriginal detective has a classically worn suit, trench coat and fedora, but the fedora is shaped like a traditional Australian slouch hat. With my Nordic Viking fighter pilot, I bait the viewer with the oxygen mask, flight helmet and goggles, but then switch the context by giving her tribal makeup, which would never be seen in any modern military. This sets the stage for a series of other switches along her costume: ceremonial necklace and belt, plate armor and sword.

17 VIKING PILOT

20 AUSTRALIAN
GUMSHOE DETECTIVE

OCCUPATION LIST
Look Through and Pick

- Air Flight - Pilot / Stewardess
- Astrologer / Alchemist
- Astronaut / Space Traveller
- Athlete - Golfer / Skier
- Athlete - Olympic Medal
- Athlete - Pro Ball
- Athlete - Street / Park
- Athlete - Wrestler / Boxer
- Big Top Circus Performer
- Bishop / Pope
- Craft - Carpenter / Potter
- Craft - Smithy / Mason
- Craft - Tinker / Cobbler / Tailor
- Dancer - Ballet / Ballroom
- Dancer - Night Club / DJ
- Dancer - Swing / Sock Hop
- Driver - Bus / Taxi
- Farmer / Gardener

- Food - Baker / Pizza
- Food - Barista / Waitress
- Food - Butcher / Milkman
- Food - Chef / Pastry
- Food - Green Grocer
- Food - Short-Order Cook
- Gangster / Thug
- Gumshoe, Detective
- Harajuku / Goth
- Judge / Magistrate
- King / Queen
- Knight / Warrior
- Lab Coat Chemist / Scientist
- Librarian / Professor
- Lumberjack / Hunter
- Mayor / City Official
- Medical - Doctor / Nurse
- Military - Command

- Military - Soldier
- Mortician / Undertaker
- Musician - Classical / Conductor
- Musician - Jazz / Hip Hop
- Musician - Rocker
- Nerdy / Nebbish
- Plant Worker / Hardhat
- Police / Firefighter / Postal Worker
- Priest / Nun / Cleric / Rabbi
- Rancher / Cowboy
- Royal Courtier / Jester
- Samurai / Ninja
- Seafaring - Captain / Fisherman
- Shaman / Tribesman / Hermit
- Shop Mechanic
- Toreador / Horse Jockey
- Town Crier / Lamp Lighter
- Train Conductor / Ticket Taker

ARCHITECTURE & CRAFT

Architectural ornament can play a major influence in any multicultural costume. Simply using the 2-D patterns found in architecture will often be enough, but building portions of costumes based on the shapes of recognizable structures can develop intriguing costumes as well.

Visualize sections of architecture as body parts, abstracting and scaling shapes to fit your needs. Pay attention to the structural shapes and material textures in buildings, and adapt them to costuming elements.

Beyond architectural ornament, there is what I like to call "evidence of craft:" stitching, riveting, joining, weaving, felting and patching. How disposable is their costume, and how do its materials wear and decay after time? It is always a good idea to learn how things are crafted, perhaps mixing primitive ways of construction with very detailed time-honored craft or even shoddy industrialized materials. For instance, the patterns and symbols on a Peruvian ceramic vessel, and the smooth lines of a 1930s Bugatti could be used on the very same piece of costume.

HATS, HELMS & HEADGEAR

As the Chuck Jones classic cartoon *Bugs' Bonnets* shows us, a simple hat can tell us everything about your character's occupation, archetype, time period and culture all in one go. When you're designing hats, helm and headgear, keep two things in mind:

- The more facial features you cover up, the less your character will emote. Notice how much more stiff and robotic each character looks, the more their faces are covered.
- The angles of a costume near the brow line can become the brow line. Use this to your advantage if it makes sense to, but be on the lookout for an emotion that might not suit your character.

MILITARY UNIFORM & REGALIA

If you're thinking about work in sci-fi (SF) and fantasy, the study of armor and weapons is essential. Military uniforms are helpful to study the way the body has been attacked and defended throughout history, and a clean-cut, no-nonsense hero or villain archetype can easily be achieved with the clean lines and design that uniforms provide.

Keep in mind the metals and materials used, their positions and functions on the figure, how they wear and corrode, and their believability in terms of mobility and function. Symbols, medals, patches, designation numbers and other regalia can add to any costume inside or outside any culture's military.

Military mechs (mechanical robots) and vehicles will also show up in costuming elements for anything sci-fi or cyber looking. Research anime films (e.g., Masamune's *Ghost in the Shell*) for their brilliant armoring combinations, NASA rocketry, hydraulics, sports gear and motorcycle-riding body armor for design that already accounts for believable mobility.

Observing and photographing Society for Creative Anachronism reenactments is one of the most valuable things you can do to research military uniforms. You can really get a good idea of how they maneuver and how portions of armor have been adjusted to function for specific purposes.

THEATRICAL ABSTRACTION

Theatrical sets and costuming often produce brilliant abstractions in order for costumes to be read by large stage audiences, from the front row to the back row. Use this long tradition of theatrical props and costuming in your research to make your costumes simple and effective. For example, the simple shapes in Kabuki theater are built the way they are for very good visual reasons: dramatic presence, simplicity and distinction of character.

COSTUME & CULTURE

PERIOD OCCUPATION GAME

It can be said that the whole of modern fashion is simply mixing and morphing elements of costume from other time periods. The same groups of symbols and ornaments often change through time, and the physical nature of costumes can reflect the ideologies and sensibilities of that particular time period. The game is fairly simple:

• Roll or pick a time period at random
• Pick an occupation
• Research
• Sketch

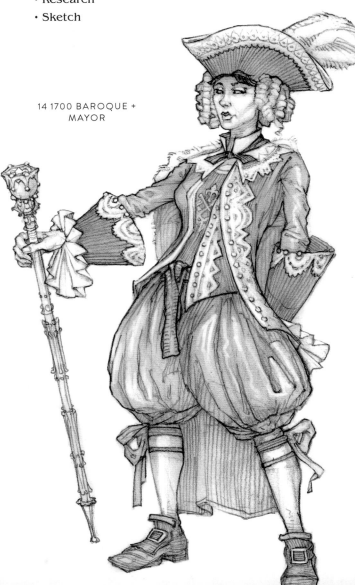

14 1700 BAROQUE + MAYOR

LET'S ROLL

Think about an occupation that's likely to exist in your time period, and then try sketching a blatantly unlikely character for your time period. Think about switching the gender associated with the occupation. For example, here we have a female mayor or city official in the Baroque period.

Use props and poses that will reflect your character's occupation, then think about ornamentation and patterns indicative of your time period. The New York Metropolitan Museum of Art's Costume Institute website lets you zero in on most of the time periods on our list, and is one of my favorite places to start researching any costume.

OCCUPATION LIST
Look Through and Pick

- Air Flight - Pilot / Stewardess
- Astrologer / Alchemist
- Astronaut / Space Traveller
- Athlete - Golfer / Skier
- Athlete - Olympic Medal
- Athlete - Pro Ball
- Athlete - Street / Park
- Athlete - Wrestler / Boxer
- Big Top Circus Performer
- Bishop / Pope
- Craft - Carpenter / Potter
- Craft - Smithy / Mason
- Craft - Tinker / Cobbler / Tailor
- Dancer - Ballet / Ballroom
- Dancer - Night Club / DJ
- Dancer - Swing / Sock Hop
- Driver - Bus / Taxi
- Farmer / Gardener

- Food - Baker / Pizza
- Food - Barista / Waitress
- Food - Butcher / Milkman
- Food - Chef / Pastry
- Food - Green Grocer
- Food - Short-Order Cook
- Gangster / Thug
- Gumshoe, Detective
- Harajuku / Goth
- Judge / Magistrate
- King / Queen
- Knight / Warrior
- Lab Coat Chemist / Scientist
- Librarian / Professor
- Lumberjack / Hunter
- Mayor / City Official
- Medical - Doctor / Nurse
- Military - Command

- Military - Soldier
- Mortician / Undertaker
- Musician - Classical / Conductor
- Musician - Jazz / Hip Hop
- Musician - Rocker
- Nerdy / Nebbish
- Plant Worker / Hardhat
- Police / Firefighter / Postal Worker
- Priest / Nun / Cleric / Rabbi
- Rancher / Cowboy
- Royal Courtier / Jester
- Samurai / Ninja
- Seafaring - Captain / Fisherman
- Shaman / Tribesman / Hermit
- Shop Mechanic
- Toreador / Horse Jockey
- Town Crier / Lamp Lighter
- Train Conductor / Ticket Taker

PERIOD DETAILS

Pay attention to hair styles and posing your character along with the sensibility of your time period. Discovering how provocative or how uptight folks were in the time period can often give context of their costumes all by itself. Here we have Egyptian rock musicians (keep reading for a step-by-step demo of the rocker in the forefront).

When researching your time period, also consider specific events or historical movements. What kind of costume defined ancient Sumerians, Victorian London, the civil rights movement or Robin Hood mythology? If you can mimic only a bit of a particular time period, you can bring that period's connotations and sensibilities to your character.

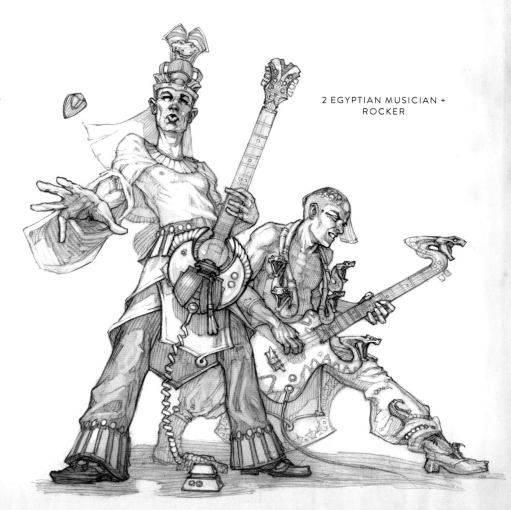

2 EGYPTIAN MUSICIAN + ROCKER

EGYPTIAN ROCKER

I created this character with the Period Occupation Game first by rolling 2 Egyptian/Sumerian, then choosing the rather unlikely occupation of Rock Musician. I knew his success would be hinged on the strength of the pose, so I looked up some of the most ridiculous rock guitarists from the 1970s and 1980s to reference their provocative posture.

Then taking only the elements of pose that would play to both the 1970s and ancient Egypt, I started to design his costume. To make him believable, I needed to add functions of performance, so I designed a 1970s electric guitar and effects pedal and had him throwing a guitar pick to the audience. I also researched theatrical and film costumes for abstractions of similar Egyptian costumes.

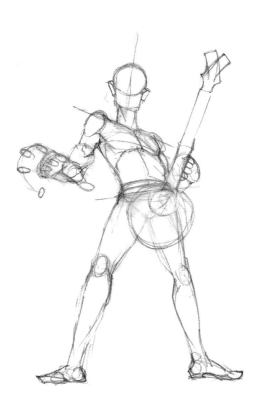

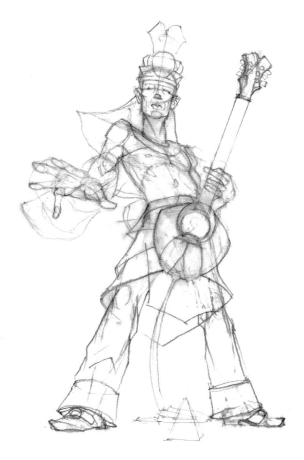

1 Measure the Proportions

Begin by measuring and lightly sketching the proportions of his provocative pose. Place the knees, feet, hands, elbows, shoulders and head. Sketch the skull and jaw, the contrapposto angle between his shoulders and hips, torso, legs and the initial shapes for his guitar. Notice that the cranium is a bit larger to suggest his ego and intelligence. His hand is much larger (almost two heads long) to really push the camera angle and sense of theatrics. Draw through, placing the knuckles and fingertips for each hand.

2 Sketch the Features

Sketch more details of the costume around your posed limbs, while adding more structure to the face, hands, torso and shoes. Lightly sketch all the elements of his Egyptian-styled costume. Place shapes for the skirting around the belt line, bell-bottom trousers and cuffs, headdress, guitar and pyramidal effects pedal.

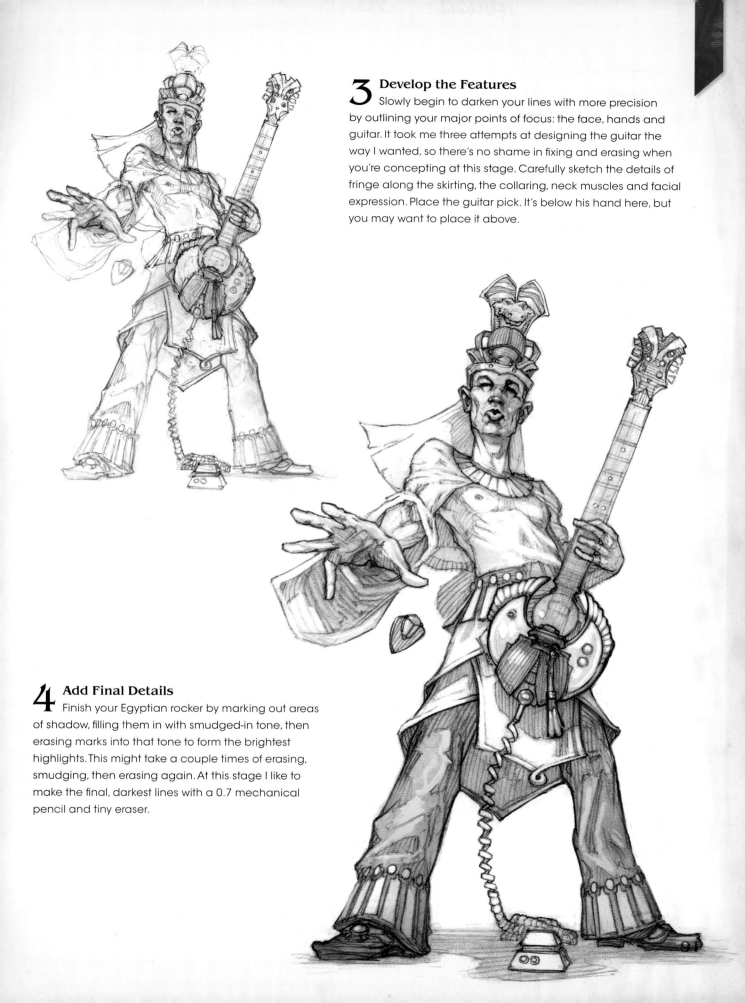

3 Develop the Features

Slowly begin to darken your lines with more precision by outlining your major points of focus: the face, hands and guitar. It took me three attempts at designing the guitar the way I wanted, so there's no shame in fixing and erasing when you're concepting at this stage. Carefully sketch the details of fringe along the skirting, the collaring, neck muscles and facial expression. Place the guitar pick. It's below his hand here, but you may want to place it above.

4 Add Final Details

Finish your Egyptian rocker by marking out areas of shadow, filling them in with smudged-in tone, then erasing marks into that tone to form the brightest highlights. This might take a couple times of erasing, smudging, then erasing again. At this stage I like to make the final, darkest lines with a 0.7 mechanical pencil and tiny eraser.

FRANKENFARMER

I created this character with the Period Occupation Game by rolling 5 1850 Victorian, then choosing Farmer/Gardener as an occupation. Then, just for fun, I added a SF & Fantasy Modifier List roll (see Archetype Occupation Challenge in chapter 3), 6 Frankenstein.

After looking up photo reference for farmers with 1850s and Victorian costuming, I found a nice group of pics from Civil War reenactors that fit the time period nicely. I started to think about the character of Frankenstein's monster and how the occupation of farmer might somehow relate. Frankenstein's monster is scared of fire, so I made a visual joke of his farmer's pipe flaming up on him!

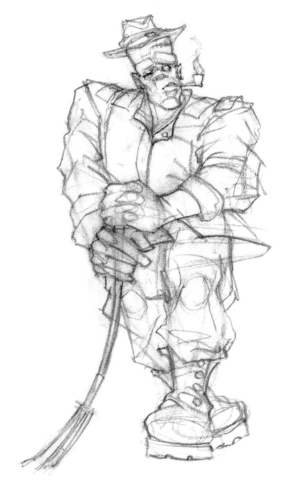

1 Measure the Proportions

Begin by measuring the proportions of Frank's hulky frame. Make his head rather small compared to the body, and also long and top-heavy. There's some physical comedy happening with him leaning on his pitchfork, which is about to break, so be sure to include the slight tilt of his body. Notice the contrapposto angle, and the way his weight is placed on both the pitchfork and his right leg.

2 Sketch the Features

Lightly sketch in the costuming, creating wrinkles from the points of tension they radiate from. Carefully sketch in some of his funny expression to lock in the joke: giant inverted brow, one eye open to notice the flame, and puckered lip holding the pipe. With the hat and hashmarks, the Civil War costuming is already starting to indicate the time period.

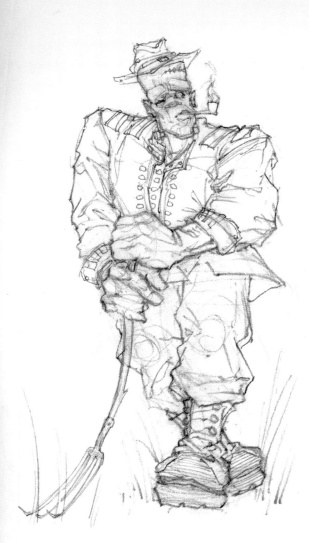

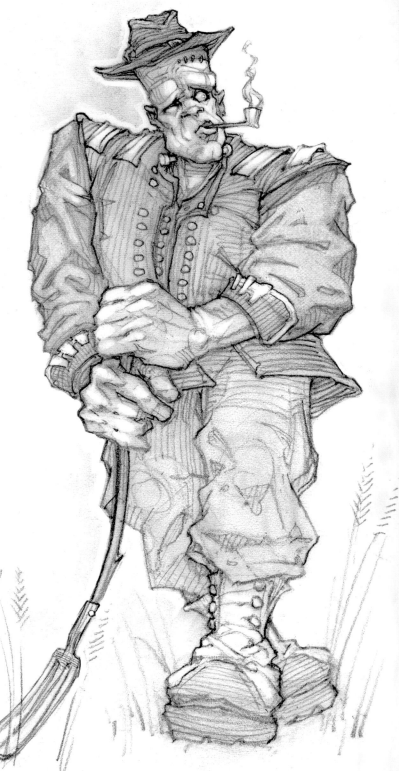

3 Develop the Features

Start adding detail to the costume with sharper, darker outlines. Darken in the details of Frank's costume including the hat, buttons, and both shoulders' and sleeves' hashmarks. Then start lightly smudging in tone. Keep the smudging consistent and most of it concentrated inside the major shapes of his body.

4 Add Final Details

Finish your FrankenFarmer by darkening the final features of his facial expression: nostrils, puckered lips, lashes framing his eyes and brow line. Then erase the bright highlights, first coming from the flame, making it a light source, and then along the hands, hashmarks and shoes.

SILHOUETTES & SILHOUETTING

Popular a hundred years before photography, silhouettes have long been an artistic tradition and a powerful graphic tool. From cut paper miniature portraiture, to Henri Rivière's shadow theater, on into modern fashion and advertisement, their function and dramatic effect remain the same.

The high contrast of silhouettes is one of the most effective ways to draw the viewer's attention: the whitest whites of light, right next to darkest darks of shadow. The studies in R.L. Gregory's *Eye and Brain* tell us that our brains are hardwired to prioritize those visuals, zeroing in on them without thinking.

Since the dimly lit paintings of Caravaggio, artists have known the impact of high contrast, and some of my very favorite illustrators have used silhouetted imagery almost exclusively in their work for these very same reasons, including Erté, William Heath Robinson, Harry Clarke, Ludwig Hohlwein, Jim FitzPatrick, Martin French and Mike Mignola.

SILHOUETTING FOR THE ENTERTAINMENT INDUSTRY

The Skillful Huntsman (2005) popularized the conceptual process of silhouetting for the entertainment industry and provides great insight into how character development has evolved through the use of silhouettes.

There are a couple of big reasons why companies may insist on this concept technique, one being that it gives an excellent idea of how the character will be identified among other characters. It can show how a character will appear when it's quite small on screen, and it provides a group of folks many different variations of form to pick from without a lot of time spent finalizing any particulars.

I was professionally introduced to the process by Adam Cook and the team he assembled at Super-Genius, and I

have since created a couple techniques with the very same processes at play:

- **Pencil:** Working very small, using the side of the pencil, for wide blocky marks.
- **Ink:** Brush or nib marks, working on cold-pressed or toothy paper for more texture.
- **Marker:** Same as ink (my process is described in the next section).
- **Digital:** Sketching in shapes, with either custom brushes, Alchemy or other drawing apps.

TIPS ON PROCESS

- **Pose:** Make them act the role! This might be the most effective way to truly describe your character through silhouette. Surround yourself with reference to inform the pose, movement and gesture, and your characters' actions will explain archetype, occupation and behavior. Try to keep the limbs separated enough to form an interesting group of negative spaces around the silhouette. The more you show of your character's contour, the more aspects of props and costuming will be clear and readable. The silhouettes' poses mean more to the audience, as there's less detail for the brain to work with.

- **Proportions:** When working on human characters, keep some consistency to general human proportions. The head, feet, elbows and knees should fall fairly close to a human skeleton so that your silhouette doesn't look broken in one way or another. Much of this can be fixed and "liquefied" with Photoshop, but begin with somewhat normal proportions in mind.

- **Size of sketch:** It doesn't matter where you begin—feet, head, torso or arms—but try to keep a handle on the size where you are most successful. You shouldn't worry about detailing the fingers of each hand, but you should want to get enough detail out of your tools to create something that will be consistently read among a group of people.

- **Serendipity:** In a team environment, silhouetting can congeal a group of obscure ideas with very little effort and in very unexpected ways. Don't worry about light and shadow, don't worry about facial expression, just keep an open mind on what a set of random marks might create for you. Work straight over mistakes until you see something spring from the marks you're making. Quickly get down as many different variations on what ideas serendipitously come to the page as you can. Don't think, just draw! If you get one out of three, then you're doing well!

MARKER PROCESS

I normally warm up with a session of random characters, where I get comfortable with the process for that particular group of silhouettes. I explore the marks that the tools make before I start thinking about any particular elements of character: thin line, thick line, smooth marks, fun abstract textured marks that might play off as fur or rough material. I like to purposefully limit myself in this session, so I might learn marks that I'm not used to, marks masked with a piece of paper, marks that are old friends, completely unexpected marks.

Sometimes it's the most unexpected interpretations that bring on the best ideas.

As I start to focus on the variations of my character, I try to keep in mind a number of poses consistent with the behavior of my character, their occupational props and actions. What will they be doing or saying? Will they be crouched, in the air, arms wide or feet firmly planted? I like a three-quarter view so that I can show a bit more with the silhouette. Placement of the feet can say a lot in a three-quarter view.

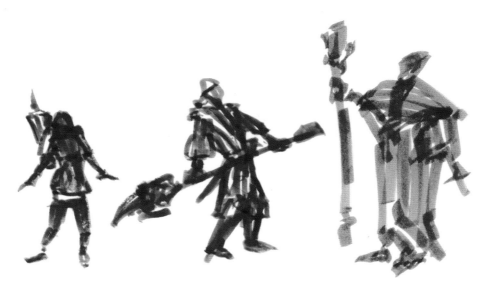

STEP 1: BLOCKY MARKS

I tend not to sketch with solid black ink, but rather with a low tone marker (sometimes a highlighter marker) to indicate some of the internal forms as I go. I sketched these silhouettes with a very light toned water-based brush marker on Graphics 360 marker paper, which can give a smoother set of marks that blend nicely with digital editing.

Notice how blocky and sporadic the marks are. Some are given a very simple shoulder line or belt line to define and redefine proportions and potential seams in the costuming. No mistakes, just a group of quick marks to define a contour with a nice pose, and some edges of costume to work with.

STEP 2: SHARPENING CONTOURS

The second stage consists of sharpening that contour. I mainly use a ballpoint pen for speed and ease. After the thin pen line, I'll sometimes use Dr. Ph. Martin's Bleedproof White and brush, or an opaque white marker to make white marks over the gray of the marker. This further defines the edges and contours of some of those basic shapes and proportions. Notice how hands and feet become clearer, aspects of the pose are corrected, and elements of costuming start to appear from the initial marks made.

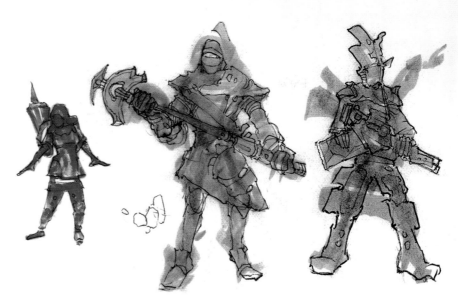

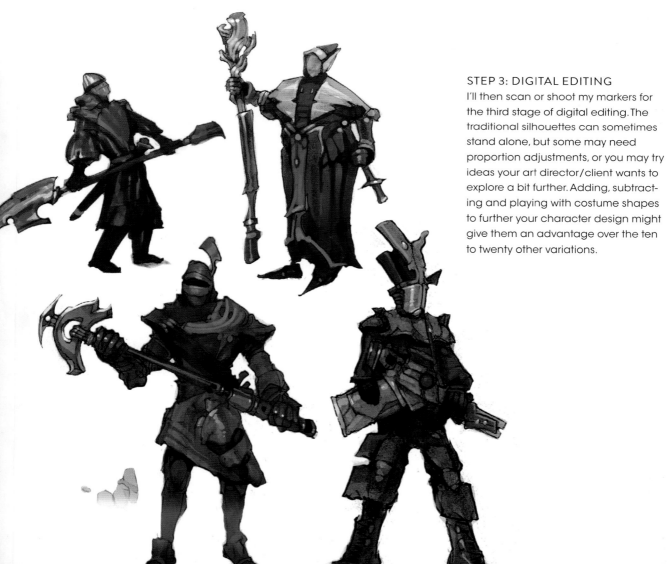

STEP 3: DIGITAL EDITING

I'll then scan or shoot my markers for the third stage of digital editing. The traditional silhouettes can sometimes stand alone, but some may need proportion adjustments, or you may try ideas your art director/client wants to explore a bit further. Adding, subtracting and playing with costume shapes to further your character design might give them an advantage over the ten to twenty other variations.

COSTUME CREATIVE PROCESS

These next few pages are filled with a creative process to try on any of your characters requiring costuming. It's a good way to test creating your characters for a client and can expand your characters in ways you might not have thought of by yourself. Ask your parents and friends or perhaps your teachers and professors to share their likes and dislikes during each round of character development. Try to sketch and provide results as quickly as possible, paying attention to the directions your client gives, and achieve the kind of visual solutions only you can create!

CHARACTER BRIEF: SHIFTERCHEF (8 SHAPESHIFTER + 6 JAPAN, KOREA + FOOD - CHEF)
The client wants a Japanese chef who plays the role of shapeshifter archetype, who starts out bad but, over the course of the story, becomes good and trustworthy. The client isn't specific about time period, but it's important to play around with some traditional elements of costume.

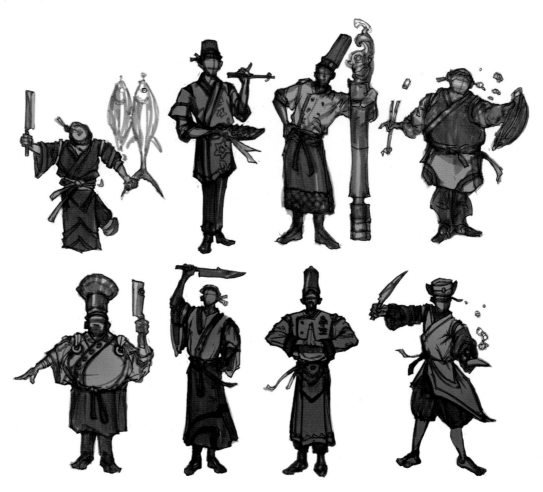

ROUND 1: DEVELOP EIGHT TO TEN SILHOUETTES
Starting out with a group of eight to ten marker silhouettes, I concentrate on including the light and dark duality and indifference of the shapeshifter archetype. Notice how little importance is paid to the face, and how much is paid to pose, gesture and elements of occupational props. All that attention tells a group of tales that the client can choose from. It starts to form his personality through mini

stories and scenes, where you can make your characters behave and act.

I try to play with a number of body forms as well, and I place forms that might appear similar away from each other to maximize the potential of each. After a brief review, the client likes the direction that three of them are moving in, so I expand those three.

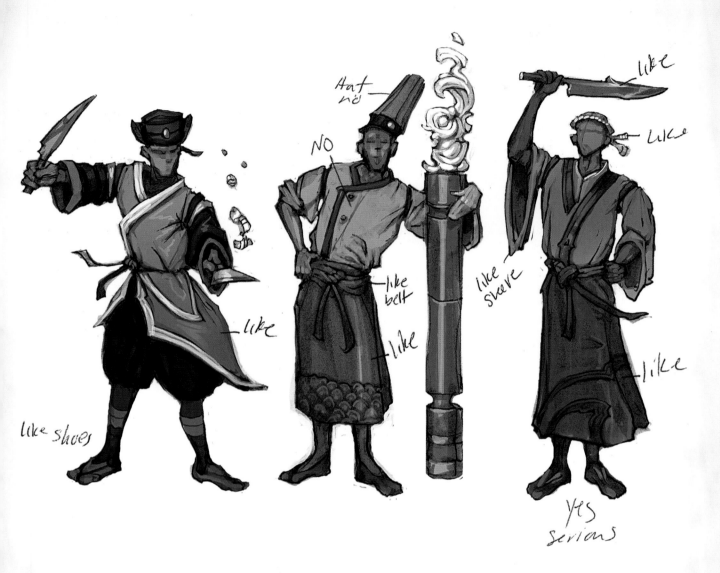

ROUND 2: DEVELOP THREE POSSIBILITIES

When working on the next quick round, you'll notice these three versions of our shifterchef gained some simple facial features, with an eye toward keeping the features dark, and a bit of a passive brow line on the central character. I added more detail to the hands and shoes and fixed some general anatomical proportions. At this point, I'll sometimes use Photoshop's liquify filter and transform tools to correct my simple silhouettes, bringing more highlights and shadow areas into each pose.

The client's feedback involves keeping the costuming more traditional, to really push the Japanese culture rather than any western chef elements creeping in (i.e., no tall white hats or double-breasted buttons). The client wants me to stay with a more traditional kimono-like sushi chef uniform, shoulder and waist ribbon belts, and sandals. The words the client gives as positive feedback can often be the exact keywords to look up a new set of photo reference from.

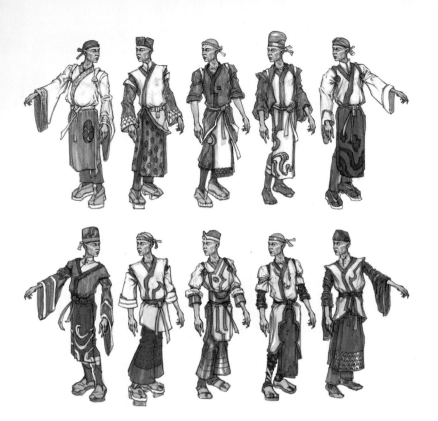

ROUND 3: COSTUME VARIATIONS
The number of variations will change depending on the client, but I've done another eight to ten variations here and focused on the aspects the client liked from the last round. I've used a repeated template under marker paper to make the process quicker and more systematic. These "paper doll" templates will generally look stiffer, less expressive, and tend to be three-quarter view to give the client a wider idea of what the entire front of the costume will look like. With the character's region defined, I gave the template Asian features, and also made him look sidelong to keep with his dualistic shapeshifter character archetype.

ROUND 4: SEMIFINAL VERSIONS
After the client has given direction on likes and dislikes, I compile two digital semifinal versions. These two versions incorporate all those elements of costume important to the story that the client was looking for: short hat (if any), high white collar, sushi chef shoulder and waist ties, long sleeves, black outer vest, light inner kimono, ornate apron, leg wraps and toe sandals.

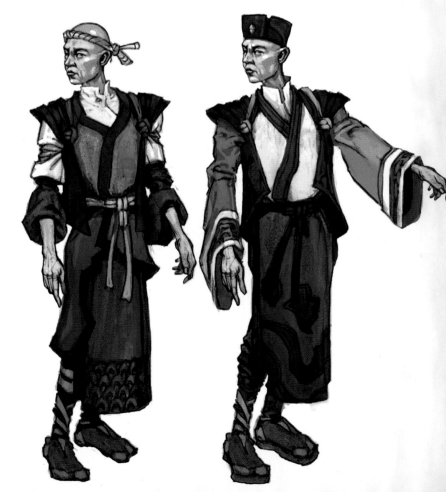

ROUND 5: FINAL CHARACTER

With two costumes approved, a more dynamic characterization can be sketched. In order to bring back some of our shifterchef's personality, I've kept an eye on the elements of character that were successful in the initial silhouetted poses. Notice how his polarized and deceptive nature are both shown through his darker eyes, slightly staggered brow and the high contrast in his costume. Dark on the outside, light on the inside. This chef could easily be the mole of the villain or the double agent who falls in love with the hero.

The process might seem long but is really effective in getting the best results from a number of voices at the same time. The character is negotiated out of a million potentials, narrowing the scope of focus until the whole group reaches the final decisions.

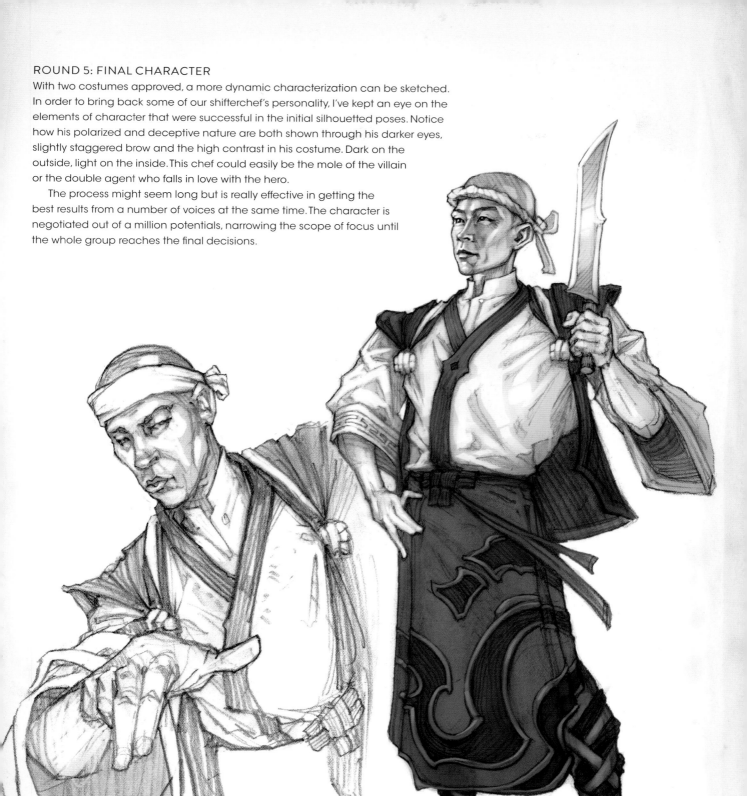

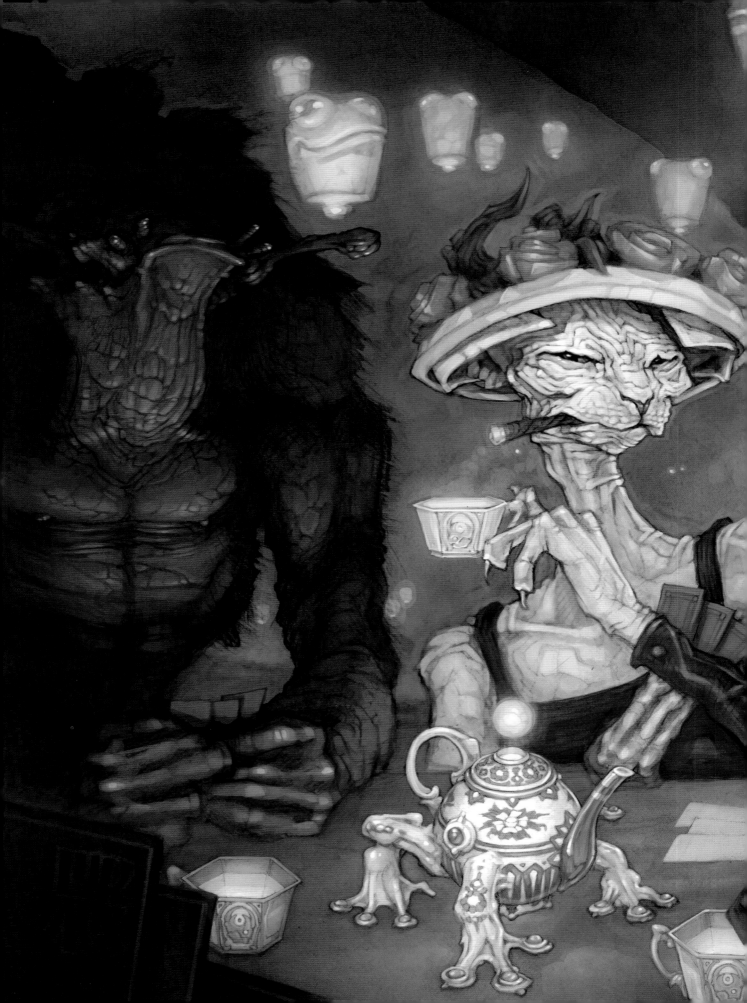

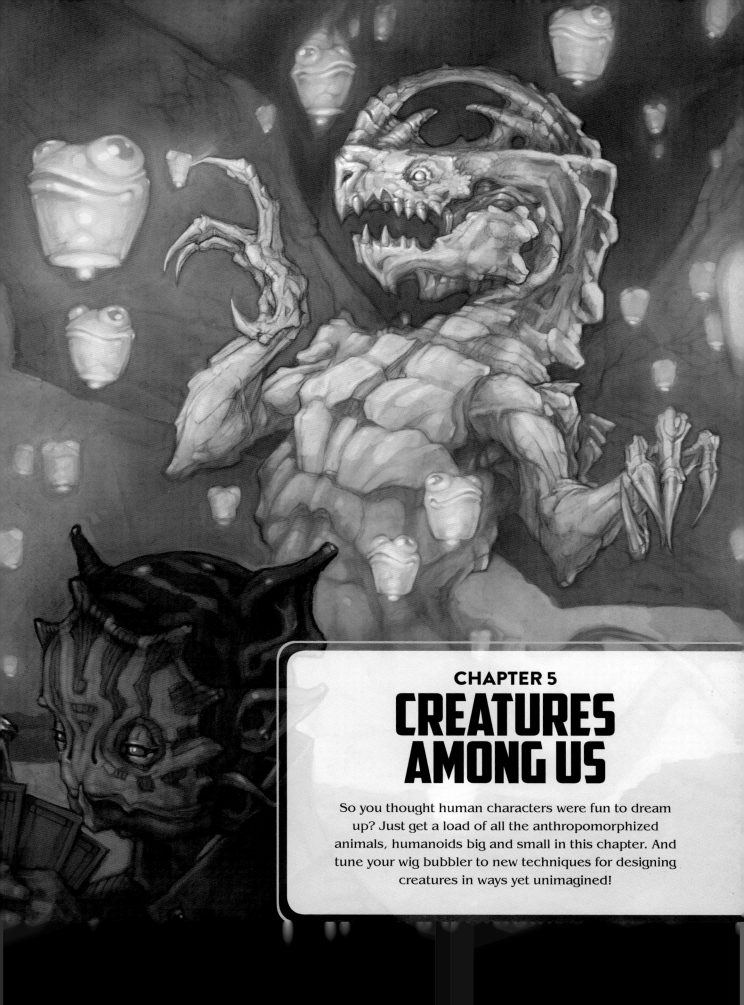

CHAPTER 5
CREATURES AMONG US

So you thought human characters were fun to dream up? Just get a load of all the anthropomorphized animals, humanoids big and small in this chapter. And tune your wig bubbler to new techniques for designing creatures in ways yet unimagined!

ANTHROPOMORPHIZATION

Anthropomorphization is the adaptation of humanlike features or behavior to that which isn't human. This includes everything from animals to inanimate objects, to metaphorical characterizations, such as Old Man Winter and the man on the moon.

Anthropomorphization clearly permeates our favorite historical mythologies and plays a very big role in conceptualizing the SF and fantasy markets today. Sometimes we need our history portrayed by someone apart from humanity, someone in between. Here are a few good techniques for maintaining that illusion.

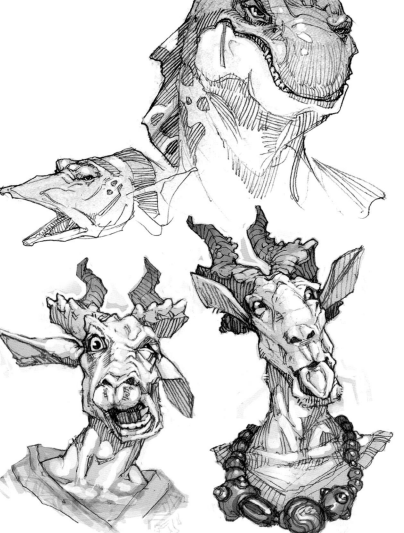

HEAD REPLACEMENT
The easiest technique is head replacement. If there's enough of a torso in your photo reference, you can crop and size the animal head right at the neck and collar line of the costume. If you render the animal head and human costume and hands accurately, you'll have a successful basic animal humanoid.

FACIAL EXPRESSION & GESTURE
With the millions of reference photos available these days, I can sometimes find photos of very specific animals exhibiting the exact emotional states I'm looking for. However, if photo reference fails in getting you past simple head replacement, the key to most anthros is in the neck-body connection. Look to the anatomy crash course at the end of the book, and notice how the neck muscles attach from the ear to the clavicle. The addition of the clavicle is the next level up in sketching your anthropomorphs.

POSITION OF THE EYELIDS & THE CORNERS OF THE MOUTH

Even when there is no brow line present, you can still make just about anything speak or emote by the manipulation of two areas of the face:

1. Rotating the direction of the upper and lower eyelids

2. Lifting and lowering the front and corners of the mouth

Very little is actually needed for virtually anything to appear with more human emotion and speech. Just take any object, find or create the corners of the mouth and a way you can change the shape of the eyes, and you can make them speak and emote in almost any way that a human can!

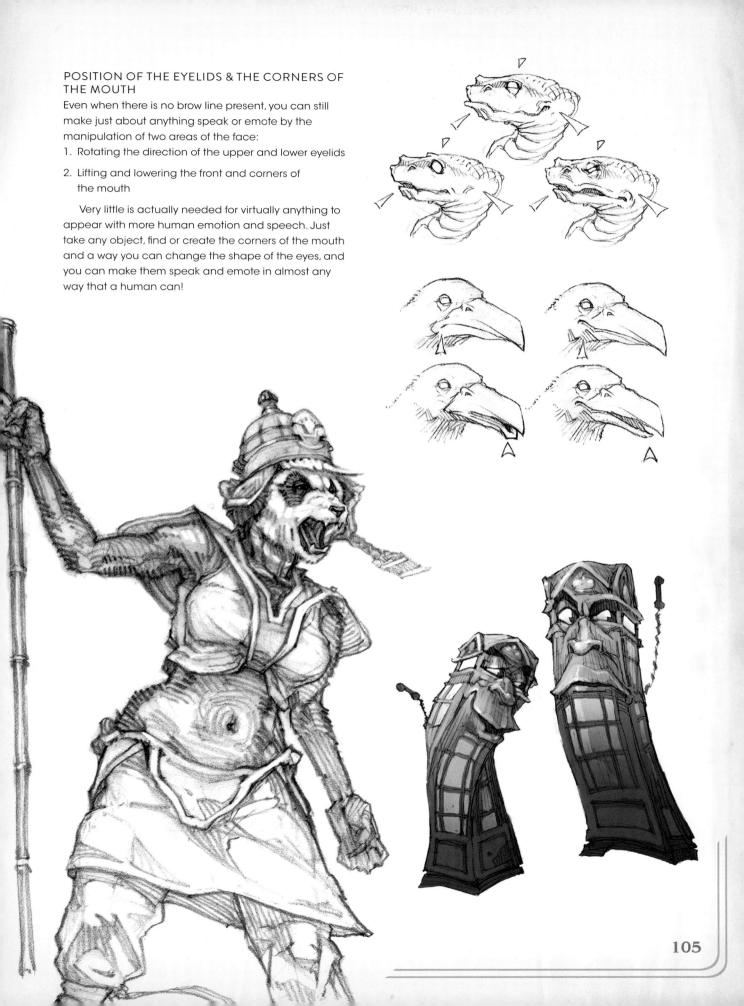

SNOUT, NOSE & CLEFT LIP

The creation of a snout, darkening of the nose and the addition of cleft lip will all immediately move any human face toward that of an animal, regardless of the level of realism.

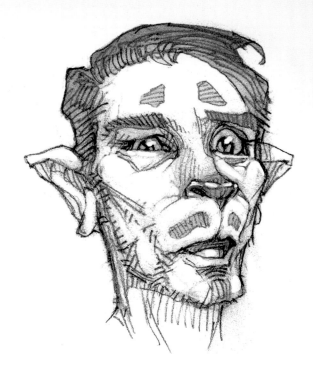

PUPIL SHAPE

Changing the shape of the pupil is a simple way to make your human character more animal. Add the pupils of a cat or the horizontal pupil of a sheep or even the scalloped-shaped pupils of a tokay gecko.

HEAD MUSCLES & TEETH

Noticeable on most mammalian characters, the M-like ridges that run along the angular head muscles can be used to emote anger or discomfort between the eyes and nose.

Also notice that as the teeth get more rounded, the more human your character becomes.

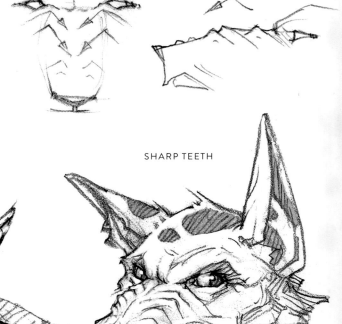

SHARP TEETH

ROUNDED TEETH

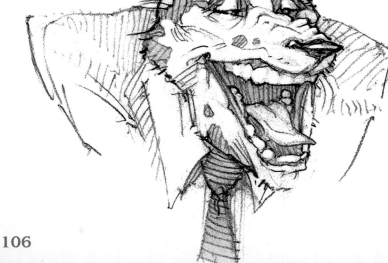

HANDS

Making fingers longer or shorter can be effective in morphing human hands slightly more animal, possibly adding a bit of claw, pad or talon to the tips of the fingers and thumb. Perhaps your character will have retracted claws most of the time, but then extend those more animal features out as the mood requires.

Tuffs of fur or feathers jutting from the knuckles and wrist can be both subtle and effective in mixing the animal into hand gesture. I like to create the impression of fur or feathers simply by breaking up a bit of my outline or shape of light.

If the character needs to remain completely animal, then replace the hands with feathers or fins as fingers.

SINGLE DIGITS

Single digit animal parts, such as tentacles, tails and insect antennae, can also be used as devices for single digit gestures that don't require a set of fingers, including pointing and scratching.

HAIR STYLE

Like spots and pattern, fins, fur and feathers can play a role in the creation of anthropomorphic hair styles. Hair style can also tell your audience something about the age, personal tastes and time period of your character. Think about what naturally grows on or near the character's head, and morph that material into the hairstyle that might suit their personality.

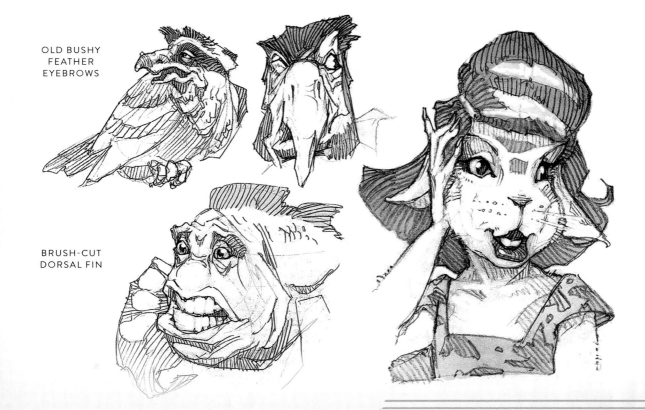

OLD BUSHY
FEATHER
EYEBROWS

BRUSH-CUT
DORSAL FIN

PATHWAYS OF PATTERN

These may look like tribal tattoos, but they're actually arrows pointing out directions along the figure. It's a map to describe the sources of pattern, and how it might flow from one area to another. Some of these pathways derive from scientific evidence, and the rest are simply fun new ways to perceive the use of pattern on your creatures or humanoids. Here are some tips for adding patterns to your characters:

HUMAN AND ANIMAL ANATOMY
- Pattern can follow the flow of certain muscle groups and will spread symmetrically.
- Pattern often accumulates at the sides and spine.
- Pattern tends to recede medially from the underbelly.

GROWTH
- Study the intricacy and detail on baby animals.
- Pattern can recede from the sense organs: nose, eyes and so on.
- I like to think about the ways smoke or water might trail from parts of the body and extend that pattern or structure.

DECAY
- Wrinkles in the skin form patterns similar to the wrinkles in clothing, radiating out between moving joints.
- Consider the areas of the body where the sun tans or burns the skin's surface, making areas of pattern darker.
- Remember exposed areas where the skin has been wind-beaten, cracked or wrinkled. Repeated behavior or locomotion will cause scarring, which can lighten skin tone around joints and protrusions.

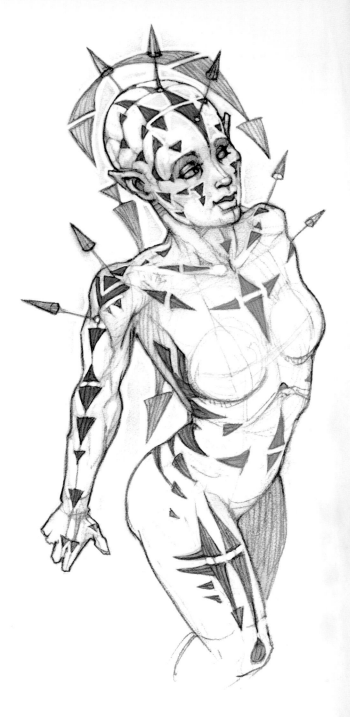

FIND YOUR OWN PATTERNS
Break these rules! Once you find a consistent pathway of pattern, find ways to redirect or mutate that flow. Once you find success with symmetry, change the direction or try staggered asymmetry.

I've used rotation (see the 5 Rs later in this chapter) to redirect the stripes on these bumblebees. Now think of what could be done with other recognizable patterns such as those found on a zebra, tiger or dragonfish.

HEAD

- Center of the cranium running from the chin, nose and widow's peak to the base of the skull, then down the spine

- Spreading like a hood, from the hairline, ear to ear, then laterally along the neck to both deltoids

- Radiating out from the center of each eye

- Down to the tip of the chin from the sideburns

TORSO

- Along the bellybutton to the sternum

- Across both pectorals and scapula, to the deltoids

ARMS
Spreading laterally from trapezius, down the deltoids, triceps, to the back of the hand, trailing off along knuckles

POSTERIOR
The major movement of pattern begins its source along the spinal column, then gets weaker and weaker as it trails off toward the underbelly.

SPINAL COLUMN

- Down the cranium to sacrum to tail

- Spreading bilaterally across the length of the back

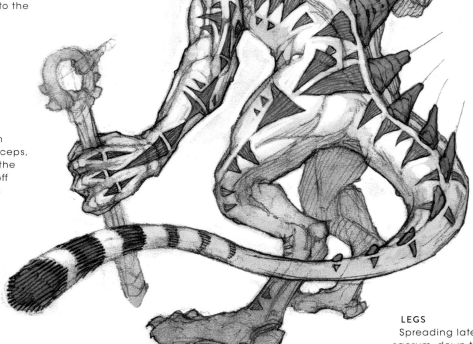

LEGS
Spreading laterally from sacrum, down the thigh flank, then anteriorly to the knees, shins and tops of feet

DRAW FROM THE SOURCE
Another aspect to consider is how much your pattern will build up and trail away from its source. Notice the stripes getting thinner, and the size of the shapes getting smaller from the source.

CREATURES AMONG US
HUMANOID CHALLENGE

This challenge is based on the Humanoid Game from my first book, *Fantasy Genesis*, along with some new lists found in these pages. If you've never played before, do yourself a favor and concept a couple humanoid characters with word associations borne from the whole group of lists. Simply picking a couple animals to anthropomorph with is fun, but what you're mainly looking for are a couple words to add into either of these challenges.

TIPS FOR THE ANTHROPOMORPHIZATION OF FANTASY HUMANOIDS

- Think about the region where your animal lives, and draw from the humans who inhabit that same region, including their costuming traditions. Examples: a walrus with fur costuming, a toucan with colorful Guatamalan fabrics or a southwestern gecko wearing a cowboy hat.
- Look at some props and tools based on the occupation, and create a scenario of the character's daily life. What does your animal's workday look like? How do they play? Perhaps they lose something important, or perhaps they find something that is useful to their species alone.
- Think about the styles and sensibilities of a particular time period, including costume and hair or fur styles. Think about a specific historical event in your character's time period, what your animal might think about that event, or even ways they could have played a role with their specific animal behavior. Example: night-watch owl before World War II's Normandy invasion.
- Think about the kinds of ceremonies, music, dance and sports that are local to your animal's culture. Perhaps they are preparing for a performance. Perhaps some physical aspects remain true to animal form within those human ceremonies. Examples: cricket violinist, crooning rooster or hound dog.
- Think about the diet of your animal. Which restaurants do they frequent? What would make them sick, or what are they making for dinner? Example: panda cooking bamboo.
- Think about what kind of fictional archetype beyond occupation that your animal would be suited for. Perhaps they display a kind of behavior in the animal world that you can show by means of the narrative role they'll fill. Are they inherently comic relief or sidekick material, hero or wise old guide archetype? Perhaps if they suit an archetype too perfectly, you could spin and juxtapose another unlikely archetype for them? Example: tiny rodent hero/heroine.

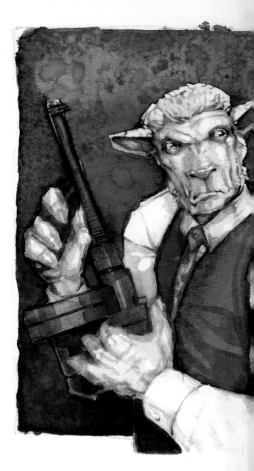

PERIOD HUMANOID CHALLENGE: GANGSTER SHEEP
- Pick two to three words from the Humanoid Game at the end of this chapter.
- Roll for an influential time period.
- Pick an occupation for your character.

The unshearables! Here I've rolled 1 Sheep + 9 1930s and picked Gangster/Thug. I initially picked gangster as my humanoid's occupation, thinking it's so very opposite of a sheepish personality. Then, after looking up 1930s gangsters for a "tommygun," a classic image of Robert Stack from *The Untouchables* appeared, which was perfect for my 1930s sheepy gangster humanoid.

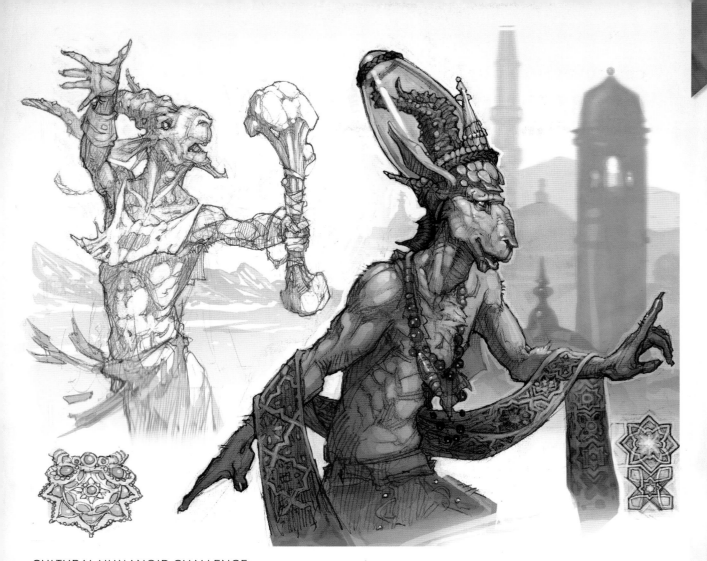

CULTURAL HUMANOID CHALLENGE: CLERICAL RAM

- Pick two to three words from the Humanoid Game at the end of this chapter.
- Roll for a cultural style to influence your character.

Here I've rolled 5 Ram + 9 Broccoli + 2 Middle Eastern culture. The combo conjured both a broccoli-like baton used in a desert sport and ram horns that look like broccoli stalks. After looking at some Moroccan patterns and headdresses of Turkish imams, my humanoid became a kindly poor cleric, teaching parables in the streets.

PERIOD HUMANOID CHALLENGE: BOP SLOTH

Break the rules. If the word associations just aren't hitting the mark for you, switch either period or cultural challenge so you pick the animal or plant or inanimate object to create your humanoid from. I sketched this character continuity sheet from a sloth (not on the *Fantasy Genesis* lists), a 1950–1960 time period roll, and my occupation choice of Jazz Musician.

Remember the aim for these challenges is to bring more exploration of time period and culture to our characters, and just about anything could make a good humanoid.

PERIOD HUMANOID CHALLENGE: TERRAPINA

Before I started this period challenge, I knew I really wanted to sketch a tough female character. So after picking the words Turtle/Telephone, along with 18 Future Millennium time period, there were enough wig bubbles popping for me to simply forgo the occupation.

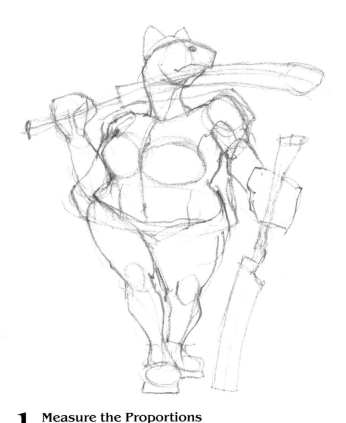
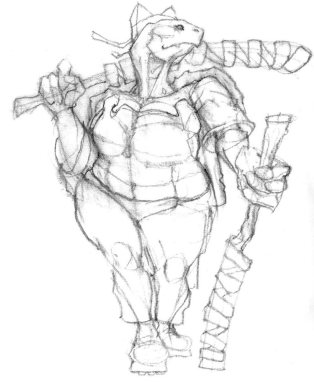

1 Measure the Proportions

There are plenty of smooth lines in most aquatic animals, making aquatic female humanoids a bit easier to draw. Begin by measuring and lightly sketching the proportions of Terrapina's pose: beak and neck, shoulder line and chest, wider hips and legs. Sketch in the curving centerline and basic shapes of her clubs, which will become the telephone connotation.

2 Sketch the Features

Sketch more details into Terrapina's costume by lightly sketching in her leather boots and kat hat, the ellipses of her cuffs, splitting her top into plating like that of a turtle. Then concentrate on the details of the face, including a more human-sized eye surrounded with darker eyelashes and a high cheekbone. Notice how the ends of her clubs have turned branchlike and are starting to look like telephone cord wires.

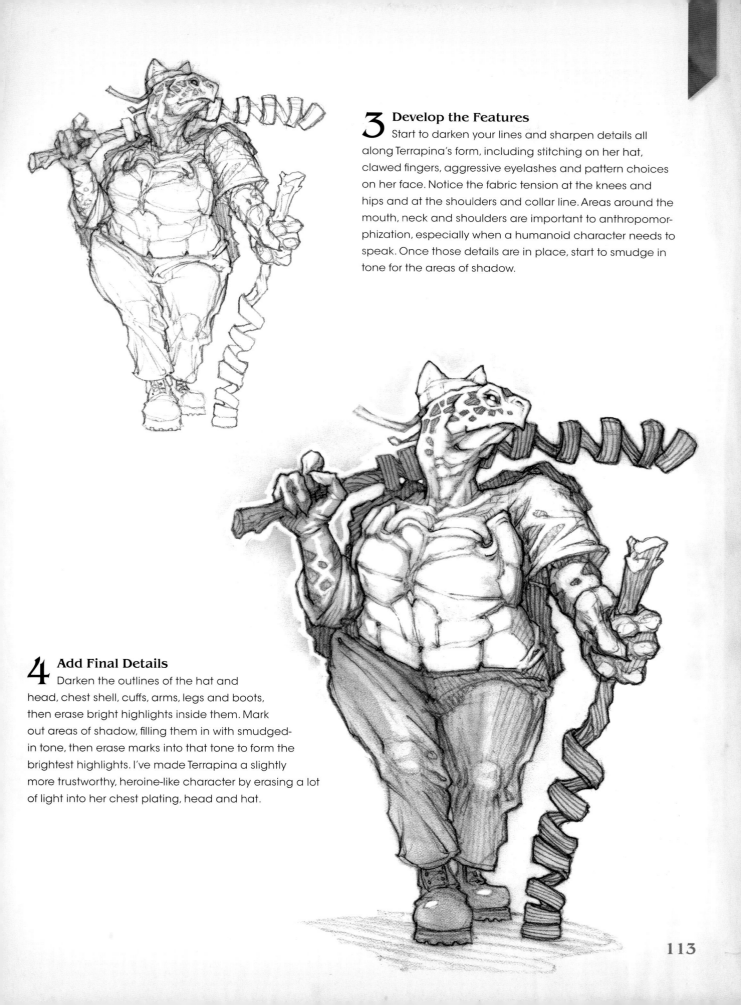

3 Develop the Features

Start to darken your lines and sharpen details all along Terrapina's form, including stitching on her hat, clawed fingers, aggressive eyelashes and pattern choices on her face. Notice the fabric tension at the knees and hips and at the shoulders and collar line. Areas around the mouth, neck and shoulders are important to anthropomorphization, especially when a humanoid character needs to speak. Once those details are in place, start to smudge in tone for the areas of shadow.

4 Add Final Details

Darken the outlines of the hat and head, chest shell, cuffs, arms, legs and boots, then erase bright highlights inside them. Mark out areas of shadow, filling them in with smudged-in tone, then erase marks into that tone to form the brightest highlights. I've made Terrapina a slightly more trustworthy, heroine-like character by erasing a lot of light into her chest plating, head and hat.

CULTURAL HUMANOID CHALLENGE: STRONGLION

Instead of picking two words to associate with on this Cultural Humanoid Challenge, I simply picked 5 Feline - Wildcat, and rolled two cultural styles to mix: 15 Korean and 13 French. Then after picking Big Top Circus Performer for this humanoid's occupation, a Nouveau-styled lion strongman became clearer and clearer. Since the Art Nouveau period was essentially the result of wonderful cultural mixing across Europe and France because of trade from all over the East, I couldn't help but think Nouveau would be a perfect mix.

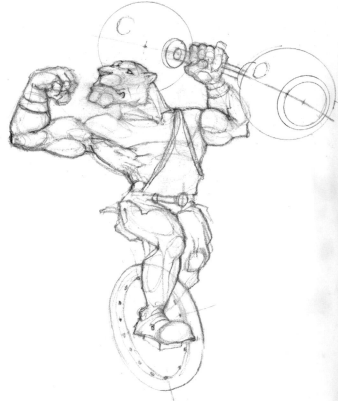

1 Measure the Proportions

Begin by measuring proportions and lightly sketching the shapes of his pose: fists and arms, facial features, torso, legs and the ellipse for his unicycle. Notice how the jawline is a bit larger, and the cranium and ear are smaller.

2 Sketch the Features

Lightly sketch more details into his facial features and anatomy. Then concentrate on the details of his barbell and unicycle. Following the slightly bent centerline of the barbell, lightly draw in the circles and ellipses. Give the unicycle more of a rim by creating two ellipses of the same size right next to each other. Draw these circles and ellipses either by hand, marking out their coordinates, or by using a compass and ellipse template.

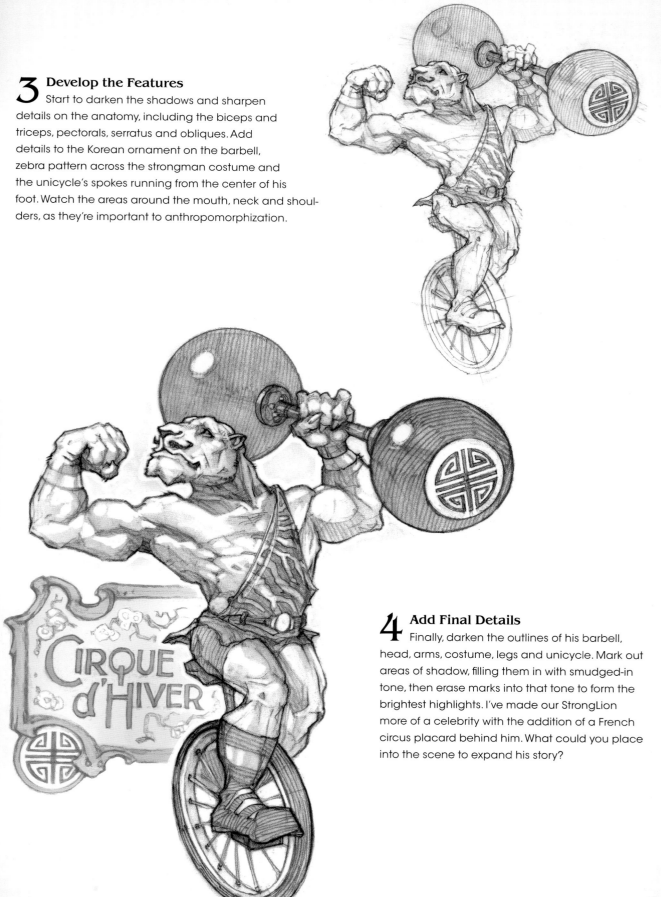

3 Develop the Features

Start to darken the shadows and sharpen details on the anatomy, including the biceps and triceps, pectorals, serratus and obliques. Add details to the Korean ornament on the barbell, zebra pattern across the strongman costume and the unicycle's spokes running from the center of his foot. Watch the areas around the mouth, neck and shoulders, as they're important to anthropomorphization.

4 Add Final Details

Finally, darken the outlines of his barbell, head, arms, costume, legs and unicycle. Mark out areas of shadow, filling them in with smudged-in tone, then erase marks into that tone to form the brightest highlights. I've made our StrongLion more of a celebrity with the addition of a French circus placard behind him. What could you place into the scene to expand his story?

THE FIVE Rs

There's no system to creativity, and no way to force the imagination, but there are ways to change and expand the ways we think! This group of five tools—Removal, Ratio, Repetition, Replacement and Rotation—are among my most simple and effective ways of answering visual problems.

Half the obstacle in creating anything new and unique is looking at the same old things in different ways: tearing down our old metaphors and their functions, then building them back up with slightly unexpected changes. Whether we're working in the context of world building, creature and humanoid conceptualizing, or even editorial ideation and symbolism, each of these five modes of thinking can be helpful in the creation of something completely new and unique!

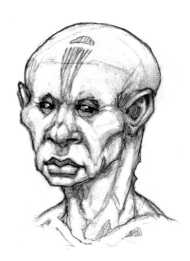

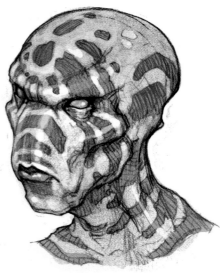

REMOVAL

What could I take away that the audience will be looking for? You could remove a part or portion from a face or a body shape, an object, or a whole scene in your character's story. Some of the best narrative "reveals" are based on hiding or removing something very simple before we realize it's been removed.

In terms of creature humanoids, removing parts of the face can sometimes make for smoother, more aquatic or exoskeletal creatures. Removal can also produce odd-numbered limbs or sense organs (e.g., Cyclops).

Notice how the removal of the jawline and brow line throw off the perception of the other facial proportions. Consider incising through a part, or think about how parts might appear truncated or completely invisible, like this virtual archer's limbs.

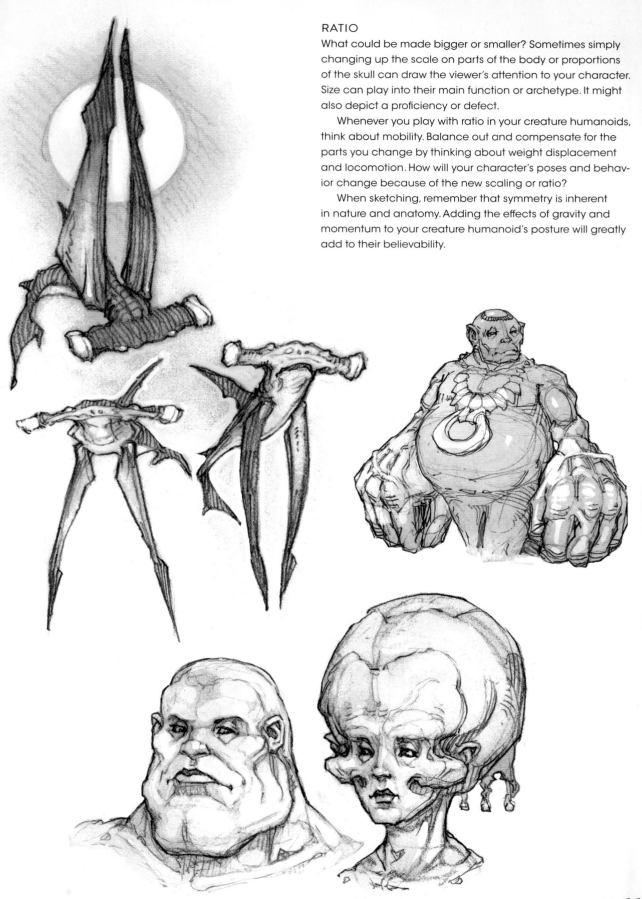

RATIO

What could be made bigger or smaller? Sometimes simply changing up the scale on parts of the body or proportions of the skull can draw the viewer's attention to your character. Size can play into their main function or archetype. It might also depict a proficiency or defect.

Whenever you play with ratio in your creature humanoids, think about mobility. Balance out and compensate for the parts you change by thinking about weight displacement and locomotion. How will your character's poses and behavior change because of the new scaling or ratio?

When sketching, remember that symmetry is inherent in nature and anatomy. Adding the effects of gravity and momentum to your creature humanoid's posture will greatly add to their believability.

REPETITION

What could I repeat and how could I repeat it? In many ways, repetition is the opposite of removal. In terms of creature humanoids, my thoughts shift to picking parts of the body form, determining how they function, then determining how I can multiply that function, and placing those parts along the natural pathways of pattern (discussed earlier in this chapter).

Genetic redundancy can come into play in how ancient or pre-historic your creature humanoid will look, as can mutation, symmetry and asymmetry. Do odd- or even-numbered limbs and organs make a little bit more or less sense for your creature/humanoid? Repetition can go rather insectile if you're looking for those qualities as well.

REPETITION OVERKILL

It's important to understand that there will eventually be a point of overkill to repetition. Remember, the more parts you repeat, the smaller and more difficult it is to draw them.

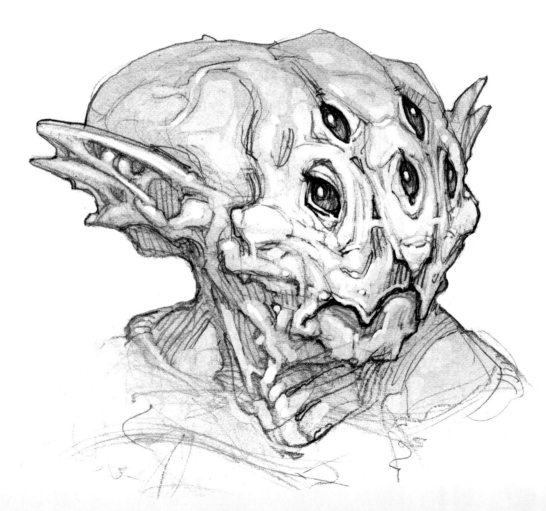

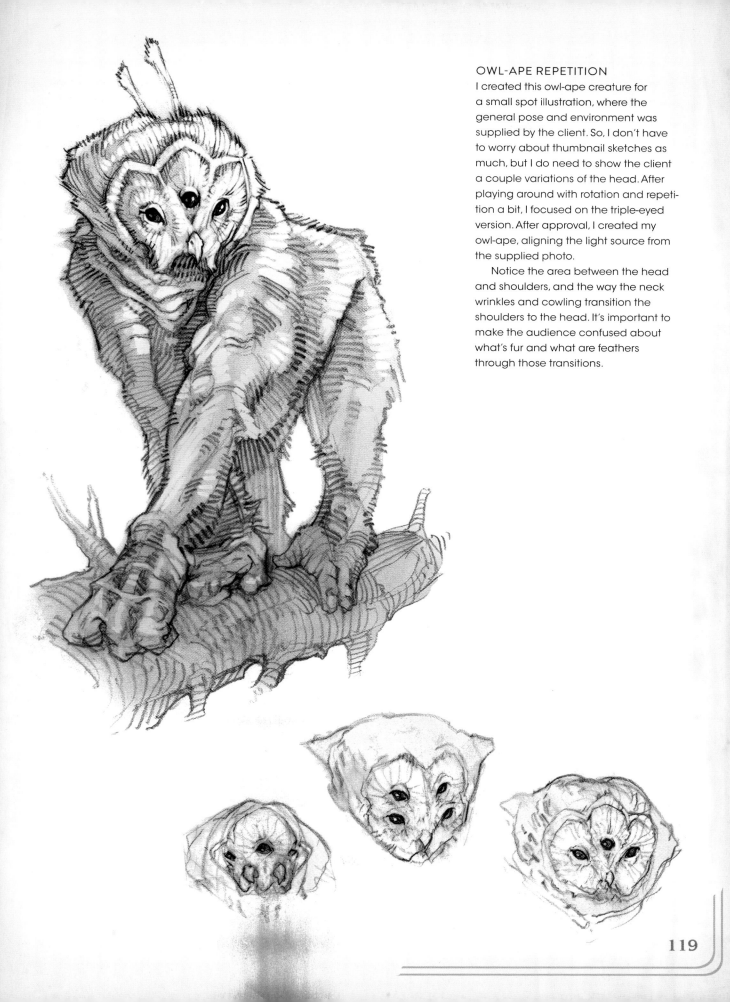

OWL-APE REPETITION

I created this owl-ape creature for a small spot illustration, where the general pose and environment was supplied by the client. So, I don't have to worry about thumbnail sketches as much, but I do need to show the client a couple variations of the head. After playing around with rotation and repetition a bit, I focused on the triple-eyed version. After approval, I created my owl-ape, aligning the light source from the supplied photo.

Notice the area between the head and shoulders, and the way the neck wrinkles and cowling transition the shoulders to the head. It's important to make the audience confused about what's fur and what are feathers through those transitions.

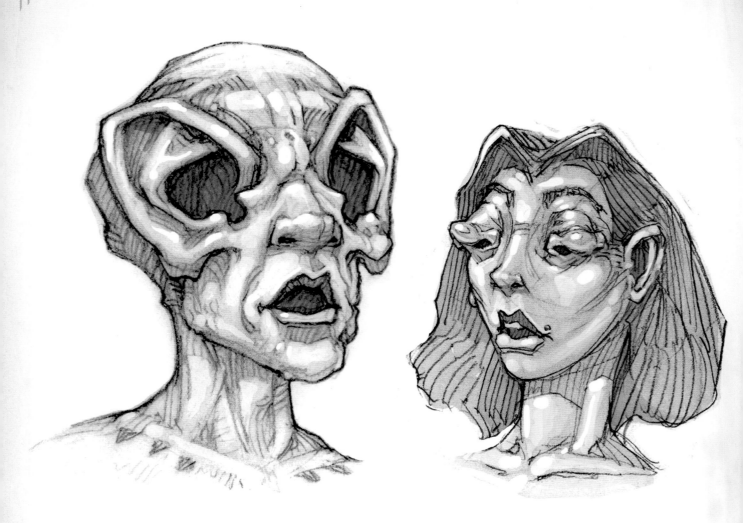

REPLACEMENT

What could I switch with what? Parts replacement, like simple head replacement is to anthropomorphism, can be one of the most effective ways to conceptualize creature humanoids. It works brilliantly for horror when an alien sense organ is needed and can be inherently weird, creepy and horrible. If done with control and limitation, one might churn up a character as memorable as Guillermo del Toro's Pale Man from *Pan's Labyrinth*.

The more photorealistic you make your creature humanoid, the more creepy and nightmarish replacement can be. You needn't be limited to facial features. Contemplate the whole body, its parts and functions. For example, you have a distinctly reptilian humanoid, but choose to replace its spine and tail with that of a furry ring-tailed lemur. Or you may want to concentrate on replacing parts with similar functions, e.g., replacing a bird's feathered wings with aquatic fins or insectile wings.

Once the audience recognizes what you've replaced and how, it will force their attention. It's also important to think about the surrounding anatomy and how you transition one part to the next. What will your new part replacement need to look believable? Will you use animal or human anatomy?

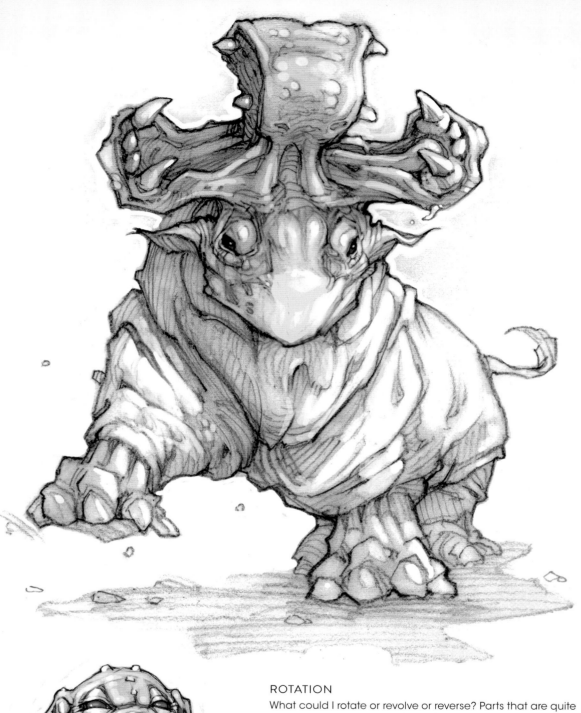

ROTATION

What could I rotate or revolve or reverse? Parts that are quite familiar in both function and location can look slightly unfamiliar by rotating or flipping them.

Here I've rotated the jaws of a hippo to form the basis of this creature concept. Reversal can also be used to indicate backward behavior in your character's pose and posture, as can pattern. It's also worth mentioning that most symbols you rotate upside down can be seen as meaning the opposite of that symbol.

Notice the humanoid's lips and ears, then think of how its ears would look rotated facing forward, like insect antennae or ram's horns.

CHARACTER BRIEF CHALLENGE

This challenge is a spot illustration containing two creature charac-
ters to be designed for a scene quite like the umbrella scene from
Hayao Miyazaki's *My Neighbor Totoro*. There's a giant ogre care-
giver archetype in armor and his sidekick pet snail.

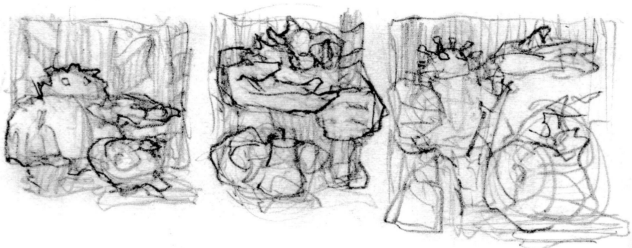

THUMBNAILS

I've come up with the pet snail's concepts in a previous
illustration, using both candle/eyestalk/wick replace-
ment and aquatic flipper repetition, but I still need a
scene where they're interacting. Thinking about the care-
giver ogre protecting his pet's flaming eyes, I sketched
these tiny thumbnails.

THINK SMALL

Keeping your initial sketches small can force your design and framing into basic easy-
to-read shapes. Small thumbnails can also keep the concept or idea simple, so you're
not trying to say too much with one scene.

A tree idea came up through a Fantasy Genesis combo (Drill/Tree), so I added it to
the background. I thought about the ratio of the ogre's body and how he will guard his
pet from the rain with his hands. How big is too big? Will the ogre be a horned ogre?
Will the function of those horns be replaced with repeated matchsticks or some other
symbol or device that springs from the context of fire and candles?

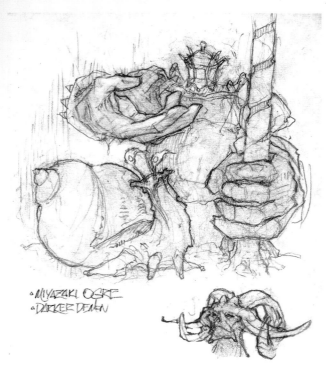

1 Develop the Thumbnail Ideas

The client asked for development on the middle thumbnail, paring down the ogre head options to one with horns, and deciding the lantern idea works better than the matchsticks. Sketching out those major shapes with more detail, I created a couple variations using rotation of horns and removal of neck to suspend the ogre's lantern head. Which direction could I rotate the horns to make them look unique?

How much of the collar and chest armor should be removed? Perhaps that was a good time to add one of those "Drill/Trees" from before?

2 Continue Developing in Photoshop

After the lantern-headed rough sketch was approved, I started cutting and pasting with Photoshop. Changing the size and shapes of body parts and forms, I gave a bit more room for the protection from the rain aspect of the content to live. I also added a bit of tone to work out what will appear light on dark and dark on light, and what will be given the highest amount of contrast.

3 Redraw the Final Sketch

I finalized the sketch by printing out the rough sketch changed in Photoshop. Then, using the semi-transparent quality of Graphics 360 marker paper, I re-drew a final sketch with all aspects of content and design worked out, paying more attention to the details of each character. Some folks ideate and concept with nonphoto blue pencil, then ink this final stage. Others may simply paint on top of their initial sketch or sketch completely digitally. Now the scene is ready for paint!

CREATURES AMONG US
SUPER-MINI CHALLENGE

This challenge will have your audience momentarily confused by the size of your world and the characters within it. It will also help you develop more control of your visual timing. This is the time it takes the audience to notice any extra content you've placed in your work or to understand the twist you've given your character. It is a strong skill to develop and suggests control over comedic or dramatic tension as well.

Among my very favorite characters are Terry Pratchett's Nac Mac Feegles. We love them for their unyielding strength and their brilliant accents and antics, but another part of their memorability lies in their wee stature and size. Pushing that size or scale is what this challenge is all about.

VISUAL CONTEXT FOR UNUSUAL-SIZED CHARACTERS

The Super-Mini Challenge is based on making a character appear either gigantic or very tiny by placing them in that visual context. Here you see three examples of this, achieving two tiny lilliputian characters and a giant character.

ATTACK OF THE FIFTY-FOOT BADGER

Developing these scenes can be quite easy: simply pay attention to what you place in front of your character and what you place behind them. Make a smaller animal such as a badger look giant by placing a building, mountain or even a planet in front of him. Or make that same badger tiny by placing a coin or bottle cap in front of him.

Everything around the two soldiers changes size as soon as we see the soldiers' visual context next to the jaybird. Placing the tiny Amazonian warrior character next to his stag beetle provides similar visual context. You don't have to show full body poses in every scene, as more detail can be had by framing what's both big and small right next to each other.

HIGH CONTRAST & BLURRED MARKS

CONTRAST & BLURRED MARKS

You can give your work greater depth of field and control your visual timing with the help of contrast and blurring. Our eye and brain connection forces us to focus in on contrast and motion.

Our perception is in fact "hardwired" to read areas of high contrast and detail in an almost autonomic response. It's the reason why tilt-shifting a photo will add focus to the subject, and why 1940s film noir remains popular—because our brains can't help but react and never tire of it.

Whatever areas we give high contrast will be seen first by our audience. Conversely, whatever areas we make low contrast and blurry or smudged will look as though they're farther in the background and, more importantly, perceived last. It's quite a powerful tool once you start to use it in your work. You can systematically force your audience's attention through your work and have almost complete control over your visual timing!

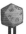

SUBTLE SCALE CHANGE

Once you've tackled a scene with obvious change in scale, try creating a scene with more subtle visual context. Imagine an action or day-to-day process, something a bit more personal, then replace an integral part of that process with a similarly shaped object. For example, a character sewing a button or playing checkers, then replace the button or checkers with something big and similarly circular, such as a hubcap, water drain or truck tire. When you finish your Super-Mini, ask others how long it takes before they see the twist in size you've created, and keep working toward better control of your visual timing!

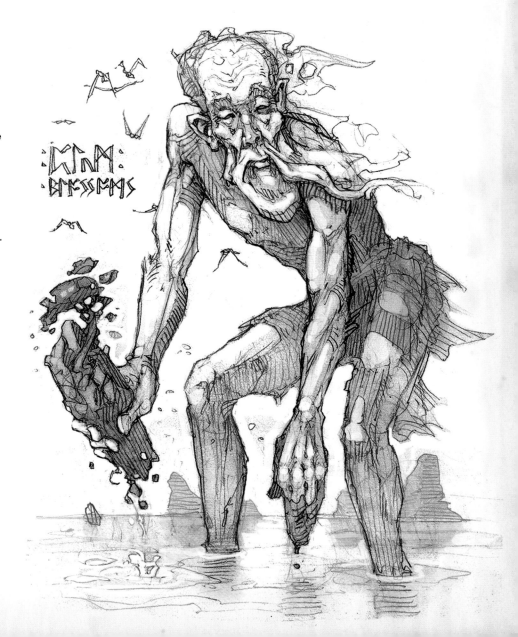

ALLITERATION CHALLENGE

This challenge will give your audience an idea of your tastes and humor, how you might follow a brief, or ideate visually and literally. Alliteration is a stylistic writing technique in which you create flourishes with words of the same first consonant sounds.

Simple two word alliterations can produce some of the most memorable titles, brands and names. Alliterative names can rank quite remarkably as they roll off our tongues, e.g.,

Peter Pan, Bugs Bunny, Willy Wonka and Severus Snape. Corresponding combos of alliteration can also be tricky tasks that tangle and twist our tongues, but, presented properly, will prove predictably perfect to even the pickiest people.

· Write an alliterative sentence.
· Look up photo reference.
· Design your scene.
· Sketch it out.

Sixties Sally Swings several Super Slick 78s

TERRIFIC TIPS

Don't forget to bring a thesaurus to the party! It helps to limit yourself to two characters in order to get enough detail to describe them, but also try to extend the story by creating visual elements that aren't seen in the words themselves. Most importantly, have fun. If writing just isn't your bag, here are a few alliterative ideas to explore:

· Behold the blundering beluga bandits, blissfully blasting blueberry bazookas.
· Clever Clarence carefully carves cauliflower for Count Clifford's curry.
· Given Guadalajaran gains, ginger giraffes gamble gobs on golfing goblins.
· Many mischievous measures may musical miracles make.
· Sixties Sally swings several super slick seventy-eights.
· Mighty Michael moves mountainous mixtures of magical malts.
· Terry's tele takes ten tenacious tubes to transmit.
· Well, we wonder where way-out Wanda's wig wanders.

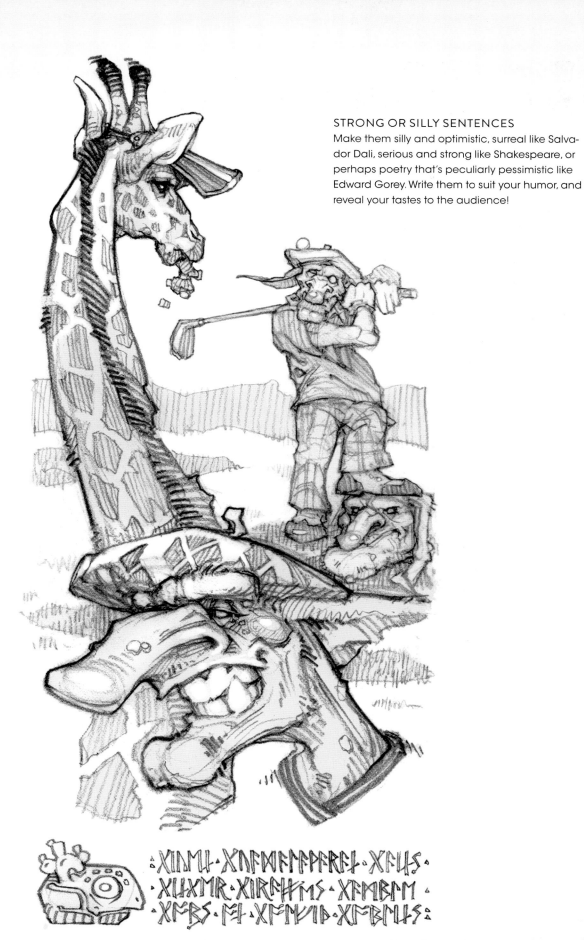

STRONG OR SILLY SENTENCES
Make them silly and optimistic, surreal like Salvador Dali, serious and strong like Shakespeare, or perhaps poetry that's peculiarly pessimistic like Edward Gorey. Write them to suit your humor, and reveal your tastes to the audience!

FANTASY GENESIS HUMANOID GAME

This is the game made popular by my first book, *Fantasy Genesis*. Like the Surrealist games, it's based on what kind of ideas can develop from the magic of word association. A roll of Whale and Crater could bring your creation a series of crater-blowholes on its back. Or chainlike tentacles might wriggle from the legs of a humanoid based on the rolls of Octopus and Chain.

Test the limits of our human anatomy, replacing body parts and forming new hybrid surface textures and patterns. You may conceptualize something never seen before!

- Roll four words for Anima.
- Roll two words for Veggie, Elemental and Techne (six in all).
- Pick two or three of the ten words until a fun humanoid idea appears in your mind.

VEGGIE SET
1d4

1
PLANT: 2d6

2. Seaweed
3. Fern
4. Desert Cacti
5. Thick Leaf - Jade
6. Flower - Domestic
7. Vine
8. Poppy
9. Bamboo
10. Tall Grass
11. Flower - Wild
12. Carnivorous

2
FRUIT & VEGETABLE: 2d6

2. Artichoke
3. Pinecones
4. Berries and Grapes
5. Ginger
6. Tree Fruit - Apple, etc.
7. Bean
8. Pumpkin - Gourd
9. Broccoli - Greens
10. Corn
11. Grain - Wheat
12. Pineapple

3
FUNGI: 1d4

1. Moss
2. Ooze - Jelly
3. Lichen
4. Mushroom

4
TREE: 1d6

1. Willow
2. Birch
3. Maple - Oak
4. Banyan
5. Pine
6. Palm

ELEMENTAL - MINERAL SET
1d4

1
FIRE & ELECTRIC: 1d4

1. Fire Vapor
2. Electric Bolt
3. Ember Hot Coal
4. Molten Lava

2
LIQUID: 1d8

1. Icicles
2. Fog - Vapor
3. Wave
4. Dew Drops
5. Ripple
6. Frost - Snow
7. Suds - Bubbles
8. Tar - Gum

3
EARTH & METAL: 2d6

2. Malachite
3. Mt. - Cliff Face
4. Brick - Cobblestone
5. Rust - Oxide
6. Cracked Clay
7. Stalactite-mite
8. Glass - Crystals
9. Powder - Sand
10. Slate - Shale
11. Cement - Sediment
12. Mercury - Chrome

4
ASTRAL & ATMOSPHERIC: 2d4

2. Star Field
3. Crater - Asteroid
4. Solar Flare
5. Galaxy Form
6. Cloud - Volcano
7. Planets - Saturn's Rings
8. Cloud - Cyclone

TECHNE SET
1d6

1
TRANSPORTATION: 1d8
1. Car - Truck - Bus
2. Aircraft
3. Rail Train - Trolley
4. Cycle
5. Sled - Ski
6. Boat - Ship
7. Spacecraft
8. Tank Tread

2
ARCHITECTURE: 1d8
1. Ornament - Gargoyle
2. Bridge - Framework
3. Castle - Domed
4. Ornament - Pillar
5. Modern Skyscraper
6. Alter - Window - Totem
7. Doorway - Archway
8. Old Village - Cottage

3
TOOLS 1: 2d6
2. Drill
3. Knob - Door
4. Umbrella
5. Bundle - Bail
6. Hammer
7. Brush - Hair - Tooth
8. Razor - Knife
9. Spigot
10. Rope
11. Nails
12. Lock - Key

4
MACHINE 1: 1d6
1. Switch - Dial - Button
2. Turbine - Prop
3. Lightbulb - Lamp
4. Clock - Gears
5. Pump - Bellows
6. Powered Saw

5
TOOLS 2: 2d6
2. Bandage
3. Shovel - Pick
4. Capsule - Tablet
5. Nuts - Bolts
6. Chain
7. Thread - Stitch
8. Shear - Scissors
9. Pen - Brush
10. Spring - Coil
11. Syringe
12. Tube - Plumbing

6
MACHINE 2: 1d8
1. Reactor Core
2. Telephone
4. Engine
5. Laser Beam
6. Computer - IC
7. Dish Antenna
8. Rocket

ANIMA SET
1d6

1
SEALIFE: 2d6
2. Urchin - Shelled
3. Crab - Lobster
4. Squid - Octopus
5. Fish - Deep Sea
6. Jellyfish - Starfish
7. Fish - Tropical
8. Whale - Dolphin
9. Turtle - Salamander
10. Nudibranch - Leach
11. Coral - Anemone
12. Shark - Ray - Eel

2
INSECT: 2d6
2. Worm
3. Ant
4. Mosquito
5. Moth - Butterfly
6. Fly - Dragonfly
7. Locust - Mantis
8. Bee - Wasp
9. Caterpillar
10. Beetle - Scarab
11. Flea - Mite
12. Spider

3
MAMMAL 1: 1d6
1. Sheep - Cow
2. Mouse - Rabbit
3. Pig - Boar
4. Deer - Pronghorn
5. Ram - Bull - Buck
6. Elephant - Giraffe

4
REPTILE: 1d4
1. Gator - Gila
2. Frog - Newt
3. Lizard - Snake
4. Turtle

5
BIRD: 1d6
1. Wild Fowl - Duck
2. Farm Fowl - Rooster
3. Seabird - Penguin
4. City - Raven - Sparrow
5. Tropical - Stork - Heron
6. Bird of Prey - Hawk

6
MAMMAL 2: 1d6
1. Bat
2. Bear
3. Lupine - Wild Dog
4. Horse - Zebra
5. Feline - Wildcat
6. Primate

ANATOMY CRASH COURSE

The study of the human form and physical anatomy is a lifelong pursuit. Along my own journey I've accumulated these notes from a variety of different sources, écorché and life drawing. It is by no means a complete guide but will hopefully help you with some of those obscure poses and views of the muscle groups you might not always see.

Begin a figure by identifying the major movements, direction and flow. Pay attention to your figure's balance, placement of weight, and the lines between hips and shoulders. This juxtaposition of shoulders and hips is called "contrapposto." Using this technique of staggering the hips and shoulder lines can effortlessly focus the viewer's attention through the figure and make your characters more dynamic.

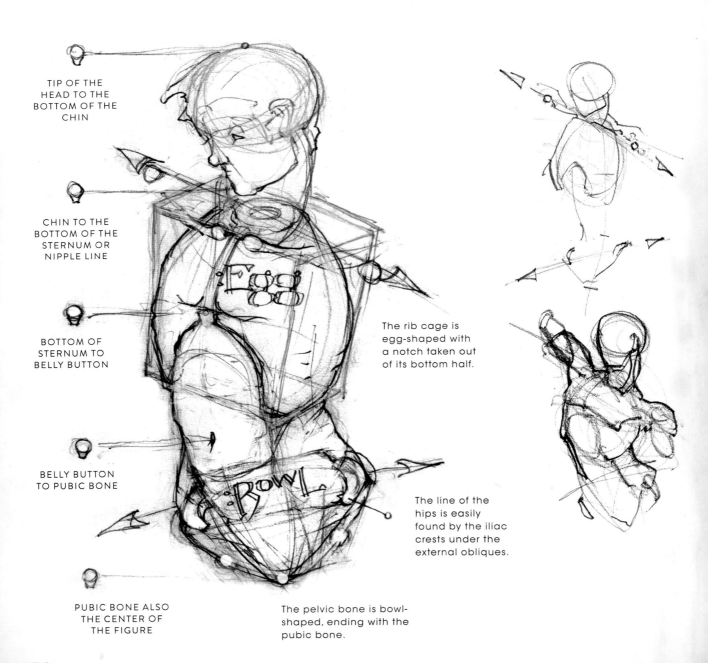

TIP OF THE HEAD TO THE BOTTOM OF THE CHIN

CHIN TO THE BOTTOM OF THE STERNUM OR NIPPLE LINE

BOTTOM OF STERNUM TO BELLY BUTTON

BELLY BUTTON TO PUBIC BONE

PUBIC BONE ALSO THE CENTER OF THE FIGURE

The rib cage is egg-shaped with a notch taken out of its bottom half.

The line of the hips is easily found by the iliac crests under the external obliques.

The pelvic bone is bowl-shaped, ending with the pubic bone.

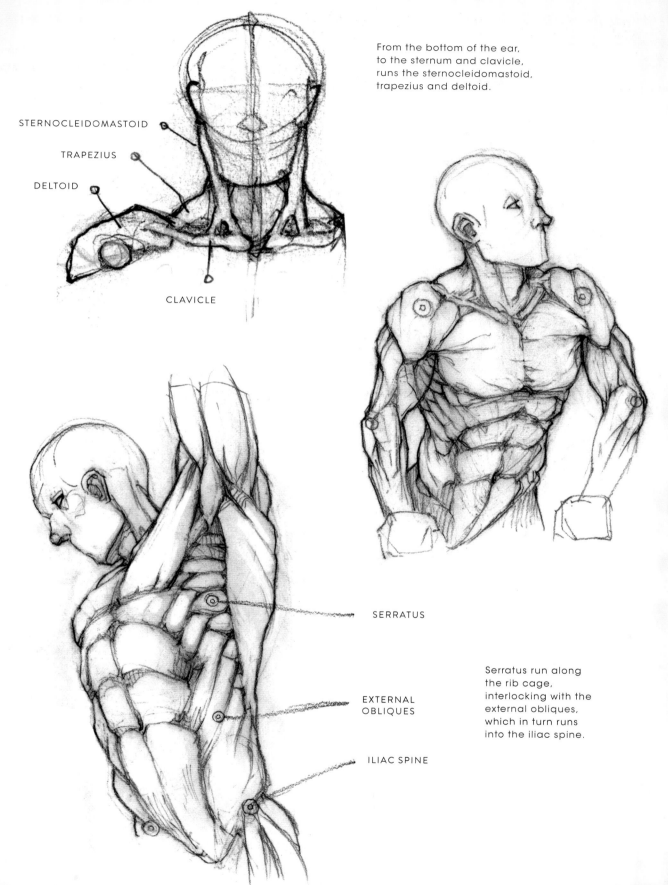

From the bottom of the ear,
to the sternum and clavicle,
runs the sternocleidomastoid,
trapezius and deltoid.

STERNOCLEIDOMASTOID

TRAPEZIUS

DELTOID

CLAVICLE

SERRATUS

EXTERNAL
OBLIQUES

ILIAC SPINE

Serratus run along
the rib cage,
interlocking with the
external obliques,
which in turn runs
into the iliac spine.

131

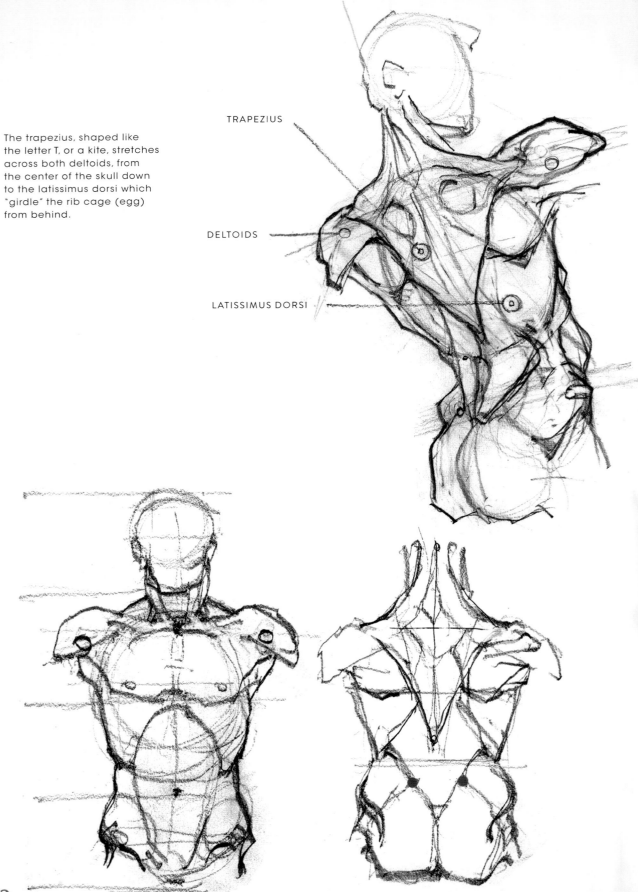

The trapezius, shaped like the letter T, or a kite, stretches across both deltoids, from the center of the skull down to the latissimus dorsi which "girdle" the rib cage (egg) from behind.

TRAPEZIUS

DELTOIDS

LATISSIMUS DORSI

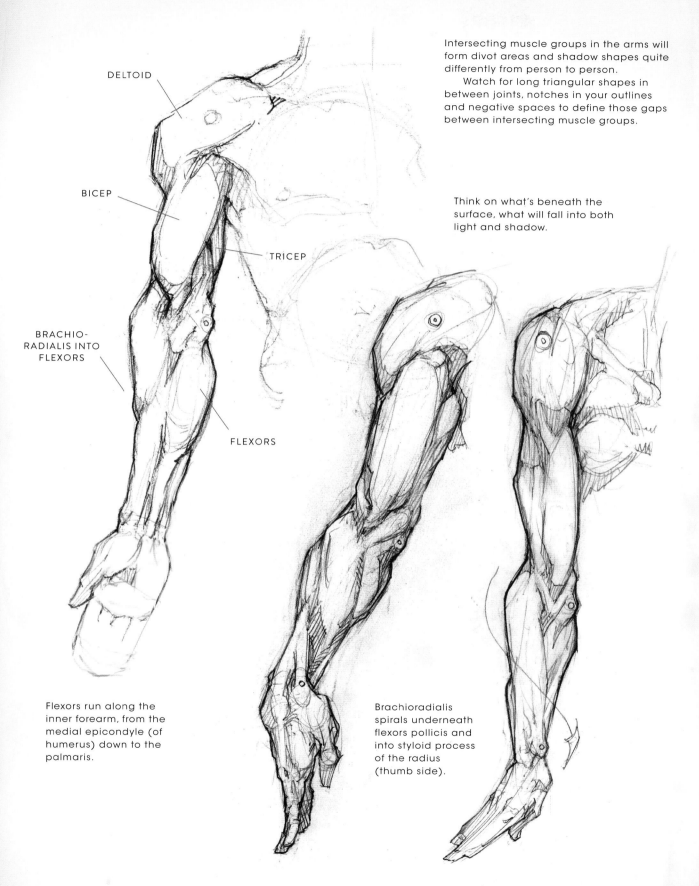

DELTOID

BICEP

TRICEP

BRACHIO-
RADIALIS INTO
FLEXORS

FLEXORS

Intersecting muscle groups in the arms will form divot areas and shadow shapes quite differently from person to person.

Watch for long triangular shapes in between joints, notches in your outlines and negative spaces to define those gaps between intersecting muscle groups.

Think on what's beneath the surface, what will fall into both light and shadow.

Flexors run along the inner forearm, from the medial epicondyle (of humerus) down to the palmaris.

Brachioradialis spirals underneath flexors pollicis and into styloid process of the radius (thumb side).

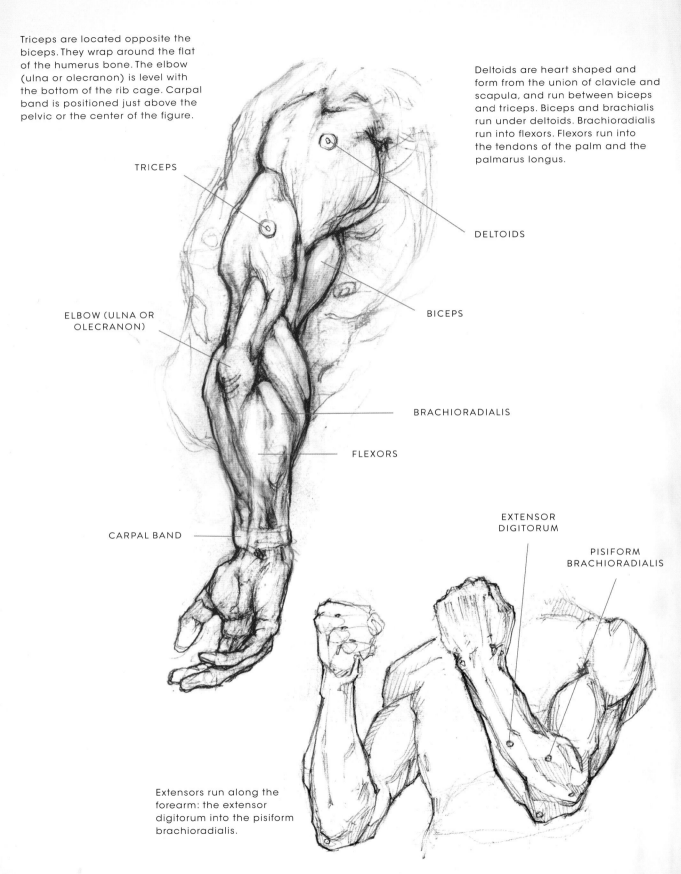

Triceps are located opposite the biceps. They wrap around the flat of the humerus bone. The elbow (ulna or olecranon) is level with the bottom of the rib cage. Carpal band is positioned just above the pelvic or the center of the figure.

Deltoids are heart shaped and form from the union of clavicle and scapula, and run between biceps and triceps. Biceps and brachialis run under deltoids. Brachioradialis run into flexors. Flexors run into the tendons of the palm and the palmarus longus.

TRICEPS

DELTOIDS

ELBOW (ULNA OR OLECRANON)

BICEPS

BRACHIORADIALIS

FLEXORS

CARPAL BAND

EXTENSOR DIGITORUM

PISIFORM BRACHIORADIALIS

Extensors run along the forearm: the extensor digitorum into the pisiform brachioradialis.

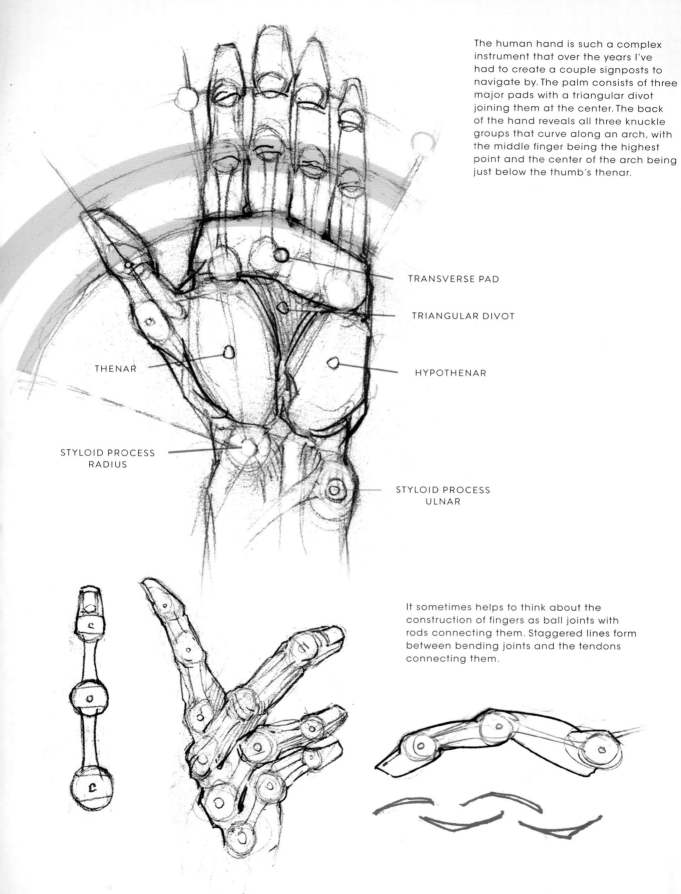

The human hand is such a complex instrument that over the years I've had to create a couple signposts to navigate by. The palm consists of three major pads with a triangular divot joining them at the center. The back of the hand reveals all three knuckle groups that curve along an arch, with the middle finger being the highest point and the center of the arch being just below the thumb's thenar.

TRANSVERSE PAD

TRIANGULAR DIVOT

HYPOTHENAR

THENAR

STYLOID PROCESS
RADIUS

STYLOID PROCESS
ULNAR

It sometimes helps to think about the construction of fingers as ball joints with rods connecting them. Staggered lines form between bending joints and the tendons connecting them.

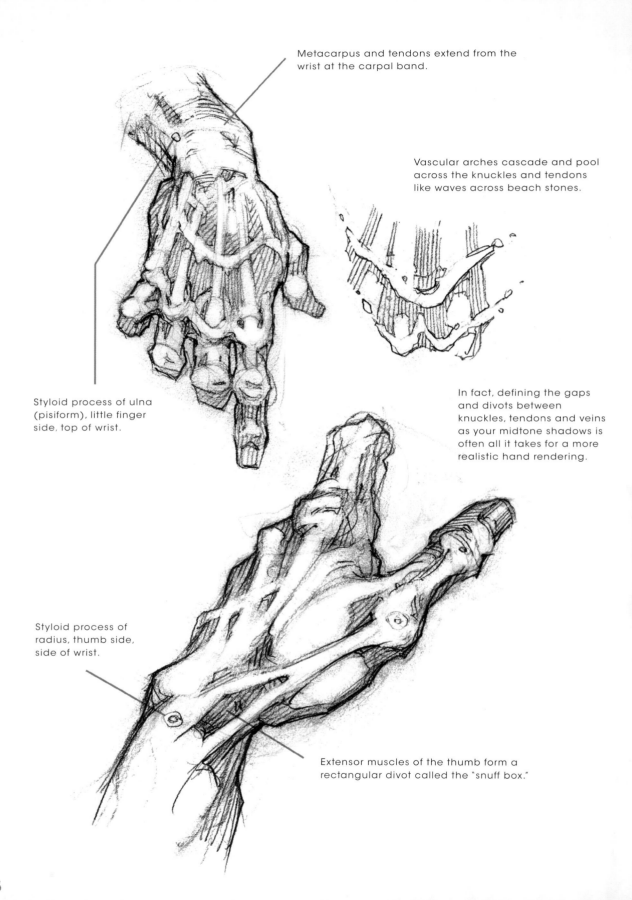

Metacarpus and tendons extend from the wrist at the carpal band.

Vascular arches cascade and pool across the knuckles and tendons like waves across beach stones.

Styloid process of ulna (pisiform), little finger side, top of wrist.

In fact, defining the gaps and divots between knuckles, tendons and veins as your midtone shadows is often all it takes for a more realistic hand rendering.

Styloid process of radius, thumb side, side of wrist.

Extensor muscles of the thumb form a rectangular divot called the "snuff box."

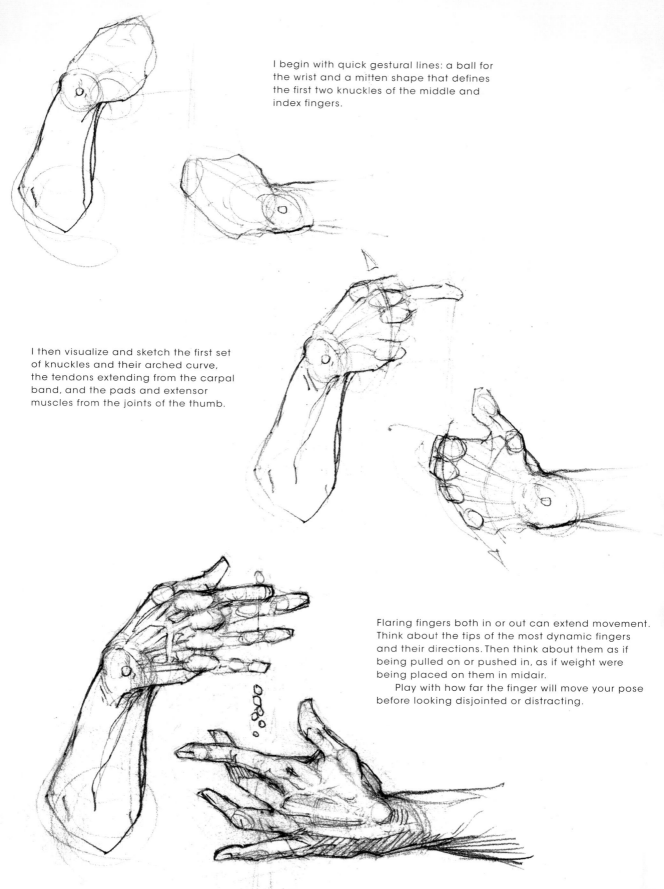

I begin with quick gestural lines: a ball for the wrist and a mitten shape that defines the first two knuckles of the middle and index fingers.

I then visualize and sketch the first set of knuckles and their arched curve, the tendons extending from the carpal band, and the pads and extensor muscles from the joints of the thumb.

Flaring fingers both in or out can extend movement. Think about the tips of the most dynamic fingers and their directions. Then think about them as if being pulled on or pushed in, as if weight were being placed on them in midair.

Play with how far the finger will move your pose before looking disjointed or distracting.

BODY TEMPLATES

Dummies, paper dolls or body templates are useful when you simply need a repeated body form to test a series of costume variations. It's best to draw your own body templates and create poses that suit your character more precisely, but here are a couple that might give you a good starting point.

If you copy these templates, you can use a light table to sketch through for the precise proportions, or simply use a large sheet of Graphics 360 marker paper or tracing paper to develop your costumes straight from the book.

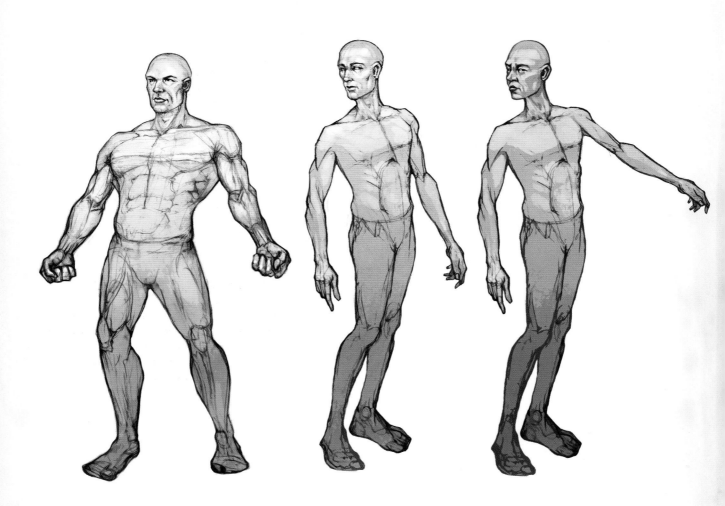

MALE TEMPLATES
I keep a couple templates around for several different male body types. Here are my templates for both an athletically built character and two tall and lankly built characters.

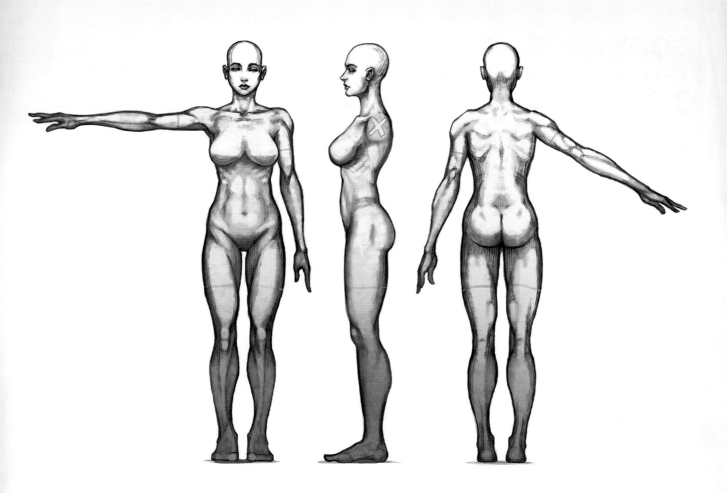

ORTHOGRAPHIC TEMPLATE

This is an orthographic or turn-around template. As with the other templates, pose doesn't really make a difference, but orthographics are strictly used for measurement and technical design. Orthos are made for modelers, animators and designers to show more exacting detail from multiple angles.

FEMALE TEMPLATES

Notice these templates are made by simply flipping the character horizontally, then changing up the posing of the legs.

HALF-BAKED ADVICE TO STUDENTS

Since much of this book was created for my classes, first let me thank all of the great folks whom I've had the pleasure and opportunity to teach. We never get to our destination alone, so thank you all for becoming links in this creative chain. When I began teaching it became clear how my own skills were growing through this wondrous creative interaction. I share my skills and experience with students, but we're all in the same boat together, making mistakes and learning from them. It's made my brain forever listening for the first time, forever a "beginner's mind."

Practice awareness! Observe the world around you on as many different levels as your eye and brain connection will allow. Observe all the common gestures and micro-behaviors of people you meet during the day. The ones that are subtle and almost impossible to catch can often be the most poignant. Bringing these observations to light will show our tastes and common experiences to an audience, but also the detail at which we perceive. If we can put those details back into our characters, folks are bound to remember them. Always be aware of that initial spark of wonder that brought you to this point. Remember the dreams you had when you were a child, what brought you to realizing that you needed to be a creative.

Stay earnest! Being unreasonably excited about a potential gig can be paramount in landing it. Stay genuinely interested in following your favorite artists, reading your favorite subjects, authors and their casts of characters, observing the techniques you most want, and mimicking them until you're consistent.

Most of all, remain interested in developing your skill set! Stay positive in your outlook, and, if you can't, then turn your depression into comedy. Through everything, keep observing and keep practicing.

"I'm going to be sketching and painting whether I'm making money at it or not, so I may as well keep doing it until I do." ~**Art and Fear** *by Bayles and Orland*

You may tire of this business. It's extraordinarily easy to do. You may tire of the day gig you have to keep for years while waiting for a solid paycheck, another polite rejection letter from a juried, annual or gallery show, another collaboratory venture gone impossibly awry, the last promotional reinventing of yourself not keeping you in the game for quite as long as expected. Perhaps yet another year passes without an inkling of that magic e-mail that began the whole game. You may grow so hung up on life's funky jug of soured milk that you need to keep a group of folks around just so you can force them into verifying the obvious. I know I have. "Hey, guys, this is sour right? Oh, sorry . . . It's still bad then . . ."

All of these things have been a solid drag in practicing this brilliant craft that I'm so pig ignorantly passionate about, and I guess that's partially why I don't give up on this career path. That ignorantly stubborn and innocent passion that keeps me up at night is my best defense against the harsh realities of this business, and not letting those obstacles become insurmountable.

Good luck, keep in touch, and one day pay it forward!

Chuck Lukacs

Portland 2017

140

RESOURCES

WORKS CITED

The Artist's Complete Guide to Facial Expression, Gary Faigin, Watson-Guptill (2008)

Atlas of Human Anatomy for the Artist, Stephen Peck, Oxford Press (1982)

The Book of a Hundred Hands, George Bridgman, Dover (1971)

Bridgman's Complete Guide to Drawing From Life, George Bridgman, Outlet (1992)

Eye and Brain, Richard L. Gregory, Princeton Press (1997)

The Hero With a Thousand Faces, Joseph Campbell, Princeton Press (1972)

History of European Drama and Theatre, Erika Fischer-Lichte, Routledge (2004)

Jung and the Post-Jungians, Andrew Samuels, Routledge (1985)

On Valence and Dominance, Control Study by Alexander Todorov, APA (2010)

Peoplewatching, Desmond Morris, Vintage Books (2002, 1977)

The Skillful Huntsman, Le, Yamada, Yoon, Design Studio Press (2005)

SUGGESTED READING

Anatomy Lessons From the Great Masters, Hale and Coyle, Watson-Guptill (2000)

Animal: The Definitive Visual Guide to the World's Wildlife, DK (2001)

Animals: Real and Imagined, Terryl Whitlatch, Design Studio Press (2010)

An Atlas of Animal Anatomy for Artists, Ellenberger, Baum and Dittrich, Dover (1956)

Color and Light, James Gurney, Simon and Schuster (2010)

Comic Artist's Photo Reference series, Buddy Scalera, IMPACT Books (2006–2011)

Creative Illustration, Andrew Loomis, Viking Press (1947)

Framed Ink, Marcos Mateu Mestre, Design Studio Press (2010)

Imaginative Realism, James Gurney, Andrews McMeel (2009)

PoseFile reference series, Hartman and Kilpatrick, Antarctic Press

Science of Creature Design, Terryl Whitlach, Design Studio Press (2015)

Strength Training Anatomy, Frédéric Delavier, Human Kinetics (2010)

Virtual Pose series, Mario Henri Chakkour

WEBSITES AND BLOGS

anatomy360.info

artpact.com

artrenewal.org

bodylanguageproject.com/dictionary

bpib.com/illustra.htm

conceptart.org/go/learn

creaturebox.com

creaturespot.com

drawnanddrafted.com

drawthisdress.tumblr.com

facebook.com/pg/humansofnewyork/photos

fleskpublications.com

gurneyjourney.blogspot.com

handyarttool.com

muddycolors.blogspot.com

posemaniacs.com

sciencefriday.com

shadowcoreillustration.blogspot.com

societyillustrators.org

thesartorialist.com

PODCASTS

Escape From Illustration Island

Ninja Mountain Scrolls

One Fantastic Week

Pencil Kings

SideBar

Your Dreams My Nightmares

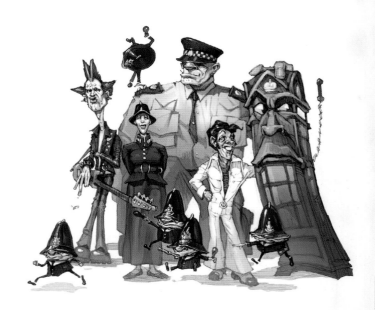

INDEX

ABOUT THE AUTHOR

Between the publishing of *Fantasy Genesis* and the book you hold, I've transplanted myself, both body and wig bubbler. Amidst the wonderful Portland pines of the Pacific Northwest and Columbia River Gorge, happily sharing this life with my beautiful healing Acupuncturist and our series of weirdo felines, whom I love quite fiercely. My interests have grown further toward teaching, working for film, for progressive sustainable ecology and alternative resources, charitable philanthropy for victims of domestic violence, and the occasional music composition or kite flight. Visit me at my website, chuck-lukacs.com.

Other fine IMPACT Books are available from your favorite bookstore, art supply store or online supplier. Visit our website at fwcommunity.com.

22 21 20 19 18 5 4 3 2 1

DISTRIBUTED IN CANADA BY FRASER DIRECT
100 Armstrong Avenue
Georgetown, ON, Canada L7G 5S4
Tel: (905) 877-4411

DISTRIBUTED IN THE U.K. AND EUROPE
BY F&W MEDIA INTERNATIONAL LTD
Pynes Hill Court, Pynes Hill, Rydon Lane, Exeter, EX2 5AZ United Kingdom
Tel: (+44) 1392 797680
Email: enquiries@fwmedia.com

ISBN 13: 978-1-4403-4997-3

Edited by Mary Burzlaff Bostic
Production edited by Amy Jones
Designed by Jamie DeAnne
Production coordinated by Jennifer Bass

METRIC CONVERSION CHART

To convert	to	multiply by
Inches	Centimeters	2.54
Centimeters	Inches	0.4
Feet	Centimeters	30.5
Centimeters	Feet	0.03
Yards	Meters	0.9
Meters	Yards	1.1

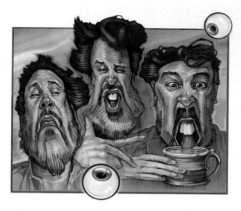

ACKNOWLEDGMENTS

I'd like to extend my very special thanks to Martin French and all the brilliant Faculty at the PNCA. All the wonderful art directors that have lent their support and guidance: Dawn Murin, Jeremy Jarvis, Richard Whitters, Kate Irwin, Jon Schindehette, Peter Whitley, Kyle Hunter, Sean Glenn, Robert Rapier, Cynthia Sheppard, Kieran Yanner, Tyler Jacobson, Mark and Sara Winters, Colin Kawakami, Ron Foster, Tim Shields and family; every writer, R&D, coordinator, designer and illustrator on board at Wizards of the Coast past and present, every fan and creative who continues to lend me support, and make the games I grew up with more amazing every year!

No artist creates in a vacuum, and were it not for your influence, guidance and inspiration over the years, I'd of not even flipped off the lens lid to light this crooked path. Special thanks to Todd Lockwood, Jim FitzPatrick, Brad Holland, James Gurney, Gregory Manchess, Roger Dean, Victor Ambrus, William Stout, Mark Nelson, John Howe, Brian Froud, Charles Vess, Scott Gustafson, Skip Liepke, Thomas Blackshear, Glen Orbik, Mike Mignola, Patrick Woodruffe, Robert Venosa, Guy Billout, C.F. Payne, Anita Kunz, Paul Bonner, Michael Kaluta, Catherine Jeffery Jones, Bernie Wrightson, Bernie Fuchs, Stephen Hickman, Kinuko Craft, Allen Williams, Brom, Rebecca Leveille Guay, Donato Giancola, all my instructors, and the host of wildly skilled, and kind-hearted Lightpushers who've bent my brush bristles in the right direction.

Gracious thanks to all my friends and family. To those who excel, without proper means or opportunity. To the survivors of life threatening hostility, relocation, illness and disease. To those who carry on with bright eyes and hopeful hearts after losing everything. To those who find more strength in fighting for peace and the unity that is inherent in our cultures and mythologies, rather than resorting to ignorance and violence. To all those who can remember the simple dreams of their youth, using all their skills and all their strengths to fulfill them.

IDEAS. INSTRUCTION. INSPIRATION.

Check out these **IMPACT** titles at IMPACTUniverse.com!

These and other fine **IMPACT** products are available at your local art and craft retailer, bookstore or online supplier. Visit our website at IMPACTUniverse.com.

Follow **IMPACT** for the latest news, free wallpapers, free demos and chances to win FREE BOOKS!

Follow us!

IMPACTUniverse.COM

- Connect with your favorite artists
- Get the latest in comic, fantasy and sci-fi art instruction, tips and techniques
- Be the first to get special deals on the products you need to improve your art